BRAF

c

DIRECT DESIGN RESPONSE

Copyright © 1998 by Rockport Publishers, Inc.

All rights reserved. No part of this book may be reproduced in any form without written permission of the copyright owners. All images in this book have been reproduced with the knowledge and prior consent of the artists concerned and no responsibility is accepted by producer, publisher, or printer for any infringement of copyright or otherwise, arising from the contents of this publication. Every effort has been made to ensure that credits accurately comply with information supplied.

First published in the United States of America by:
Rockport Publishers, Inc.
33 Commercial Street
Gloucester, Massachusetts 01930-5089
Telephone: (978) 282-9590
Facsimile: (978) 283-2742

Logo design by: Kathy Chapman

Distributed to the book trade and art trade in the United States by:
North Light Books, an imprint of
F & W Publications
1507 Dana Avenue
Cincinnati, Ohio 45207
Telephone: (800) 289-0963

Other Distribution by:
Rockport Publishers, Inc.
Gloucester, Massachusetts 01930-5089

ISBN 1-56496-364-0

10 9 8 7 6 5 4 3 2 1

Front cover (clockwise from top left): pp. 115, 71, 99, 119, 118
Back cover (clockwise from top left): pp. 104, 78, 107, 64
Front flap (top to bottom): pp. 133, 49
Back flap: p. 85
Printed in Hong Kong by Midas Printing Limited.

THE BEST

DIRECT
DESIGN
RESPONSE

Rockport Publishers, Inc.
Gloucester, Massachusetts

ROCKPORT
PUBLISHERS

Contents

DIRECT
DESIGN
RESPONSE

Introduction

It is a good assumption that almost every day you find a piece of direct mail in your mailbox. Some you open, some you read, some you toss in the garbage without ever even opening it. Have you ever stopped to think what makes you open, read, or throw away a piece of mail? Successful direct mail marketing programs are exceedingly complicated. There are an enormous number of considerations to deal with—the purpose, the client's needs, the intended audience. The piece must meet the requirements of the postal system, and be packaged effectively to deal with the tumbling involved in mail processing. The pieces displayed in this book show creativity and innovation at its best.

It is not difficult to send out a mailing, but it is difficult to elicit a response. First of all, it is necessary to entice the recipient just to open the letter. Creative packaging, curiosity-inducing slogans, and mimicking other types of mail are often-used devices. Once open, the mail must be presented layered in such a way that the reader continues to open, look at, and read. Finally, the copywriting/sales pitch must be strong enough to get the reader to respond. This is a lot to ask from a simple piece of mail.

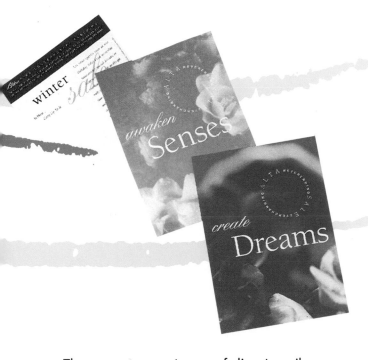

There are many types of direct mail programs. Different programs have different needs and different challenges. Some business-to-consumer or business-to-business mailings merely need to make the recipient aware of the business and its services. Clarity of message is the most important factor in such mailings. Others are invitations and announcements to special events. In this type, it is not only necessary to get the recipient to open and read the mail, but also to make the event enticing enough to actually inspire attendance. Then there is the mail that attempts to sell you something; an exceedingly difficult task since it is in direct competition with lively television advertising.

While this volume includes mostly traditional mailings, there are hints of what is to come with the proliferation of new media. There are a few Websites, which have the potential to be a great format for a direct response campaign:

they hold an enormous amount of information, can be interactive, and can be updated with ease. The next volume in this series will certainly have more examples of electronic direct-mail programs.

Designers will use this book as rich source of ideas and inspiration for their own projects. More casual readers will look through this book to see if the projects would have been successful if they had received such a piece of mail. Either way, it captures an interesting look at direct response marketing today.

CORPORATE DESIGN PROMOTION

A COLLECTION OF INSPIRING MARKETING PIECES
DESIGNED FOR THE CORPORATE WORLD

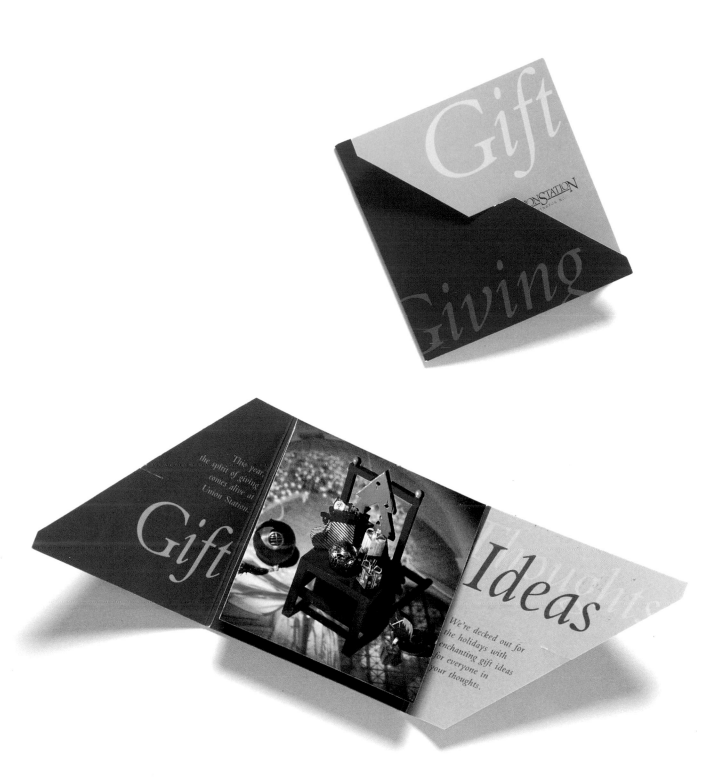

Design Firm **Grafik Communications, Ltd.**
Art Director **Judy Kirpich**
Designers **Michelle Mar, Lynn Umemoto**
Illustrator **Taran Z**
Client **LaSalle Partners**
Purpose or Occasion **Promotional holiday mailer**
Paper/Printing **Springhill 18 pt.**
Number of Colors **Four plus two PMS plus gloss varnish**

The client wanted a format that looked interesting and that would make people want to pick it up during the hectic holiday season. Thus, the designers applied a self-closing fold to the mailer to suggest the idea of gift wrapping and unwrapping.

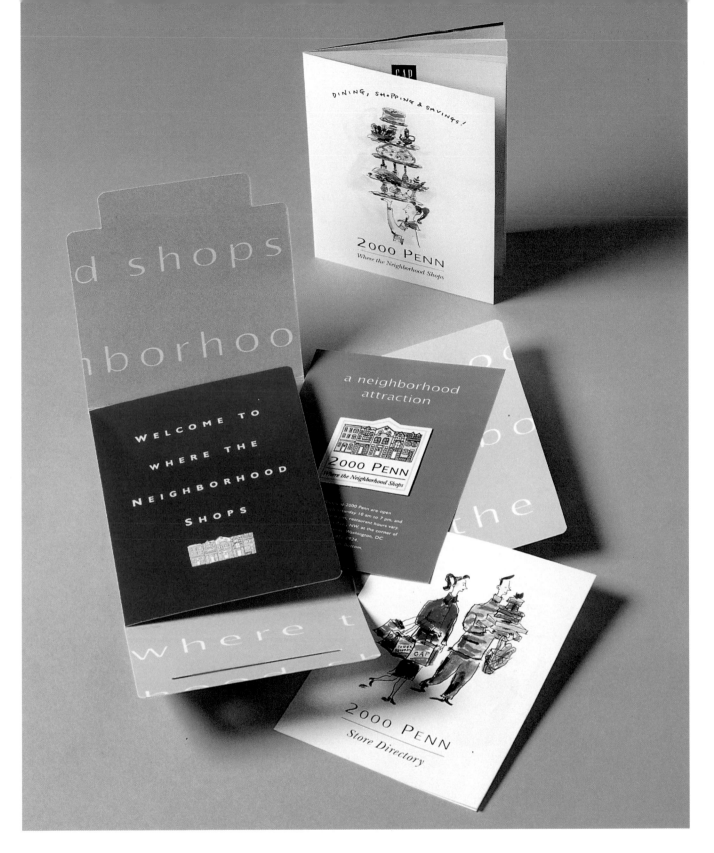

Design Firm **Grafik Communications, Ltd.**
Art Director **Judy Kirpich**
Designer **Gregg Glaviano**
Illustrator **Diane Bigda**
Client **LaSalle Partners**
Purpose or Occasion **Gift for shoppers**
Paper/Printing **Coated lustro board 12 pt./Prisma Graphics Printing Corp. of America**
Number of Colors **Four**

This 2000 Penn Carrier serves as a premium gift for shoppers and includes a directory, magnet, and coupons.

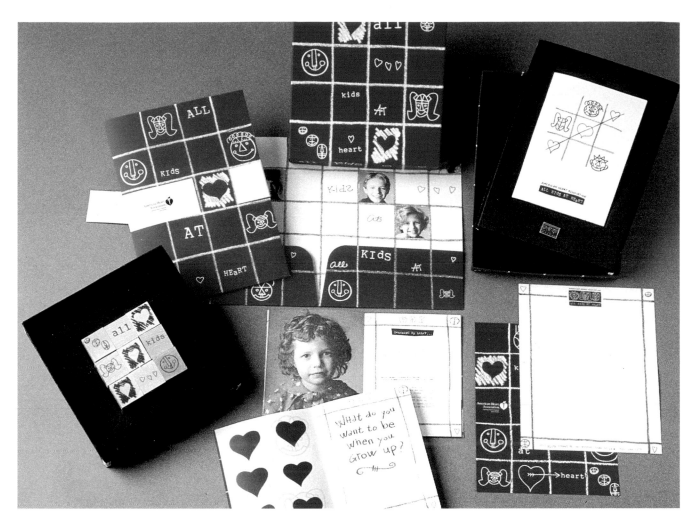

△

Design Firm **Sayles Graphic Design**
Art Director **John Sayles**
Designers **John Sayles, Jennifer Elliott**
Illustrator **John Sayles**
Client **American Heart Association**
Purpose or Occasion **Fund-raising brochure**
Paper/Printing **Hopper Hots, Flax Curtis Tuscan Terra, Curtis Terracoat/Screenprinting, offset**
Number of Colors **Two**

The logo and theme of the American Heart Association youth education program fund-raising materials reflect the purpose of the program: to educate Iowa's children about heart-healthy lifestyles. Designer John Sayles chose a "childlike" illustration style for the graphics of hearts and faces that appear throughout the collateral pieces. The brochure box includes an insert tray with an enamel "All Kids at Heart" lapel pin. The unique donor gift is a tic-tac-toe style game, made from wooden blocks with red screen-printed graphics. Rather than "x's" and "o's," players get three across with hearts and faces.

▷

Design Firm **Webster Design Associates, Inc.**
Art Director **Dave Webster**
Designer/Illustrator **Phil Thompson**
Client **AmeriServe Food Management**
Purpose or Occasion **Introduce AmeriServe**
Number of Colors **Two**

This direct-mail piece was created as a companion to an identity package designed for AmeriServe, an innovative new company offering health-oriented nutritional programs. The fresh, raw apple in the eye-catching wooden crate emphasized the slogan "Food for Thought." Copy describes the company's new approach.

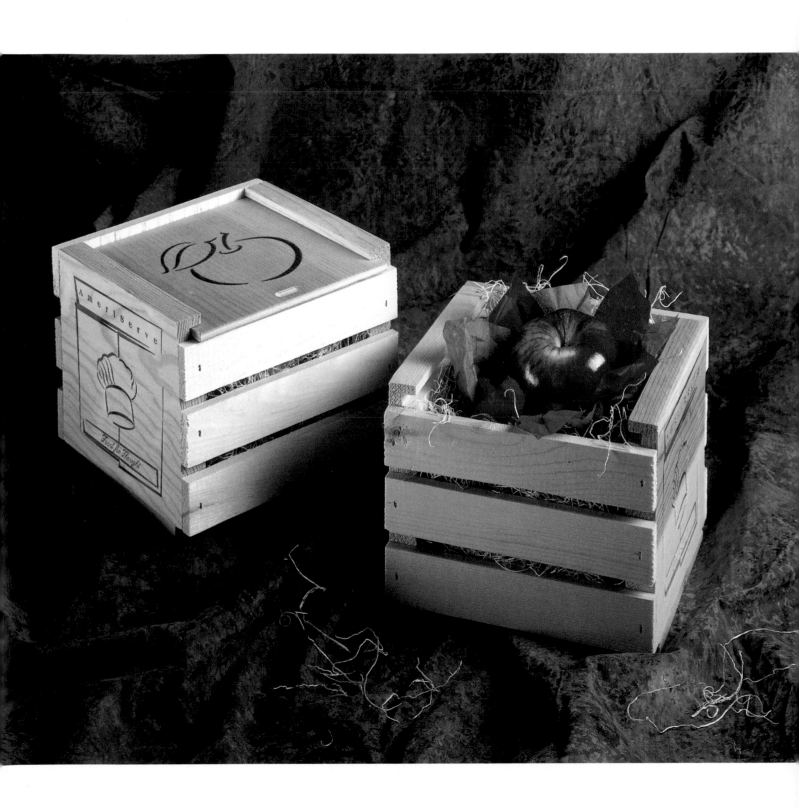

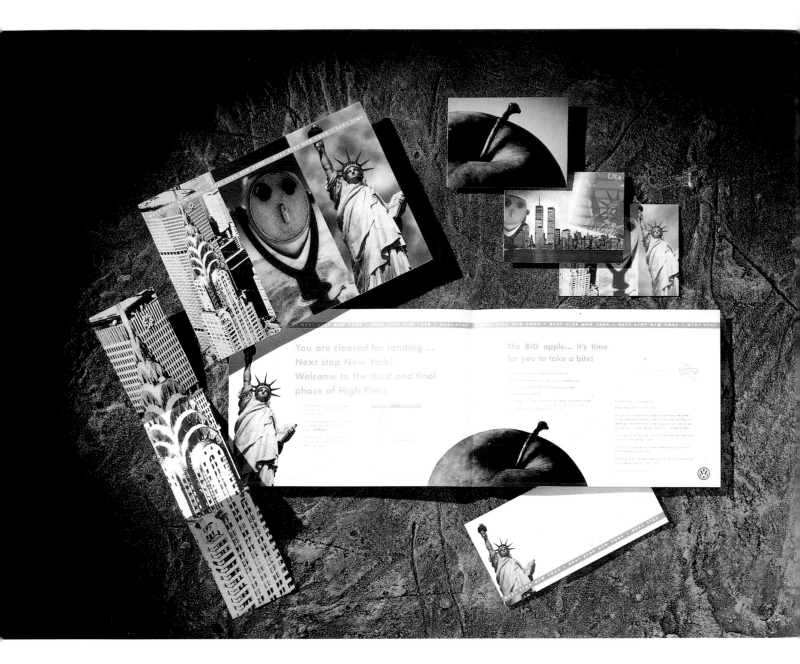

Design Firm **Acorn Creative Consultants Ltd.**
Art Director/Designer **Vanessa Dina-Barlow**
Client **Capital Incentives Ltd.**
Purpose or Occasion **VW incentives**
Paper/Printing **Silk-screen**
Number of Colors **Two**

This brief promoted a trip to New York City for qualified VW dealers. Using only two colors, the design reflected the "Big Apple", using striking duotone images and a graphic ticker-tape band. The pack consisted of a two-fold teaser, an informative brochure, and three follow-up postcards.

Design Firm **elDesign**
Art Director/Designer **Lynn St. Pierre**
Client **Detroit Zoological Society**
Purpose or Occasion **Corporate sponsorship brochure**
Number of Colors **Three**

This brochure was mailed along with the client's annual report, therefore some of the previously established color and design elements were carried though to this piece. The photographs were printed as black-and-gray duotones.

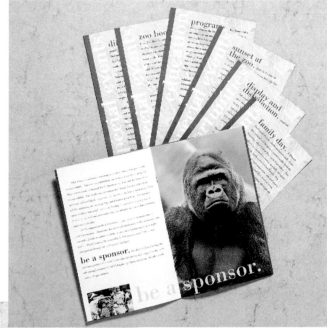

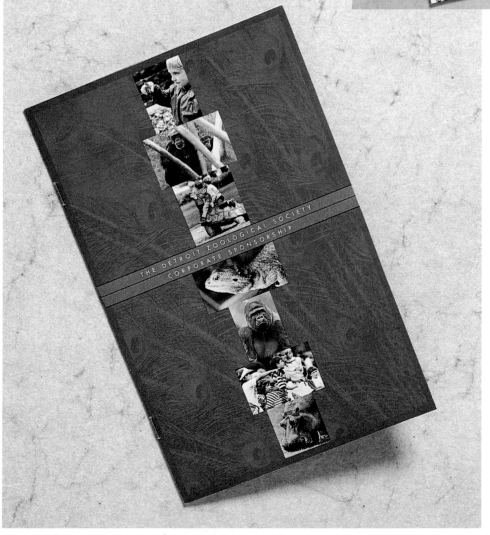

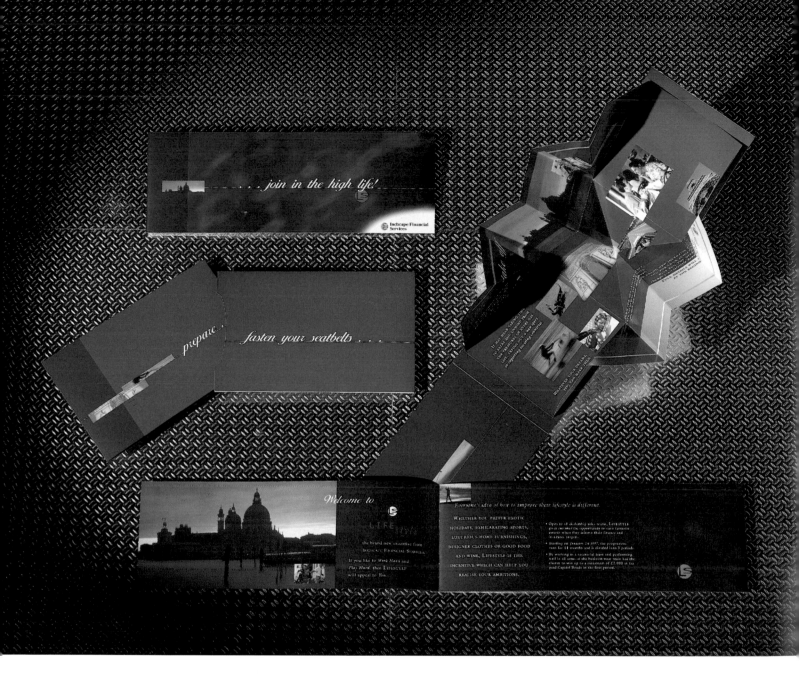

Design Firm **Acorn Creative Consultants Ltd.**
Art Director/Designer **Simon Reason**
Illustrator **Image Bank**
Client **Capital Incentives Ltd.**
Purpose or Occasion **Promote new business insurance**
Paper/Printing **McNaughton Skygloss 300 gsm, 170 gsm**
Number of Colors **Four plus special**

The direct mail piece consisted of two parts: Part 1 was a teaser consisting of a
slipcased landscape folder with minimal copy and close-up details of locations
featured in the scheme. This opened to reveal a pop-up. Part 2 was a landscape
booklet, revealing more detail of locations. KPT filters were used to create
textures.

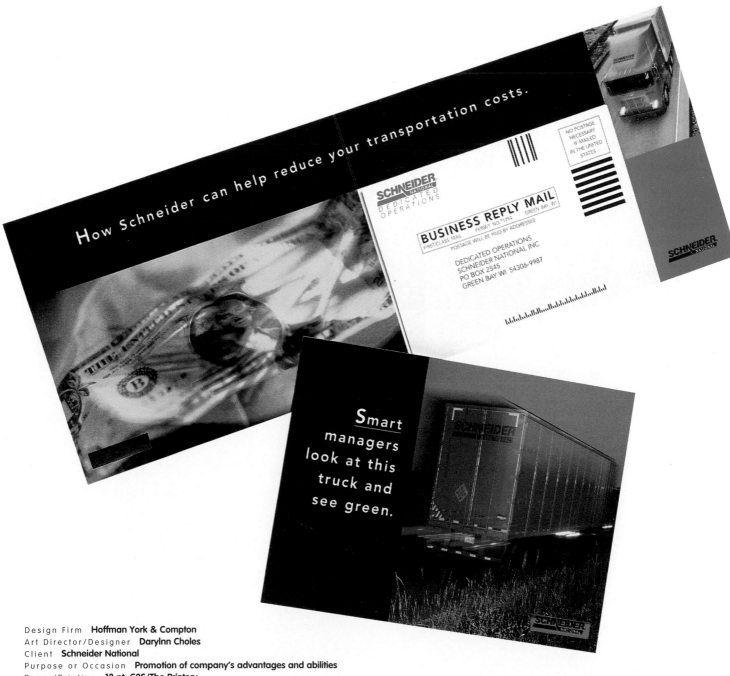

Design Firm **Hoffman York & Compton**
Art Director/Designer **Darylnn Choles**
Client **Schneider National**
Purpose or Occasion **Promotion of company's advantages and abilities**
Paper/Printing **12 pt. C2S/The Printery**
Number of Colors **Four plus one PMS**

The first in a series of six, this direct-mail piece focuses on the money the transportation company can save corporations who do not specialize in transport. The client wanted the mailer to include a distinguishing photograph of the Schneider building; a bold, powerful design; and a detachable reply card.

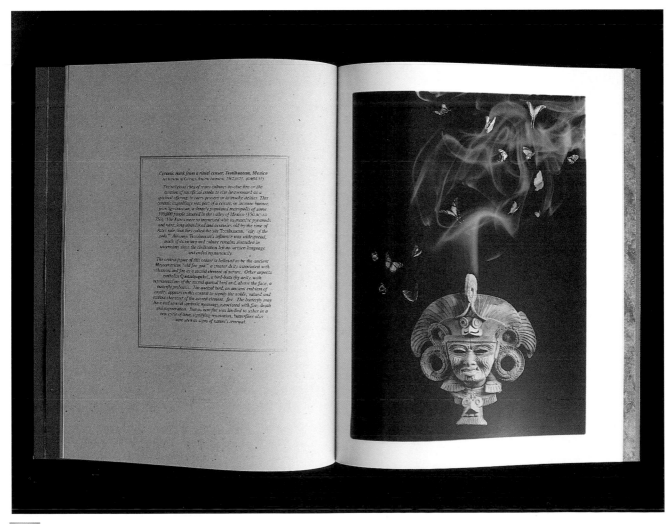

Corporate Promotions

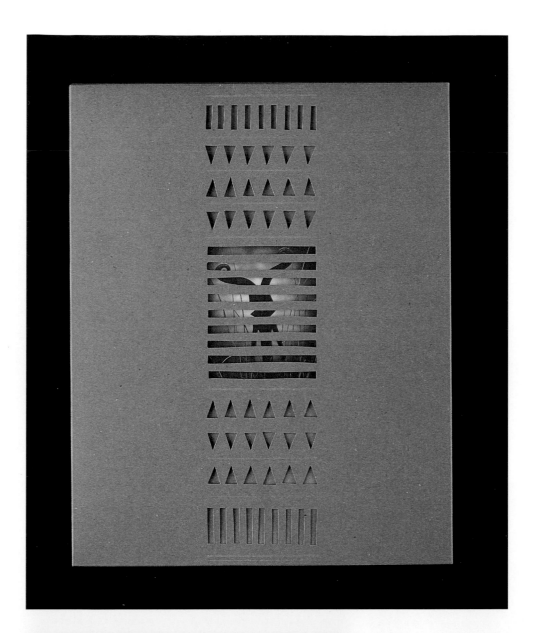

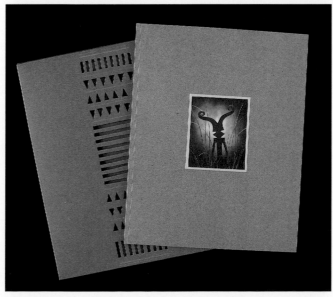

Design Firm **Wood/Brod Design**
Art Director/Designer **Stan Brod**
Photographer **Corson Hirschfeld**
Client **Hennegan Printing Company**
Purpose or Occasion **To promote Hennegan's printing capabilities**
Paper/Printing **Fox River Confetti, Eloquence/Offset geometric screening**
Number of Colors **Six plus heat-foil stamping and die-cutting**

Photos of ancient artifacts from around the world and the unusual environments they are found in are the subject of this promotion piece. Corson Hirschfeld's photographs add a mystical quality to the visuals. The designers used such special techniques as: stochastic printing (geometric screening) for fine reproduction, foil stamping to contrast the ancient environment, and die-cutting to create a primitive-looking pattern for the envelope.

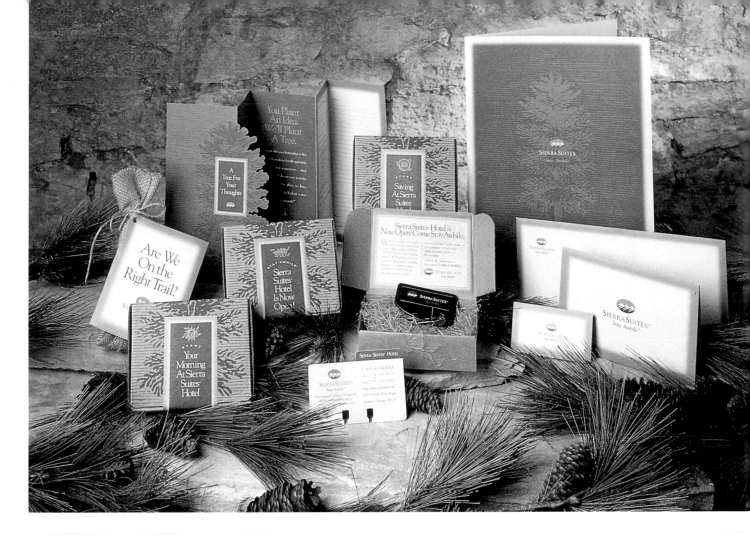

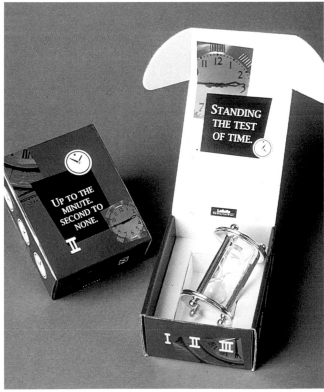

△
Design Firm **Greteman Group**
Art Directors **Sonia Greteman, James Strange**
Designers **Sonia Greteman, James Strange, Craig Tomson**
Illustrators **James Strange, Craig Tomson**
Client **Sierra Suites**
Purpose or Occasion **Direct mail for specific hotels**
Paper/Printing **Passport/Offset**
Number of Colors **Two**

The direct mail campaign included various boxes with items for office use. It was targeted to the busy, corporate executive. A metallic copper with a dark green gave the pieces a natural rich feel. All art was created in Macromedia FreeHand; the woodcut tree illustration was silk-screened onto the box.

◁
Design Firm **Sayles Graphic Design**
Art Director **John Sayles**
Designers **John Sayles, Jennifer Elliott**
Illustrator **John Sayles**
Client **LaSalle National Bank**
Purpose or Occasion **Promotional mailer**
Paper/Printing **Artcraft Fortune Gloss 80 lb. text/Offset**
Number of Colors **Two**

A new promotion for LaSalle National Bank of Chicago has something everyone can use—a little more time—in the shape of a custom hourglass enclosed in the mailing. Dramatic duotone photographs of timepieces are printed with metallic inks. The time theme is reinforced with appropriate graphics—clocks, sundials, watches—and copy that reads "Up To The Minute—Second To None." Inside the corrugated box, a custom tray holds the gold hourglass etched with the client's logo.

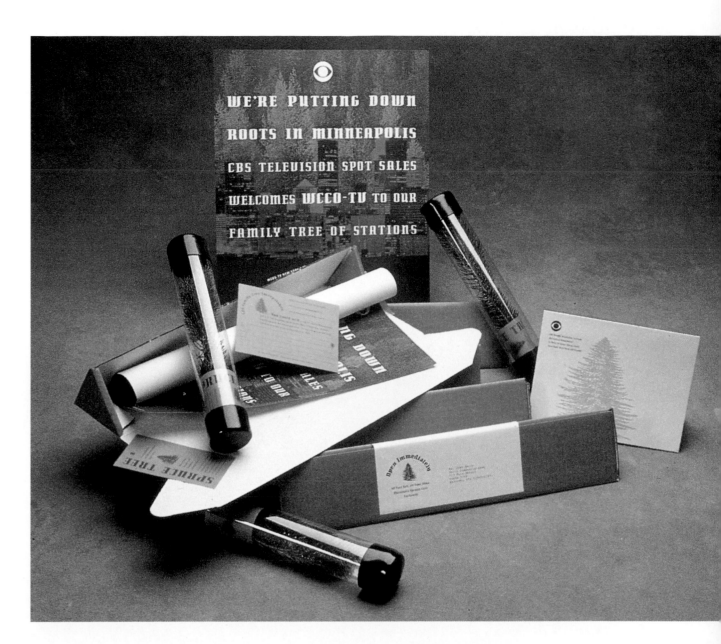

Design Firm **Toni Schowalter Design**
Art Director/Designer **Toni Schowalter**
Client **CBS Television**
Purpose or Occasion **Promotion for new affiliate**
Paper/Printing **Quest Recycled with soy inks**
Number of Colors **Two PMS**

This CBS television Minneapolis announcement was targeted to media buyers; it announces a change in ownership of a Minneapolis TV station. A sweepstakes offer helped to initiate a response. Playing on the theme of growth, the mailing included spruce tree saplings that could be planted. The pieces were sent in a brown, corrugated, triangular box.

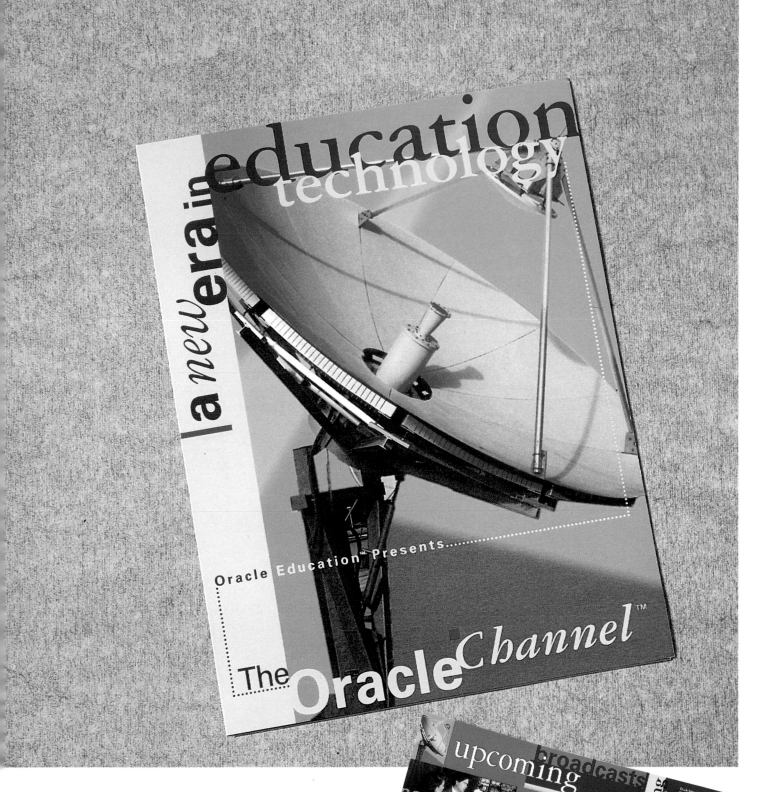

Design Firm **Clark Design**
Art Director **Annemarie Clark**
Designer **Ozzie Paton**
Client **Oracle Corporation**
Purpose or Occasion **Announce the Oracle Channel broadcasts**
Paper/Printing **Sheet-fed printing**
Number of Colors **Four process, three PMS, and varnish**

The client wanted a very colorful direct mail piece to announce the
broadcast dates for The Oracle Channel and other media-based training
opportunities offered by Oracle Education. The designers used existing
photos and designed a template that could be easily updated every two
months. The piece was created in QuarkXPress.

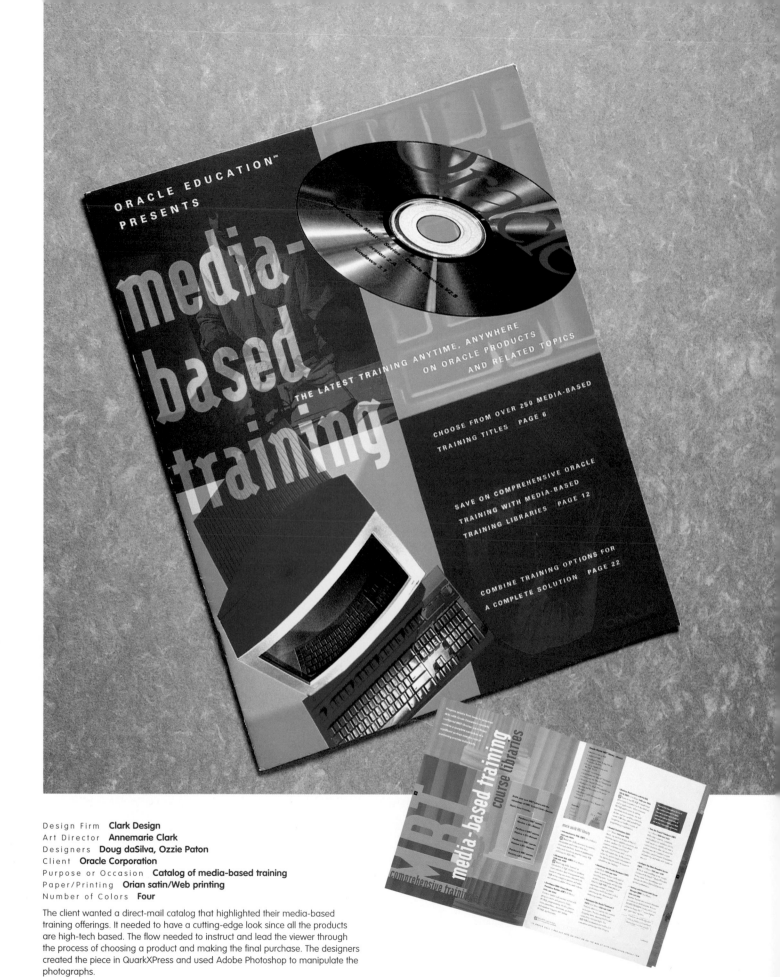

Design Firm **Clark Design**
Art Director **Annemarie Clark**
Designers **Doug daSilva, Ozzie Paton**
Client **Oracle Corporation**
Purpose or Occasion **Catalog of media-based training**
Paper/Printing **Orian satin/Web printing**
Number of Colors **Four**

The client wanted a direct-mail catalog that highlighted their media-based training offerings. It needed to have a cutting-edge look since all the products are high-tech based. The flow needed to instruct and lead the viewer through the process of choosing a product and making the final purchase. The designers created the piece in QuarkXPress and used Adobe Photoshop to manipulate the photographs.

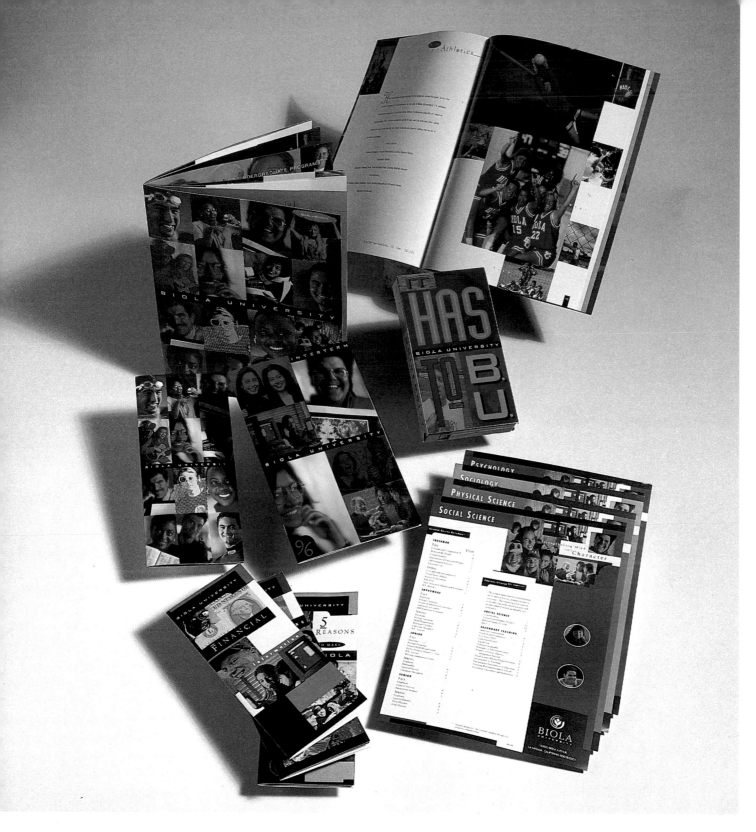

Design Firm **David Riley + Associates**
Art Director **David Riley**
Designers **Dwayne Cugdilli, Dennis Thorp, David Ferrell**
Photographer **Lonnie Duka**
Client **Biola University**
Purpose or Occasion **Recruitment collateral**

For over a decade, DR+A has been instrumental in helping Biola University
define its corporate identity. Each piece of collateral is designed to build upon
and complement the others. This marketing campaign was to highlight the
school's sense of community and, as a result, position Biola's students and
faculty as its greatest resource.

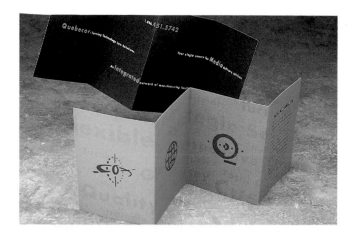

Design Firm **Hornall Anderson Design Works**
Art Director **Jack Anderson**
Designers **Jack Anderson, Heidi Favour, Mary Hermes,
Mary Chin Hutchison**
Client **Quebecor Integrated Media**
Purpose or Occasion **Announcement of name change**

The name change announcement depicts three logos: the Print NW/Six Sigma logo; a globe logo reflecting the worldwide facilities or "global aspect"; and the new Quebecor logo of the new company. The announcement was produced using a tinted varnish.

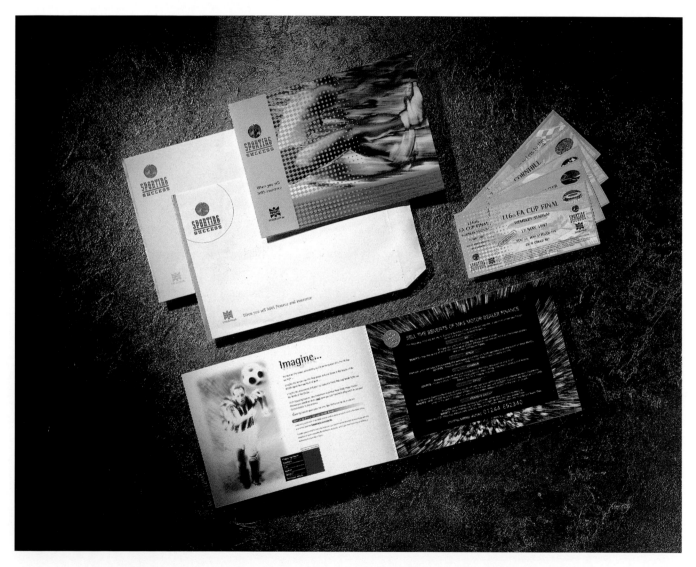

Δ

Design Firm **Acorn Creative Consultants Ltd.**
Art Director/Designer **Matthew Davies**
Illustrator **Photo Library Images**
Client **Capital Incentives Ltd.**
Purpose or Occasion **NWS Bank Dealer Incentive**
Paper/Printing **Skygloss 300 gsm lithography**
Number of Colors **Four plus silver and bronze**

The incentive plan designed for NWS motor dealers encouraged them to sell finance and insurance. Motor dealers can collect capital bonds and have the chance to win two tickets to a major sporting event of their choice. The Sporting Success logo was designed in Adobe Dimensions and all images were photo-library shots.

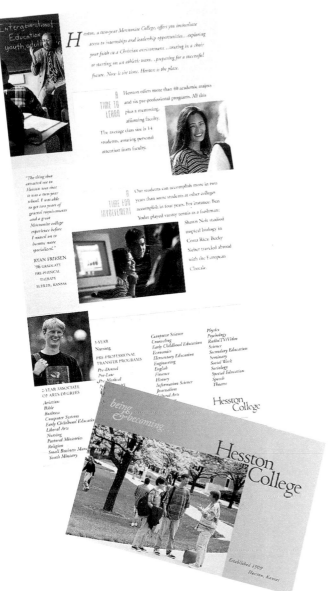

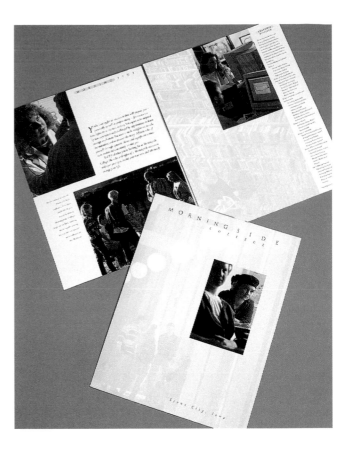

△

Design Firm **Stamats Communications, Inc.**
Art Director/Designer **Peter Heiss**
Client **Morningside College**
Purpose or Occasion **Academic focus piece**
Paper/Printing **Sterling Satin, 110 lb. text**
Number of Colors **Five**

Designed as a piece to highlight the academic offerings at Morningside College, the overall theme of "sides" and "sights" was carried throughout this brochure in order to complement the search piece and view-book publications.

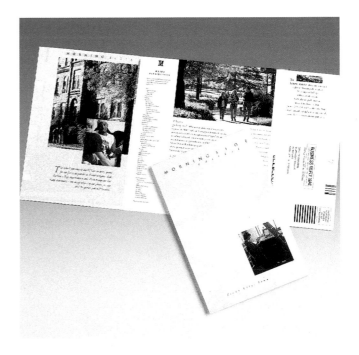

△

Design Firm **Stamats Communications, Inc.**
Art Director/Designer **Peter Heiss**
Client **Hesston College**
Purpose or Occasion **Search piece**
Paper/Printing **Sterling Satin, 110 lb. text**
Number of Colors **Five**

This small search piece retained a cool-to-warm graduated tone panel that was used for both the view book and a image poster for Hesston College. The inside was designed to flow from top to bottom, suggesting the process of growth at this two-year Mennonite school.

▷

Design Firm **Stamats Communications, Inc.**
Art Director/Designer **Peter Heiss**
Client **Morningside College**
Purpose or Occasion **Search piece**
Paper/Printing **Sterling Satin, 110 lb. text**
Number of Colors **Five**

The design reflects the theme of the "sides" and "sights" at Morningside College. Subtle, warm ghosted-back images are contrasted with small photography. The intent was to present a soft environment in which to convey the more outstanding features of the institution.

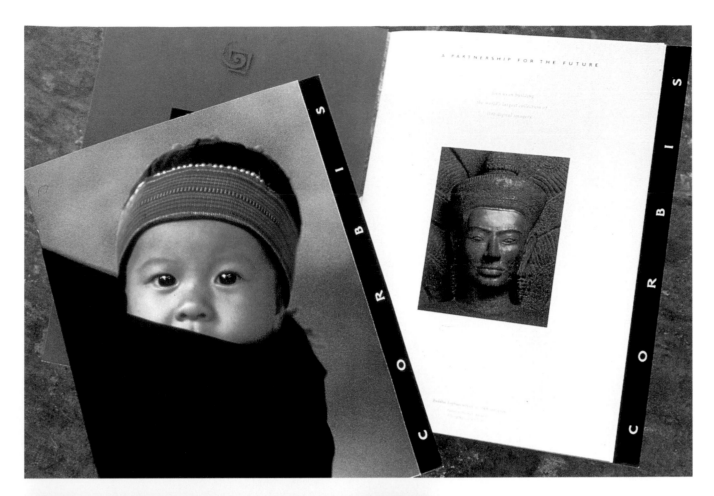

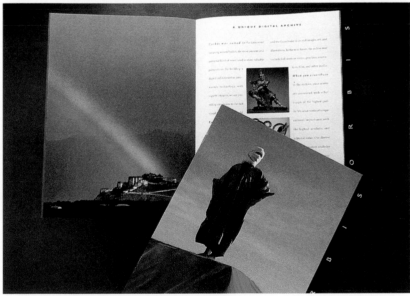

Design Firm **Hornall Anderson Design Works**
Art Director **Jack Anderson**
Designers **Jack Anderson, John Anicker, David Bates, Margaret Long**
Illustrator **Corbis archive**
Client **Corbis Corporation**
Purpose or Occasion **Promotional brochures for services**
Paper/Printing **Vintage Velvet**

The objective was to create two brochures, serving the same purpose, but for different target audiences. One brochure targeted fine-art institutions and the other targeted photographers. Corbis used the brochures to target specific sources to the benefits of archiving their images under the Corbis umbrella. These brochures were designed using QuarkXPress.

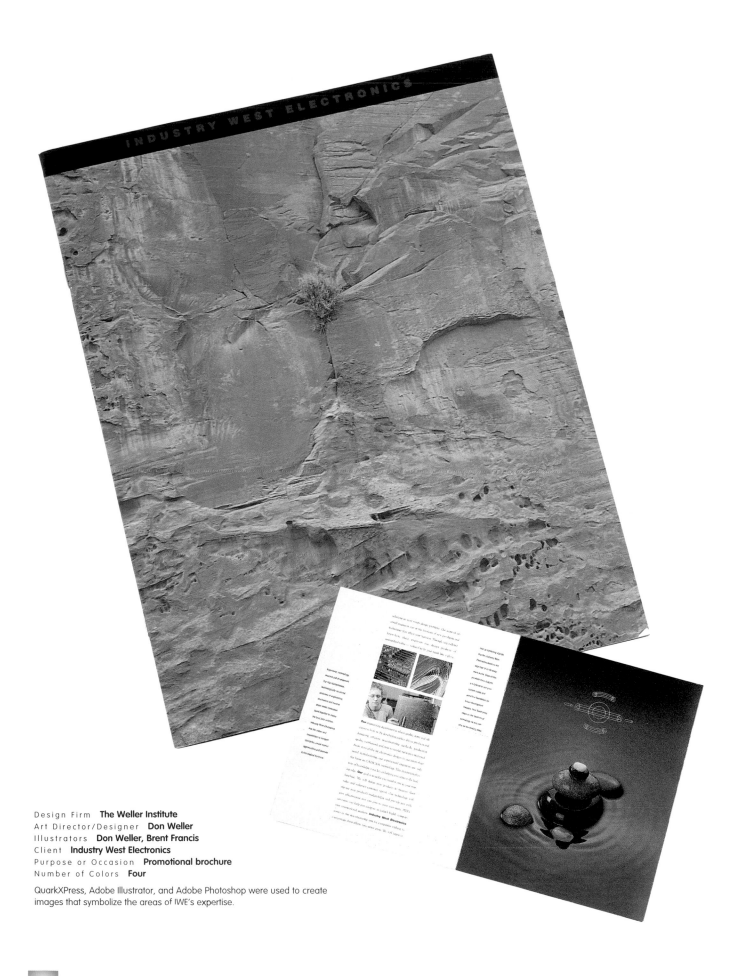

Design Firm **The Weller Institute**
Art Director/Designer **Don Weller**
Illustrators **Don Weller, Brent Francis**
Client **Industry West Electronics**
Purpose or Occasion **Promotional brochure**
Number of Colors **Four**

QuarkXPress, Adobe Illustrator, and Adobe Photoshop were used to create images that symbolize the areas of IWE's expertise.

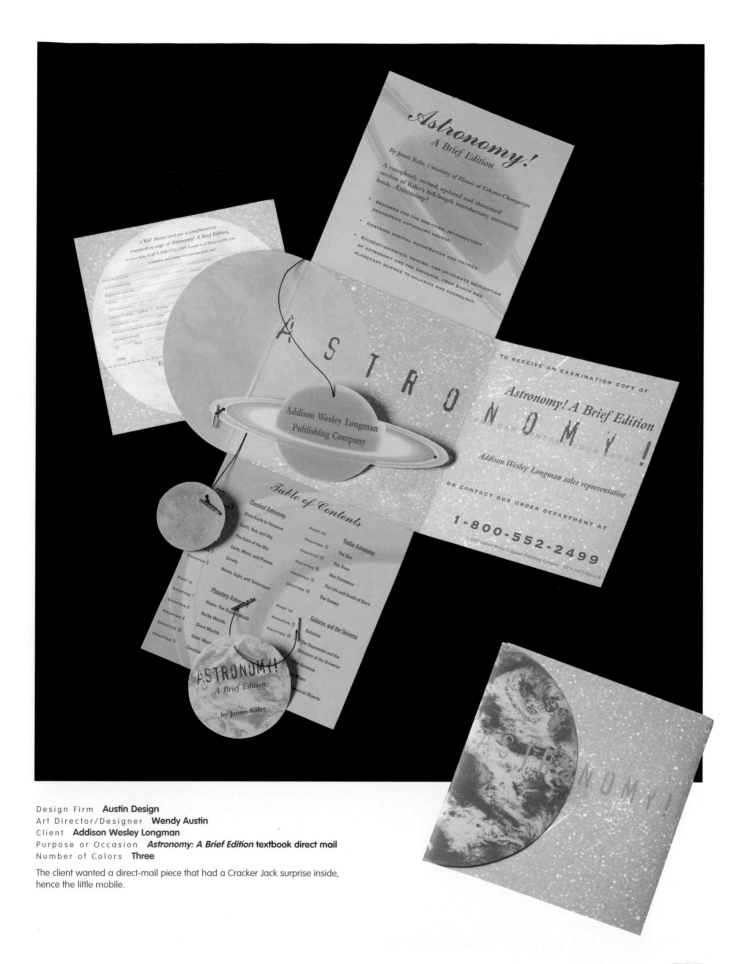

Design Firm **Austin Design**
Art Director/Designer **Wendy Austin**
Client **Addison Wesley Longman**
Purpose or Occasion *Astronomy: A Brief Edition* **textbook direct mail**
Number of Colors **Three**

The client wanted a direct-mail piece that had a Cracker Jack surprise inside, hence the little mobile.

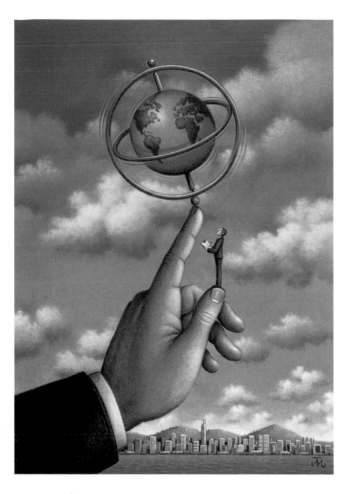

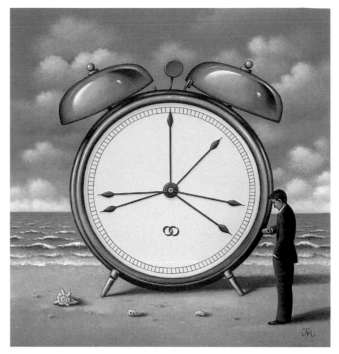

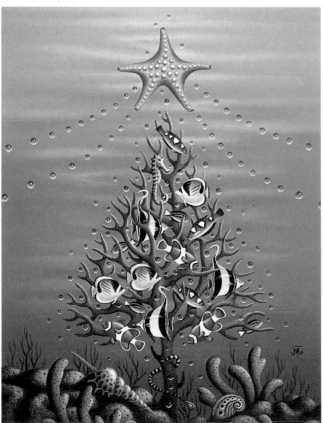

△
Design Firm **Melissa Passehl Design**
Art Director **Chris Passehl**
Illustrator **James Marsh**
Client **Keilor & Co.**
Purpose or Occasion **Corporate brochure**
Number of Colors **Four**

Text accompanied this pie chart that conveyed the performance of different sectors of the company throughout the year. It is one in a series of six images created for an annual report.

△ _TOP LEFT_
Art Director **Colin Dunne**
Illustrator **James Marsh**
Client **Lowe Bell Marketing & Events**
Purpose or Occasion **Corporate brochure**
Number of Colors **Four**

The title of this piece "How We Do It," relates to how the business oversees and monitors world events. It is one in a set of three paintings for a marketing and events company brochure.

◁
Design Firm **Pentagram Design**
Art Director **John Rushworth**
Illustrator **James Marsh**
Client **John Davies**
Purpose or Occasion **Christmas promotion**
Number of Colors **Four**

"Christmas Coral" is a painting for signed mini-poster promotion for a shipping company in the Cayman Islands.

△
Art Director **Colin Dunne**
Illustrator **James Marsh**
Client **Lowe Bell Marketing & Events**
Purpose or Occasion **Corporate brochure**
Number of Colors **Four**

Entitled, "The Next Step," this piece relates to how Lowe Bell Marketing & Events can make its clients see their organization in a new light. It is one in a set of three paintings for the company brochures.

△ *TOP RIGHT*
Design Firm **Melissa Passehl Design**
Art Director **Chris Passehl**
Illustrator **James Marsh**
Client **Keilor & Co.**
Purpose or Occasion **Corporate brochure**
Number of Colors **Four**

The title of this piece, "Communication," refers to the importance of communication between themselves and their clients. It is one of six images created for an annual report.

▷
Art Director **Colin Dunne**
Illustrator **James Marsh**
Client **Lowe Bell Marketing & Events**
Purpose or Occasion **Corporate brochure**
Number of Colors **Four**

"Who We Are" is one in a set of three paintings for a company brochure marketing and events information. It relates to the project of putting London backlands on the map.

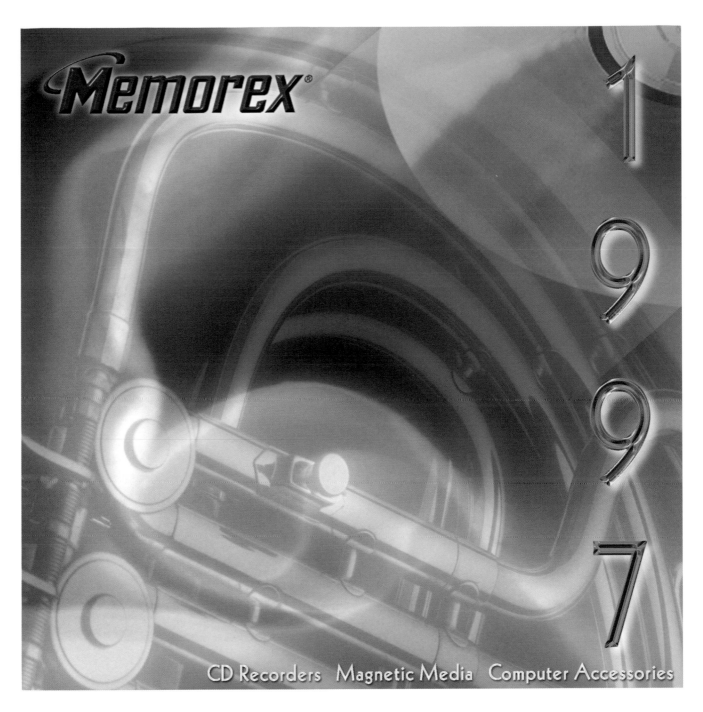

Designer **Royce Chen**
Client **Memorex (Memtek Products, Inc.)**
Purpose or Occasion **Catalog cover**
Paper/Printing **120 lb. stock paper, gloss**
Number of Colors **Four**

All images were created in Adobe Photoshop. It was created to meet the client's request: romantic with feminine touch, yet still including a major product, the CD-ROM. The images were layered, then different effects were achieved using various opacities. For the numerals of 1997, Carue and Glass were used; it was then filtered under Alien Skin to make the word look three-dimensional and glossy. Adjust/curves modified the colors and highlights.

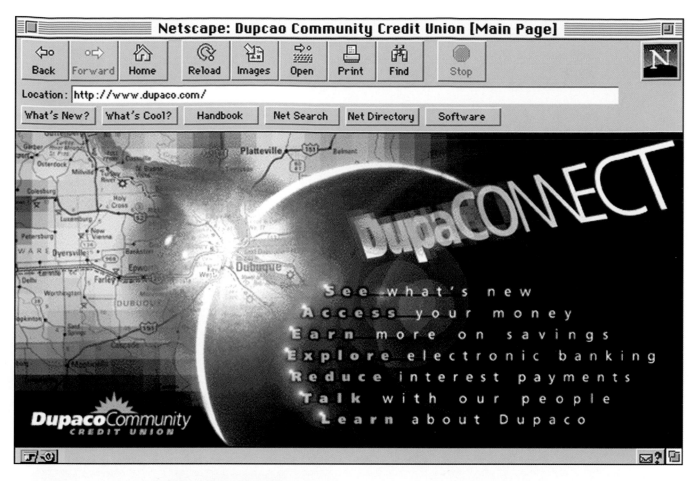

Back | Forward | Home | Reload | Images | Open | Print | Find | Stop

Location: http://www.dupaco.com/

What's New? | What's Cool? | Handbook | Net Search | Net Directory | Software

DupacoCONNECT

See what's new
Access your money
Earn more on savings
Explore electronic banking
Reduce interest payments
Talk with our people
Learn about Dupaco

Dupaco Community CREDIT UNION

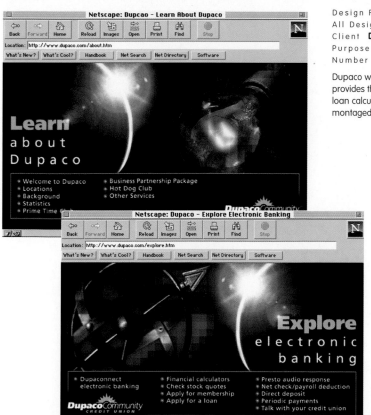

Design Firm **McCullough Creative Group, Inc.**
All Design **Mike Schmalz**
Client **Dupaco Community Credit Union**
Purpose or Occasion **Website**
Number of Colors **Three (RGB)**

Dupaco wanted a visually appealing, technologically advanced Website. The site provides their member/owners with up-to-date financial information, interactive loan calculators, and electronic banking options. Photo CD format images were montaged together using Adobe Photoshop.

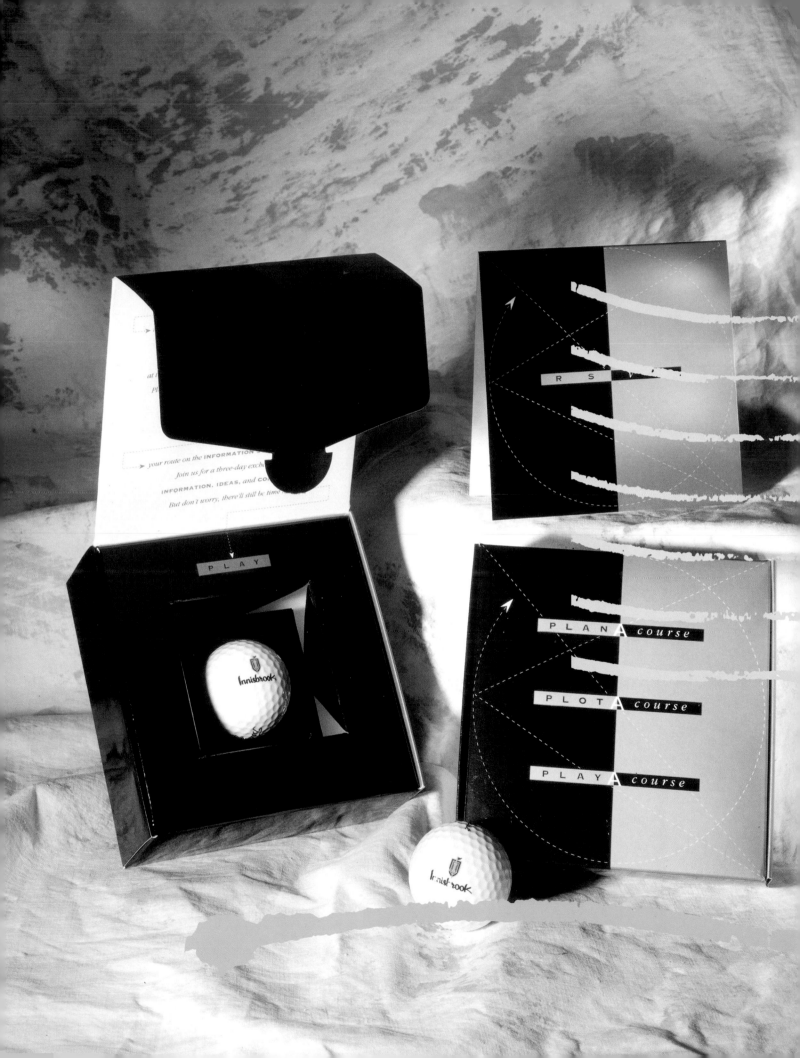

EVENT DESIGN PROMOTION

A COLLECTION OF INSPIRING MARKETING PIECES
DESIGNED TO INCREASE ATTENDANCE

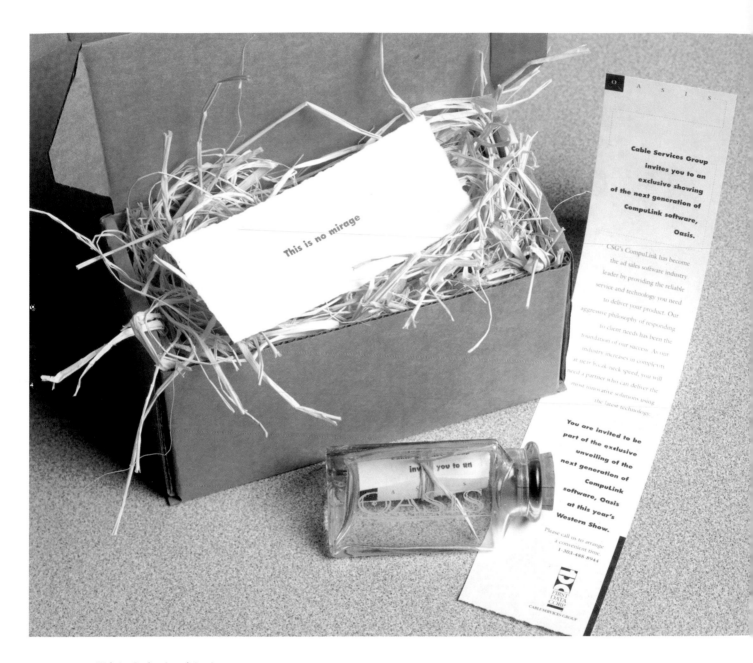

Design Firm **Webster Design Associates, Inc.**
Art Director **Dave Webster**
Designers **Dave Webster, Phil Thompson**
Client **Cable Services Group**
Purpose or Occasion **Invitation to a special showing**
Number of Colors **One**

This high-tech message in a bottle was sent to managers to invite them to the exclusive unveiling of Oasis, a new software system for monitoring cable-television subscribers.

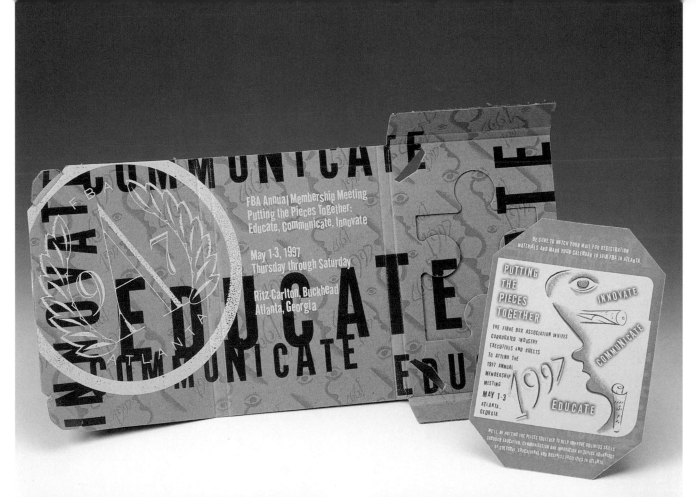

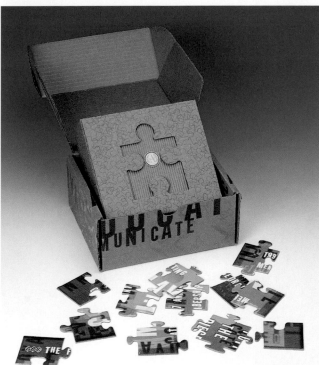

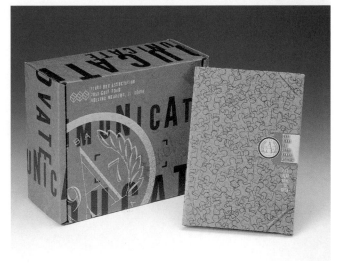

Design Firm **Love Packaging Group**
Art Director **Brian Miller**
Designer/Illustrator **Chris West**
Client **Fibre Box Association**
Purpose or Occasion **1997 FBA Annual Meeting**
Paper/Printing **Corrugated/Rand Graphics, Inc., silkscreen**
Number of Colors **Three**

FBA wanted the design to suggest the theme for the meeting as well as provide
inspiration for people to attend the event. The teaser introduced the puzzle
theme with a removable die-cut puzzle piece that could be redeemed at the
meeting to receive the official program. The puzzle piece actually fits into the
program cover. The single face card was hand-cut to fit the teaser cover. The
circle "A" icon for Atlanta was placed by hand on the back of this single-face
card to be viewed through the opening left by the removed puzzle piece. This
look was repeated in the second mailing, the nested puzzle boxes.

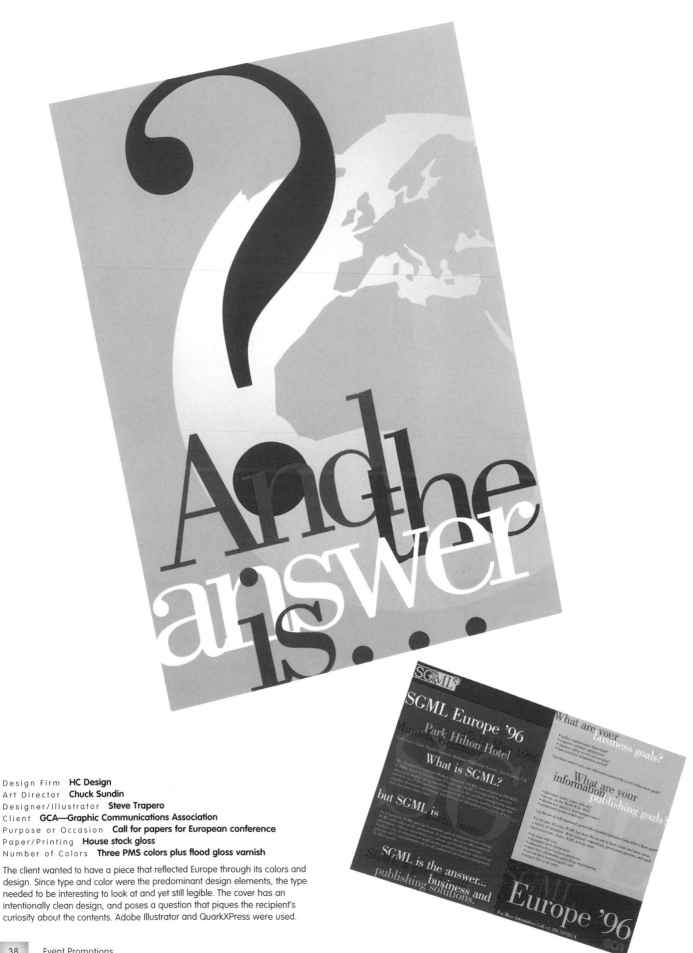

Design Firm **HC Design**
Art Director **Chuck Sundin**
Designer/Illustrator **Steve Trapero**
Client **GCA—Graphic Communications Association**
Purpose or Occasion **Call for papers for European conference**
Paper/Printing **House stock gloss**
Number of Colors **Three PMS colors plus flood gloss varnish**

The client wanted to have a piece that reflected Europe through its colors and design. Since type and color were the predominant design elements, the type needed to be interesting to look at and yet still legible. The cover has an intentionally clean design, and poses a question that piques the recipient's curiosity about the contents. Adobe Illustrator and QuarkXPress were used.

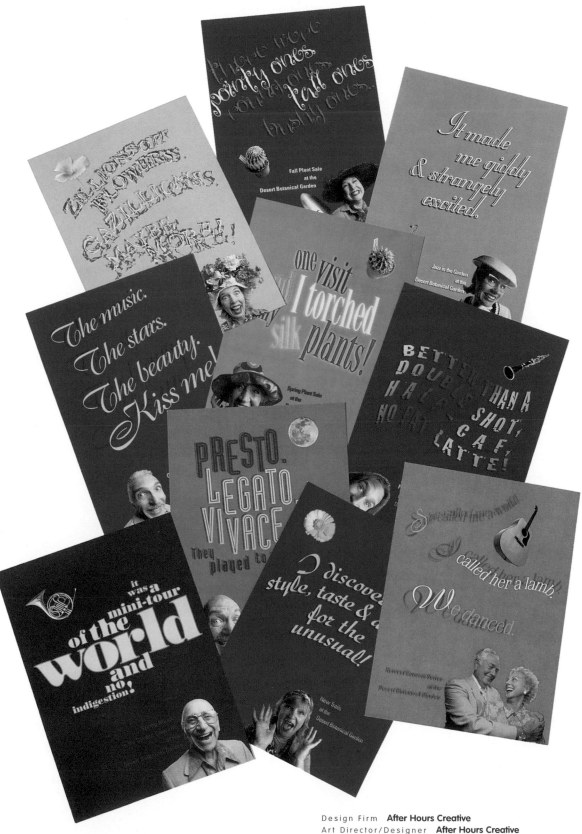

Design Firm **After Hours Creative**
Art Director/Designer **After Hours Creative**
Photographer **Bob Carey**
Client **Desert Botanical Garden**
Number of Colors **Four**

These postcards were used to increase attendance at a variety of special events held by the client. Over the past three years, the postcards have increased attendance by as much as 100% and resulted in more than $100,000 in additional funds for the garden.

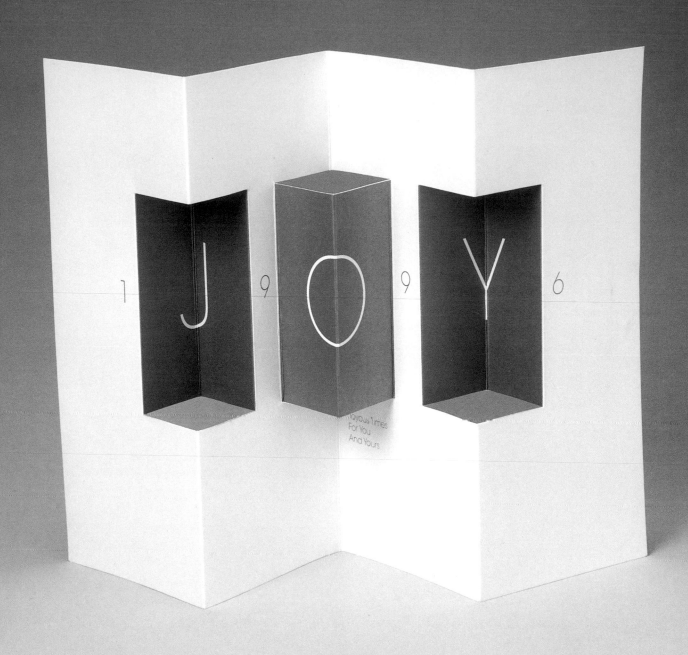

Design Firm **Wood/Brod Design**
Art Director/Designer **Stan Brod**
Client **Berman Printing Co.**
Purpose or Occasion **Holiday greeting**
Paper/Printing **Monadnock Astrolite/Offset, die-cut**
Number of Colors **Two**

This holiday card was designed for a number of purposes: One was to express the holiday spirit in a very positive manner, the second was to show Berman's printing, die-cutting, and fabricating techniques to its many clients.

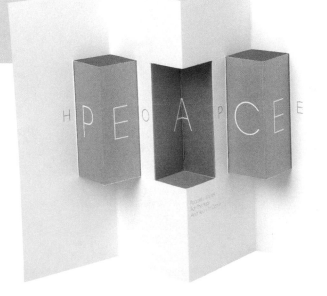

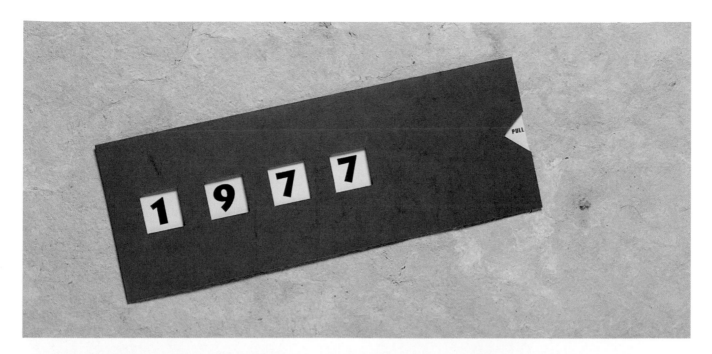

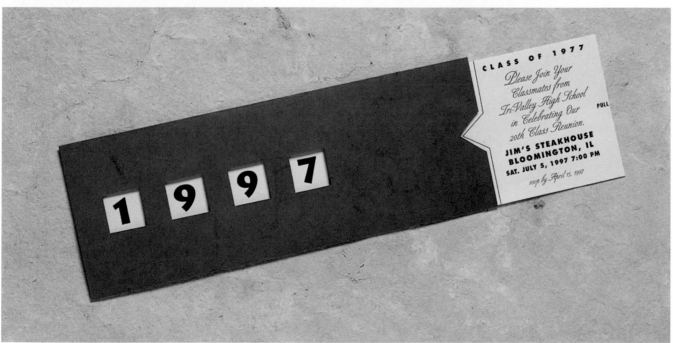

CLASS OF 1977
*Please Join Your
Classmates from
Tri-Valley High School
in Celebrating Our
20th Class Reunion.*
JIM'S STEAKHOUSE
BLOOMINGTON, IL
SAT. JULY 5, 1997 7:00 PM
rsvp by April 15, 1997

Design Firm **Tracy Griffin Sleeter**
Designer **Tracy Griffin Sleeter/Rocky**
Client **Tri-Valley High School Class of '77**
Purpose or Occasion **20th class reunion announcement**
Paper/Printing **Laser printing**
Number of Colors **One**

The class of 1977 had no class funds left from the previous reunion. With the limited quantity of sixty pieces, the designers could not justify offset or indigo printing. All invitations were hand-cut, laser printed, and glued. The time involved was six hours, and the total cost was $22.00 plus envelopes and postage.

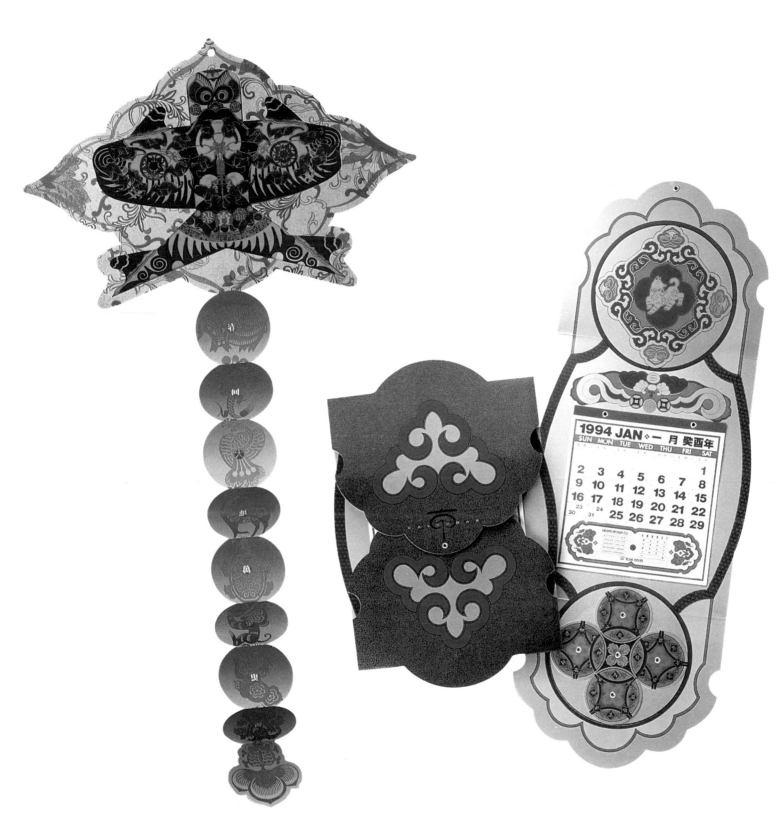

△
Design Firm **Grand Design Company**
Art Director **Grand So**
Designers **Grand So, Raymond Au, Rex Lee, Candy Chan**
Illustrators **Grand So, Rex Lee**
Client **Grand Design Company**
Purpose or Occasion **Chinese New Year Card '95**
Paper/Printing **Fancy paper/Offset, die-cut**

The 1995 Chinese New-Year Card was a kite representing the wish that the prosperity of the business would parallel the kite's upward rise.

△
Design Firm **Grand Design Company**
Art Director **Grand So**
Designers **Grand So, Raymond Au, Candy Chan**
Illustrator **Grand So**
Client **Grand Design Company**
Purpose or Occasion **1994 Grand Design Calendar**
Paper/Printing **Offset, Die-cut**
Number of Colors **Hot Golden Stamping**

The concept, derived from a Chinese luck symbol "yue yee", wishes everyone good luck and a smooth and prosperous 1994.

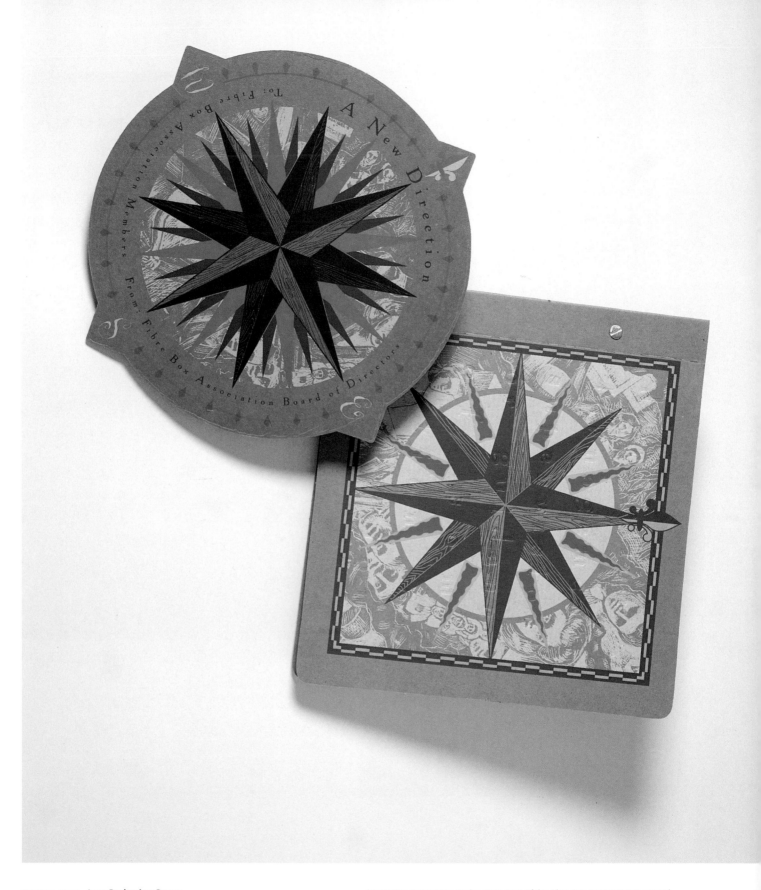

Design Firm **Love Packaging Group**
Art Director **Tracy Holdeman**
Designer/Illustrator **Chris West**
Client **Fibre Box Association**
Purpose or Occasion **FBA Annual Meeting**
Paper/Printing **Corrugated/Graphic Products (silk-screen printing)**
Number of Colors **Four**

Increasing awareness and participation of the Fibre Box Association's annual meeting was the main focus of this pair of business-to-business teaser/mailer and program pieces. The compass graphics and type were all produced with Macromedia FreeHand with the custom scratchboard illustrations scanned in Adobe Photoshop. Both the compass teaser and the program were silk-screened and spot varnished. The corrugated program cover has a special blind debossed typographic treatment. Program cover, liner sheets, and pages were all hand assembled with aluminum screw posts.

Design Firm **Standard Deluxe, Inc.**
Art Director **Scott Peek**
Designers **Scott Peek, Chad Gray**
Client **Rotary Club of Loachapoka**
Purpose or Occasion **20th Anniversary keepsake**
Paper/Printing **Postcard/Hand silk-screened**
Number of Colors **Two front, one back**

"Syrup Soppin" Day in Loachapoka, Alabama is an annual event where crafts are displayed, syrup is made the old-fashioned way, bluegrass music is played, and there is plenty of barbecue and socializing. The image on the promotional cards was also used for T-shirts. The designers hand silk-screened these cards to give them a homey feel.

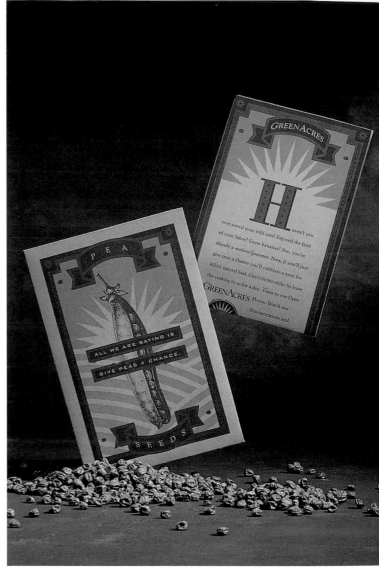

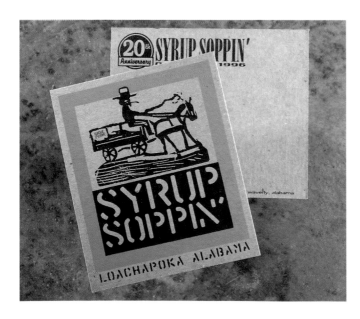

Design Firm **Greteman Group**
All Design **Sonia Greteman, James Strange**
Client **Green Acres**
Purpose or Occasion **Direct mail**
Paper/Printing **Manila paper/Offset**
Number of Colors **Two**

This direct-mail piece announces the grand opening and offers a 25% discount on particular items. All art was created in Macromedia FreeHand, and actual peas were included with the card and coupon. Manila paper and a manila envelope were used in printing.

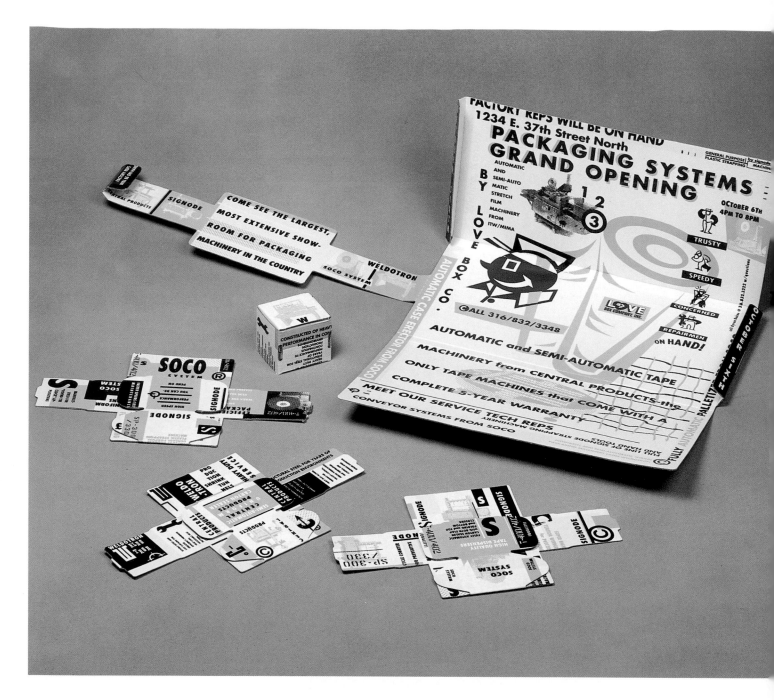

Design Firm **Love Packaging Group**
All Design **Brian Miller**
Client **Love Packaging Group**
Purpose or Occasion **Grand opening invitation**
Paper/Printing **Corrugated/Rand Graphic Products, screen printing**
Number of Colors **Three**

The invitation was manufactured out of corrugated board. The curiosity-reminder pieces inside are four small desktop boxes that each feature a different company with machinery represented at Love Packaging Systems. Photos of machinery at the facility were turned to halftones with a huge dot-screen pattern to allow for screen printing that resembles flexographic Brown-Box printing. Macromedia FreeHand was used for layout and Adobe Photoshop for converting/experimenting with the photo halftones. The flaps of the overpack are perforated, allowing the inside to convert into a poster.

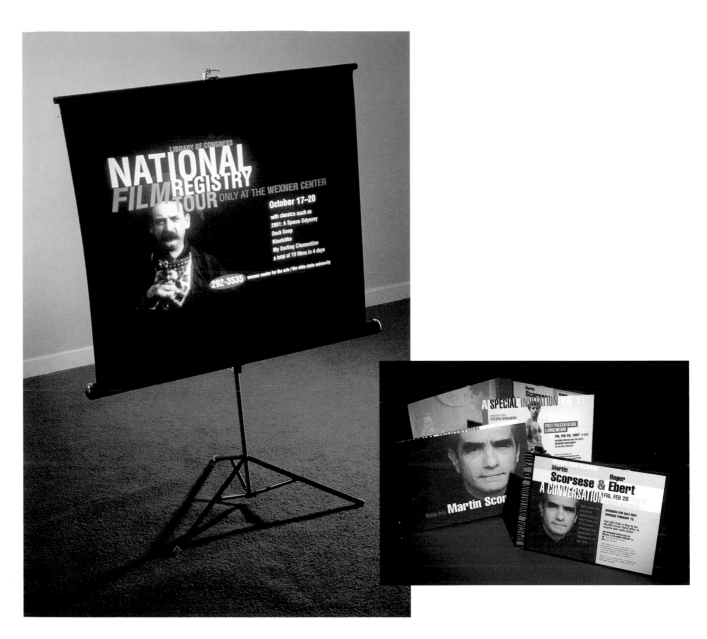

Δ
Design Firm **Wexner Center Design Department**
Designer **Terry Alan Rohrbach**
Client **Wexner Center for the Arts**
Purpose or Occasion **Promote special event**

To market the National Film Registry Tour to its target niche on a large scale, this slide was shown before feature films at area theaters. The design supported other promotional items being distributed throughout the community, creating a unified branded campaign. Adobe Photoshop and Macromedia FreeHand were used to produce the slide.

Δ
Design Firm **Wexner Center Design Department**
Designer **M. Christopher Jones**
Client **Wexner Center for the Arts**
Purpose or Occasion **Invitation to special event**
Paper/Printing **Warren Lustro Dull 100 lb. text**
Number of Colors **Four spot colors**

The objective of this piece was to notify and inform members of a special series of events surrounding the presentation of the 1996 Wexner prize to Martin Scorsese. Emphasis was placed on creating a lively and dynamic piece that reflected the strength and integrity of this well-respected film maker. Adobe Photoshop and QuarkXPress were used to create the piece.

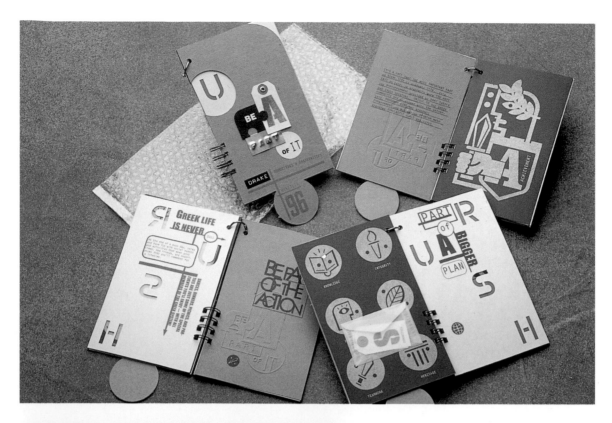

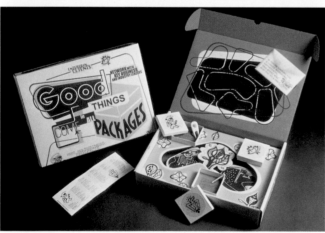

Δ
Design Firm **Sayles Graphic Design**
Art Director **John Sayles**
Designers **John Sayles, Jennifer Elliott**
Illustrator **John Sayles**
Client **Drake University**
Purpose or Occasion **Recruitment brochure**
Paper/Printing **Curtis Retreeve Eggplant, Seamist, Cinnabark, chipboard, manila tag/Offset, Action Print; screen-print, Image Maker; thermography, Parrot Printing**
Number of Colors **Three**

Using the theme "Be A Part of It," the brochure's double-ply chipboard cover is die-cut in the shape of a puzzle piece. Affixed to the chipboard are imprinted "parts"—hammered aluminum, label stock, and manila tags—each bearing a word of the brochure's title. Inside the brochure, a variety of printing and finishing techniques are used for graphics and copy, including thermography, embossing, die-cutting, and offset printing. Hand-applied glassine envelopes contain additional information. The brochure is bound with wire-O binding and an aluminum ring.

Δ
Design Firm **Sayles Graphic Design**
All Design **John Sayles**
Client **Iowa Open**
Purpose or Occasion **Golf-tournament sponsor invitation**
Paper/Printing **Hopper Hots, corrogated board/Offset, Screen-print, Image Maker**
Number of Colors **Four**

Sayles Graphic Design has created a unique direct mailing targeting prospective sponsors of the 1995 Iowa Open golf tournament. Local business leaders received a large corrugated box printed with bold graphics proclaiming the benefits of sponsoring the Iowa Open. Inside is a shadowbox scene cut from corrugated showing a golfer on a green. Small boxes labeled with the name of each sponsor package—Championship, Eagle, and Birdie—contain a printed list of benefits and a small gift: a tee, a divot tool, and a ball marker. "These boxes were sent to business leaders—people who generally have secretaries who screen their mail. This mailing looks like a gift, so it is more likely to get into the decision-maker's hands and be read," Sayles says.

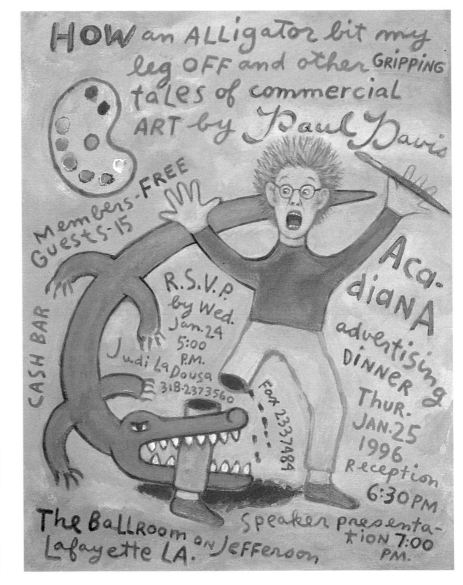

Are my parents up to the challenge?

Strong willed, very needy, adorable SWF. Loves cuddling, stuffed animals, breast milk, new clothes and attention. Favorite sports include cradle rocking, chair swinging, nude swimming (refuse to wear bra). Into minimalist abstract art and music (favorite song:"Wah wah wah"). Chronic drinker. Non-Smkr. Things my mom and dad must have: Patience, unconditional love, a sense of humor and ability to function with minimal sleep. I promise a LTR of undying love and joy. Photo enclosed. #060496

Δ
Design Firm **Lima Design**
Art Directors/Designers **L. McKenna, M. Kiene**
Client **Northeastern University**
Purpose or Occasion **Campaign dinner**
Paper/Printing **Shawmut Printing**
Number of Colors **Two**

The style of the invitation plays off of the lively logo NU uses for their Centennial Campaign. Special consideration was given to the presentation of this limited budget piece to make the most of the two colors and provide a rich looking piece for the client.

Δ
Design Firm **Paul Davis Studio**
Designer/Illustrator **Paul Davis**
Client **Acadiana Advertising Federation**
Purpose or Occasion **Dinner**
Number of Colors **Four**

This invitation is for a presentation and lecture given by the artist Paul Davis to an advertising-club dinner. The painting is acrylic on paper.

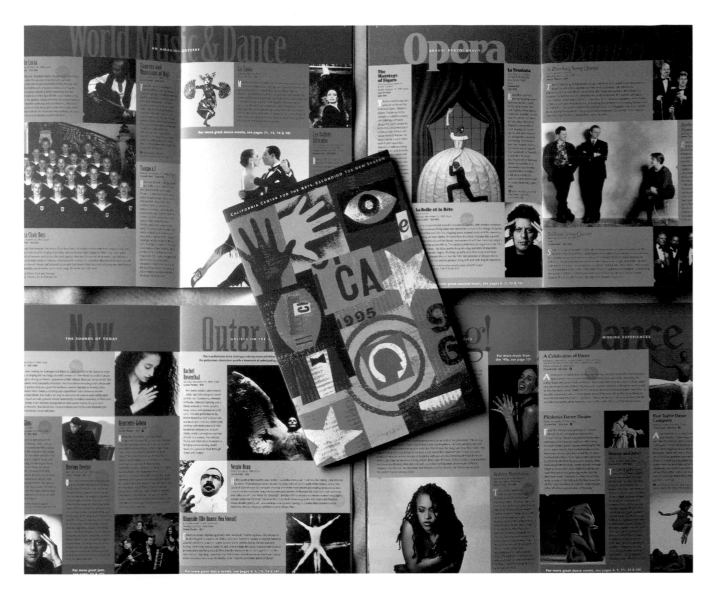

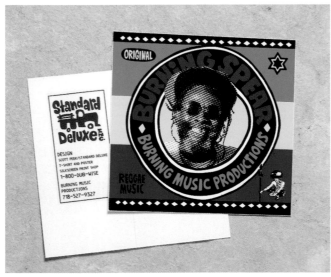

△
Design Firm **Mires Design**
Art Director **John Ball**
Designers **Kathy Carpentier-Moore, John Ball**
Illustrator **Gerald Bustamante**
Client **California Center for the Arts**
Paper/Printing **Nehoosa/Offset, Bordeaux Printers**
Number of Colors **Five**

This direct-mail brochure sells performing-arts season subscriptions.

◁
Design Firm **Standard Deluxe, Inc.**
Art Director/Designer **Scott Peek**
Client **Burning Music Productions**
Purpose or Occasion **Promotional decal to sell on tour and in a retail merchandise catalog**
Number of Colors **Four plus clear coat**

The artwork was originally created for and screen-printed on T-shirts; all the type and separations were done by hand (mostly with amberlith film and an X-Acto knife). The designer wanted to create a "rootsy" feel to fit with the music.

∇

Design Firm **Paul Davis Studio**
Designer/Illustrator **Paul Davis**
Client **AIGA**
Purpose or Occasion **Call for entries—50 Books, 50 Covers**
Number of Colors **Four**

This call for entries was for a book and cover show. It is a collage of mixed media on watercolor board.

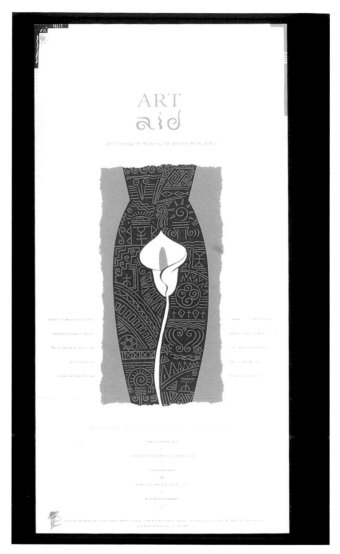

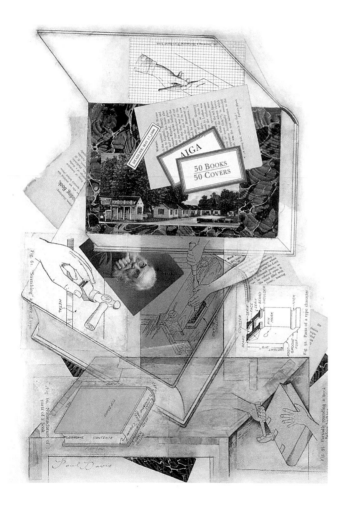

△

Design Firm **Greteman Group**
Art Director **Sonia Greteman**
Designers **James Strange, Sonia Greteman**
Illustrator **Sonia Greteman**
Client **Art Aid Fashion Show**
Purpose or Occasion **Art contest**
Paper/Printing **Confetti/Offset**
Number of Colors **Two**

This mailer acted as an announcement and poster. The event is to benefit Connet Care, a local program for those affected with AIDS. The benefit is a fashion show of wild proportions—thus the theme. All the art was created using Macromedia FreeHand. Metallic ink was used to overprint the black figure creating a layered effect.

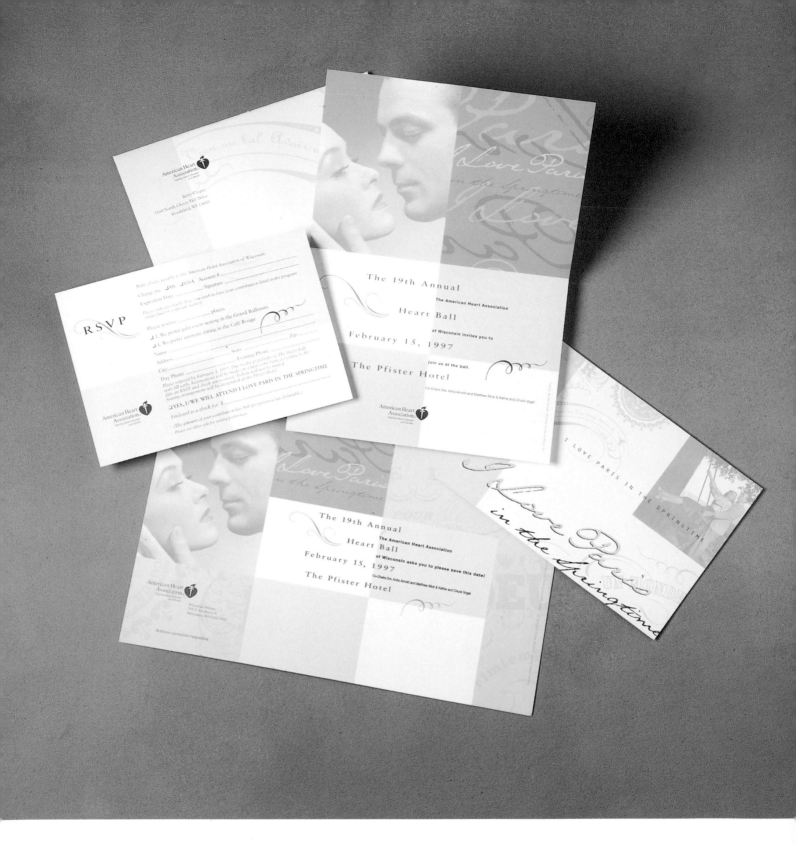

Design Firm **Becker Design**
All Design **Neil Becker**
Client **American Heart Association**
Paper/Printing **Burton & Mayer, Inc.**
Number of Colors **Two**

This series of pieces was designed to promote the American Heart Association's annual Heart Ball. The theme this year was, "I Love Paris in the Springtime." The theme was illustrated through the use of romantic imagery and typography.

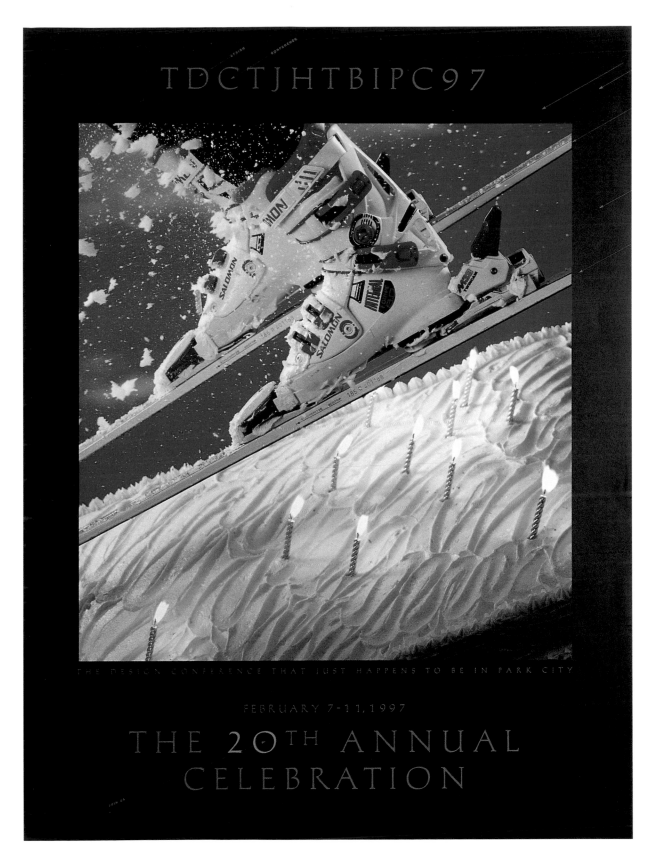

TDCTJHTBIPC97

THE DESIGN CONFERENCE THAT JUST HAPPENS TO BE IN PARK CITY

FEBRUARY 7-11, 1997

THE 20TH ANNUAL
CELEBRATION

Design Firm **The Weller Institute**
All Design **Don Weller**
Client **The Design Conference**
Purpose or Occasion **Promote design conference at resort**
Paper/Printing **Zellerback/Imperial**
Number of Colors **Five**

The image was planned to suggest the twentieth anniversary of a conference at a ski resort. The photo was slightly retouched using Adobe Photoshop, and the design was created in QuarkXPress. It was printed using dryography.

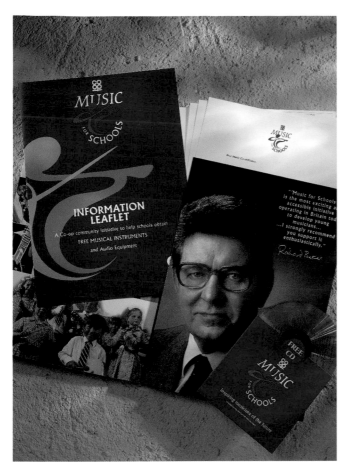

◁

Design Firm **999 Design Group**
Art Director **Sheena McMurtrie**
Designer/Illustrator **John McDonald**
Client **CWS Retail Ltd.**
Purpose or Occasion **Music for Schools initiative**
Paper/Printing **Offset Litho**
Number of Colors **Four plus special blue**

This piece of literature was aimed at principals and music teachers in every school and university in the CWS catchment areas. Its aim was to introduce the benefits of the Music for Schools initiative and encourage schools to register and collect vouchers for free musical instruments. The pack consisted of a six-page folder with introductory letters, entry forms, information literature, and a free compact disc. This was mailed to over fifteen-thousand educational establishments throughout the United Kingdom. 999 Design conceived and executed all aspects of the literature production from logo design and copywriting to digital artwork.

▽

Design Firm **Toni Schowalter Design**
Art Director/Designer **Toni Schowalter**
Client **Radio Advertising Bureau**
Purpose or Occasion **Announce upcoming competition**
Paper/Printing **Coated 80 lb. text**
Number of Colors **Four**

To generate excitement about the upcoming Mercury Awards, a basketball theme was used to provide a visual parallel to the theme: "Grab your share." Costs were kept down by using stock photography from a Photodisc. Bright colors and contemporary typography create a sense of excitement. The expanded postcard/mailer approach allowed for more display space and generated immediate attention.

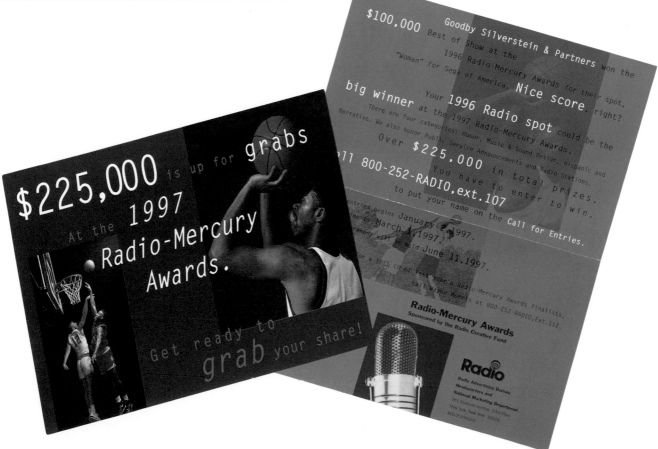

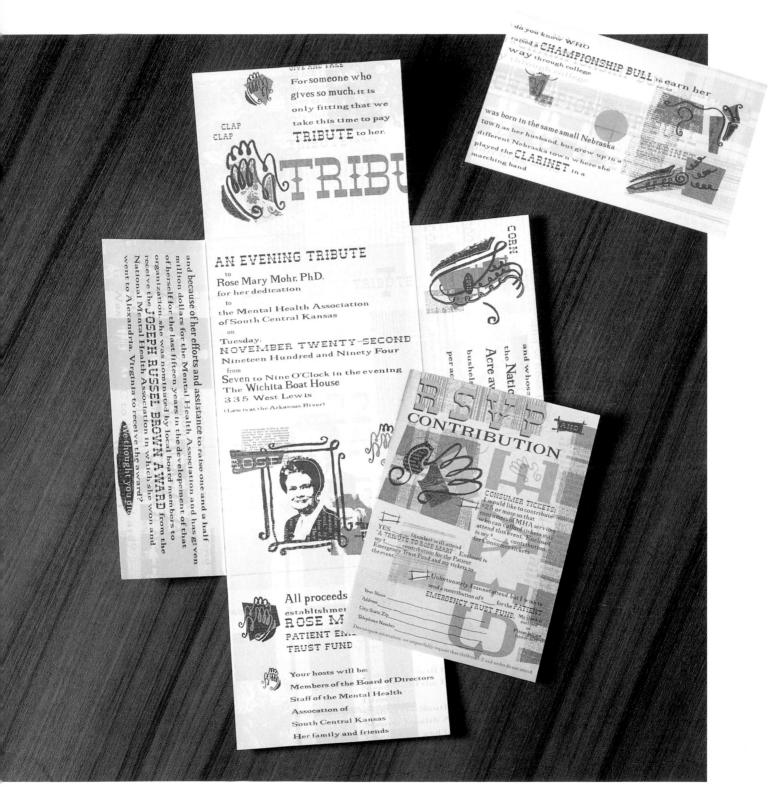

Firm **Love Packaging Group**
All Design **Tracy Holdeman, Brian Miller**
Client **Mental Health Association of South-Central Kansas**
Purpose or Occasion **Honorary banquet/fundraiser**
Paper/Printing **Scraps from paper vender Printmaster, Inc.**
Number of Colors **Two**

The Rosemary Mohr-MHA direct-mail piece was a fund raiser honoring an outstanding mental-health advocate. It provided a personal link through interesting anecdotes and related illustrations. Patterns from the designers' shirts were scanned as background elements while spot illustrations were created with colored pencils on tracing paper, which were then scanned and dropped into the layout in Macromedia FreeHand. The illustrations and type were done in a retro-style to reflect the era when Rosemary Mohr's work with the MHA began.

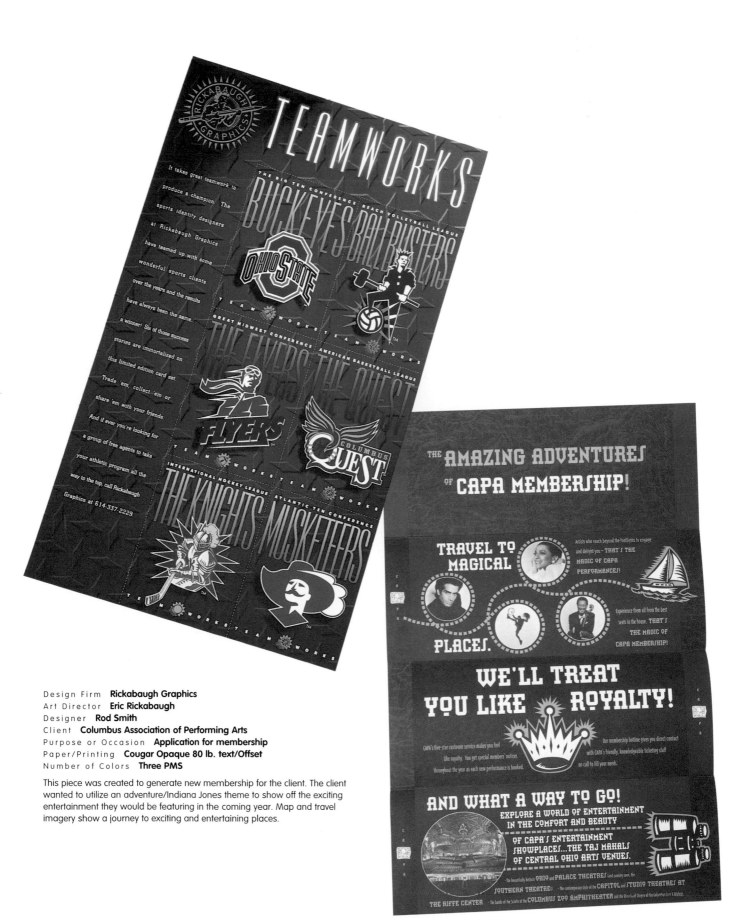

Design Firm **Rickabaugh Graphics**
Art Director **Eric Rickabaugh**
Designer **Rod Smith**
Client **Columbus Association of Performing Arts**
Purpose or Occasion **Application for membership**
Paper/Printing **Cougar Opaque 80 lb. text/Offset**
Number of Colors **Three PMS**

This piece was created to generate new membership for the client. The client wanted to utilize an adventure/Indiana Jones theme to show off the exciting entertainment they would be featuring in the coming year. Map and travel imagery show a journey to exciting and entertaining places.

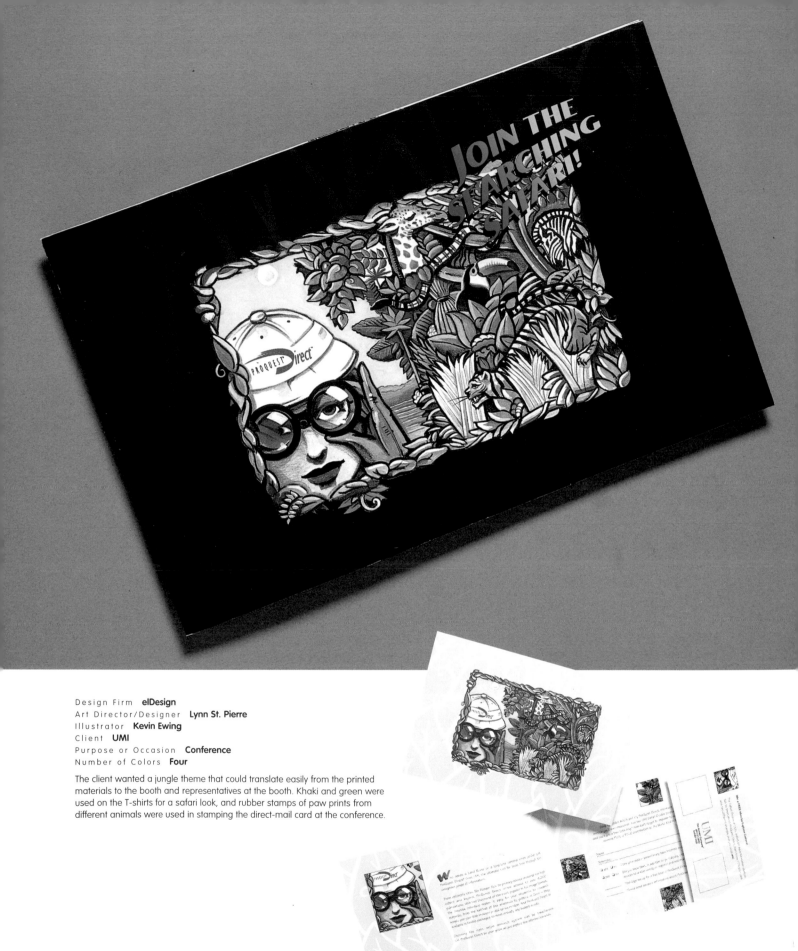

Design Firm **elDesign**
Art Director/Designer **Lynn St. Pierre**
Illustrator **Kevin Ewing**
Client **UMI**
Purpose or Occasion **Conference**
Number of Colors **Four**

The client wanted a jungle theme that could translate easily from the printed
materials to the booth and representatives at the booth. Khaki and green were
used on the T-shirts for a safari look, and rubber stamps of paw prints from
different animals were used in stamping the direct-mail card at the conference.

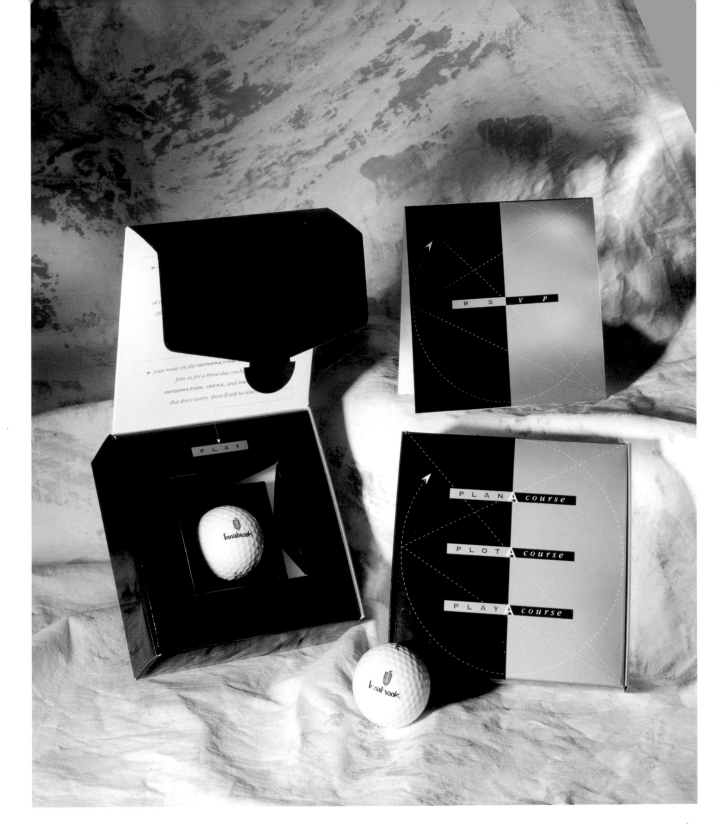

Design Firm **Webster Design Associates Inc.**
Art Director **Dave Webster**
Designers **Todd Eby, Dave Webster**
Illustrator **Todd Eby**
Client **Cable Services Group**
Purpose or Occasion **Invitation to a conference**
Number of Colors **Three plus gold**

This invitation to an executive client conference at a golf resort was designed to arouse interest even before reading the details. The phrase "Plan a course, plot a course, play a course," on the box front was a reference to the resort as well as the conference. The presentation of the golf ball inside the box reinforced the message.

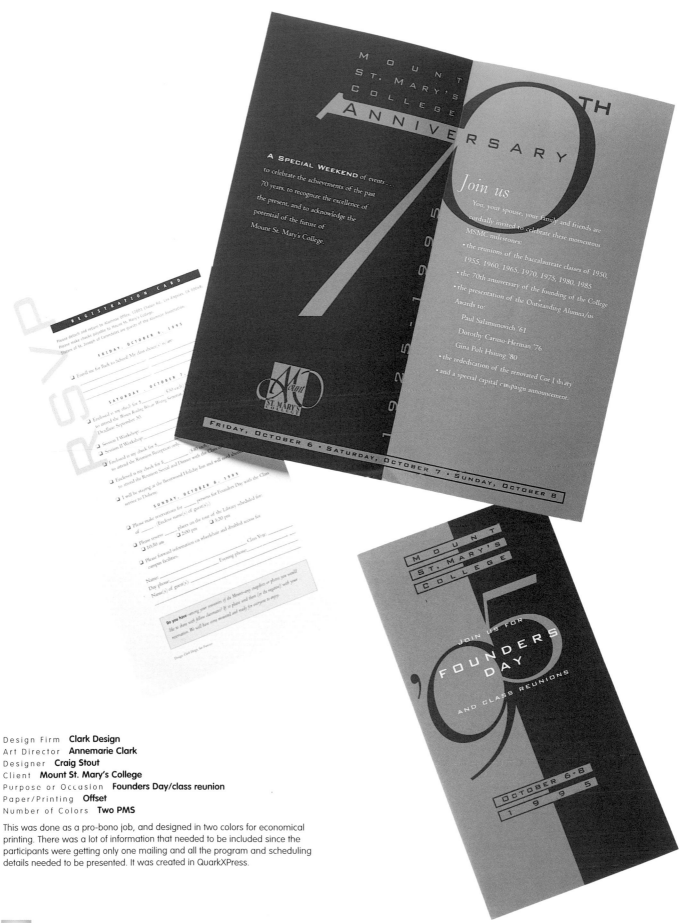

Design Firm **Clark Design**
Art Director **Annemarie Clark**
Designer **Craig Stout**
Client **Mount St. Mary's College**
Purpose or Occasion **Founders Day/class reunion**
Paper/Printing **Offset**
Number of Colors **Two PMS**

This was done as a pro-bono job, and designed in two colors for economical printing. There was a lot of information that needed to be included since the participants were getting only one mailing and all the program and scheduling details needed to be presented. It was created in QuarkXPress.

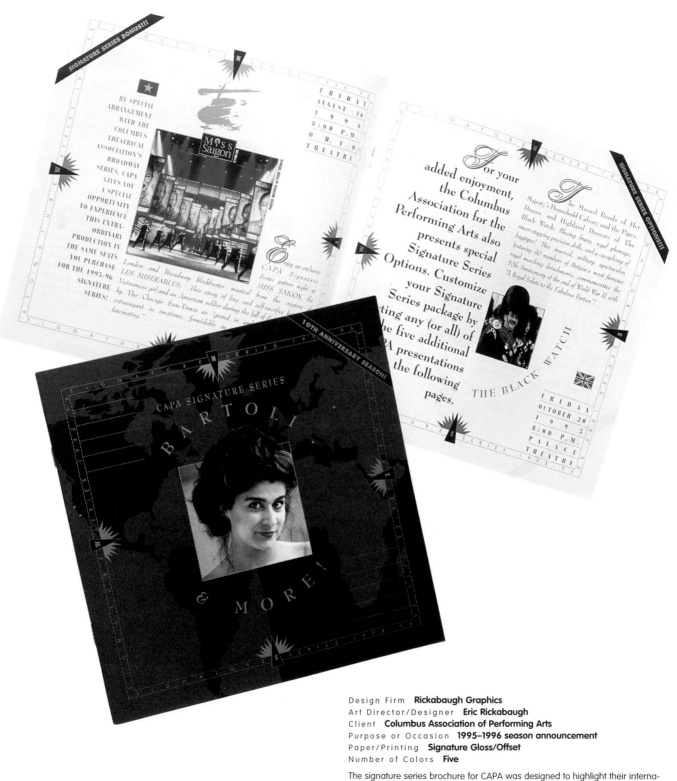

Design Firm **Rickabaugh Graphics**
Art Director/Designer **Eric Rickabaugh**
Client **Columbus Association of Performing Arts**
Purpose or Occasion **1995–1996 season announcement**
Paper/Printing **Signature Gloss/Offset**
Number of Colors **Five**

The signature series brochure for CAPA was designed to highlight their international programming. Each artist received a page that had a background of a globe, a small flag of their company, and a map locating their city of origin. The piece was crated in Adobe PageMaker and FreeHand on a Power Macintosh. The fifth color was a bronze metallic ink.

In the Public Interest

Reshaping the Business of Behavioral Health

March 31- April 2, 1996
Atlanta, Georgia

Design Firm **HC Design**
Art Director **Chuck Sundin**
Designer/Illustrator **Steve Trapero**
Client **National Community Mental Healthcare Council**
Purpose or Occasion **Promotional brochure, save-the-date postcard**
Paper/Printing **Simpson Quest Beige**
Number of Colors **Two PMS**

NCMHC holds an annual training conference for mental-health professionals. Keeping with the conference's serious tone a logo based on a unisex "Thinker" was created using subtle colors. The brochure was designed to stand out from other mail through the the use of unusual colors, a tactile paper, and an unusual format. Adobe Illustrator and QuarkXPress were used.

You Are Invited

to attend the 1996 Annual Training Conference

Early Registration Rates

National Council Members: $350

Nonmembers: $450

Special rates at the

Atlanta Marriott Marquis

Single: $129

In the Public Interest

Reshaping the Business of Behavioral Health

Register Before December 31 and save $50!

Training senior management and

leadership in the operational

components of providing high quality

behavioral healthcare services, across

traditional boundaries, and with new

and varied partners.

1996 Annual
Training Conference

March 31- April 2, 1996

Atlanta Marriott Marquis
Atlanta, Georgia

National Community Mental Healthcare Council • 1996 Training Conference

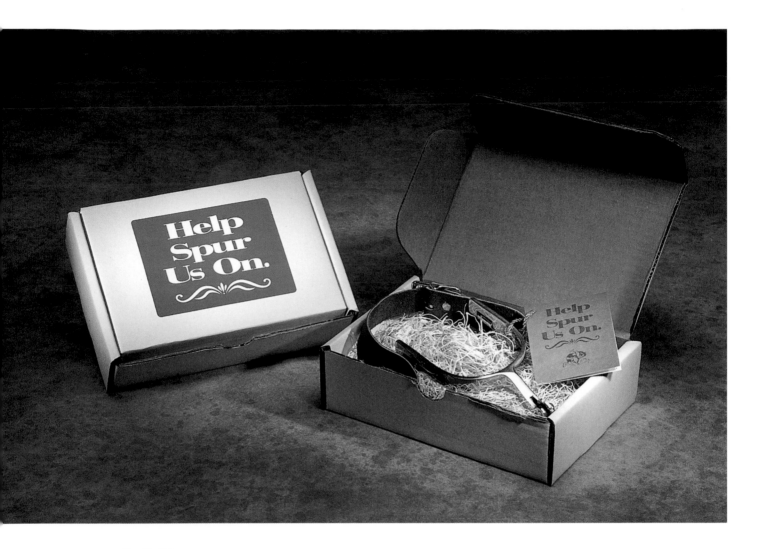

Design Firm **The Wyatt Group**
Art Director **James Ward**
Copywriter **Mike Maccioli**
Creative Directors **Mark Wyatt, Mike Maccioli**
Client **Homeless Outreach Medical Services (HOMES)**
Purpose or Occasion **Fund raiser**
Number of Colors **Two**

HOMES is a non-profit program of Parkland Health & Hospital Systems that provides medical care to thousands of homeless women and children in Dallas. To help kick off this year's fund-raising efforts, a party was held at a Dallas country-and-western nightclub. In keeping with the western motif, spurs were sent to the guest list encouraging the recipients to "Help Spur Us On." The event was a rousing success.

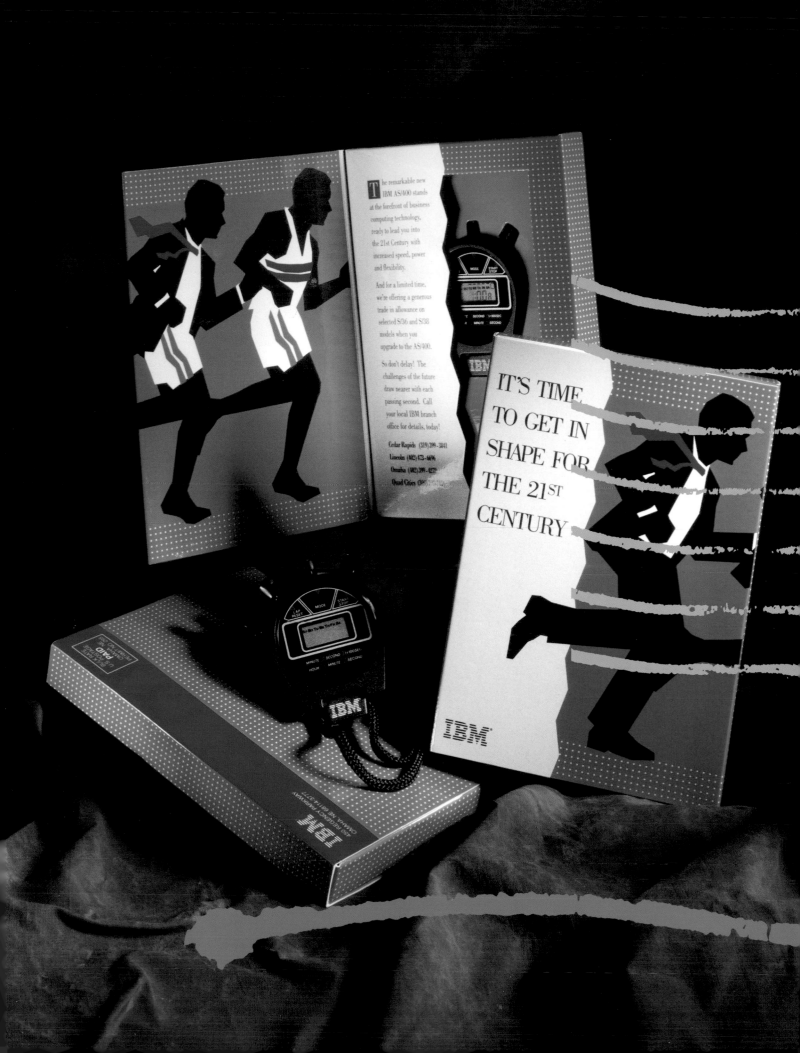

The remarkable new IBM AS/400 stands at the forefront of business computing technology, ready to lead you into the 21st Century with increased speed, power and flexibility.

And for a limited time, we're offering a generous trade in allowance on selected S/36 and S/38 models when you upgrade to the AS/400.

So don't delay! The challenges of the future draw nearer with each passing second. Call your local IBM branch office for details, today!

Cedar Rapids (319) 399 - 3841
Lincoln (402) 473 - 6696
Omaha (402) 399 - 4277
Quad Cities (309) 779 - 7124

IT'S TIME TO GET IN SHAPE FOR THE 21ST CENTURY

IBM

PRODUCT
DESIGN
PROMOTION

A COLLECTION OF INSPIRING MARKETING PIECES TO PROMOTE THE BEST NEW PRODUCTS

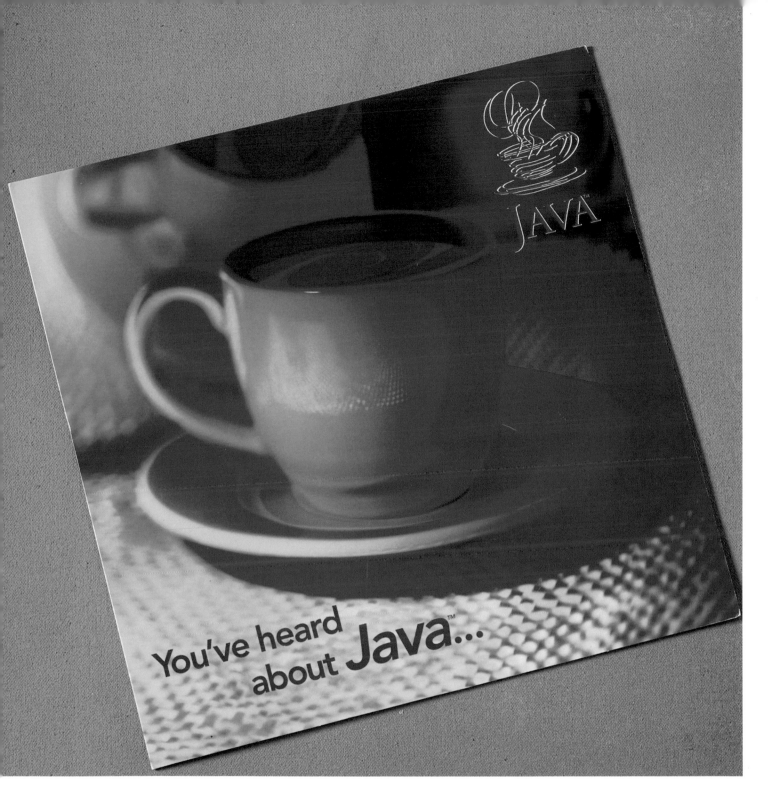

Design Firm **Directech, Inc.**
Art Director **Christine Rosecrans**
Designer **Lynne Miller**
Photographer **Greg Klim**
Photo Retoucher **Dave Kaupp**
Client **Sun Microsystems, Inc.**
Purpose or Occasion **Product promotion—Java Workshop**
Paper/Printing **Centura gloss white 100 lb. cover/W. E. Andrews**
Number of Colors **Eight**

To introduce Sun's new Java workshop and create product excitement, this self-mailer uses an unusual breakthrough format, special-effects photography, and exciting graphics.

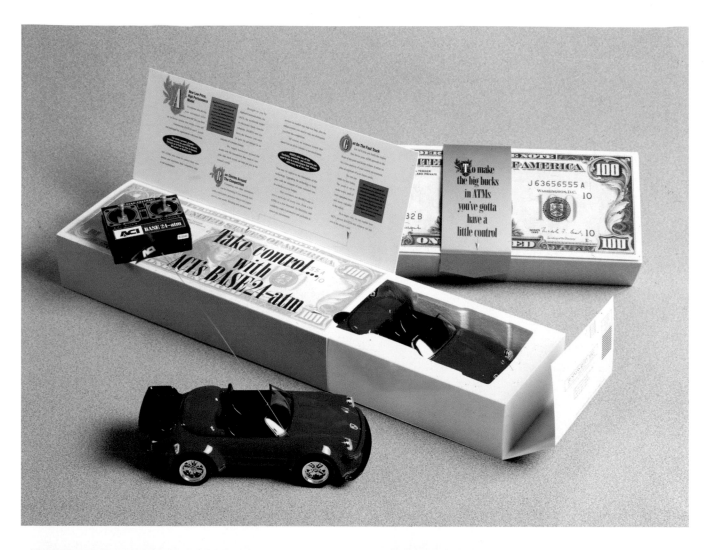

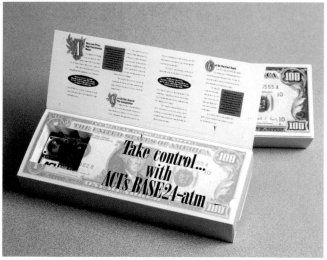

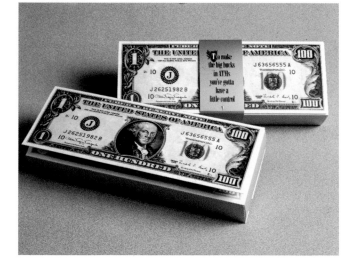

Design Firm **Webster Design Associates Inc.**
Art Director **Dave Webster**
Designers **Dave Webster, Todd Eby**
Illustrator **Todd Eby**
Client **ACI**
Purpose or Occasion **Introduce ACI ATM network**
Paper or Printing **Corporate Image**
Number of Colors **Two**

This promotion was devised to introduce ACI's new ATM network-processing program: Base 24-ATM. The target audience, 40- to 55-year-old male executives, was invited to "take control with Base-24," using the analogy of driving a car. The specialty item offered to reinforce the theme was a toy remote-control Porsche. The piece is displayed in a box designed to look like a stack of bills, an additional attraction for the banking clients.

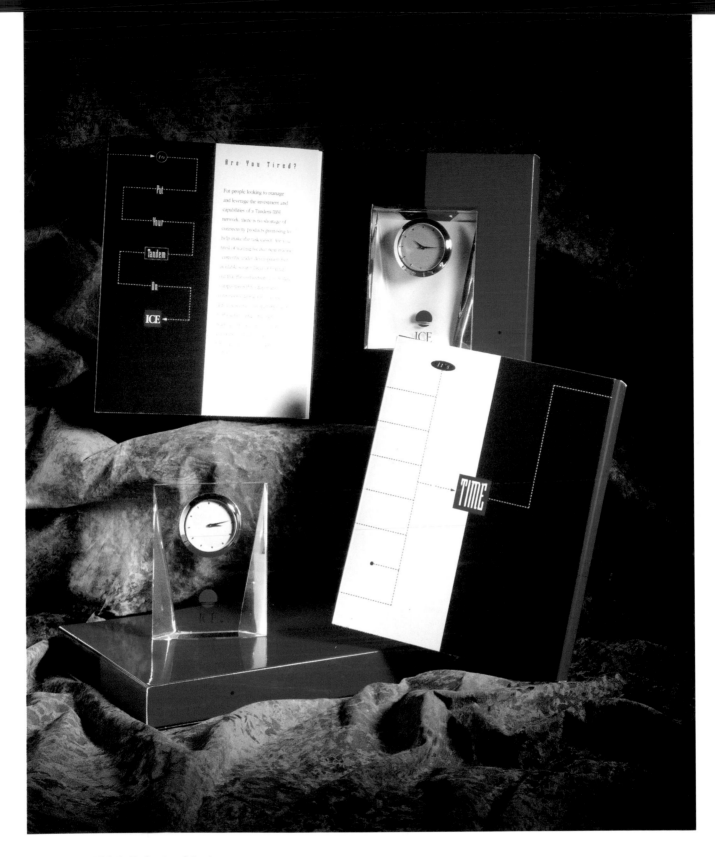

Design Firm **Webster Design Associates, Inc.**
Art Director/Designer **Dave Webster**
Client **ACI**
Purpose or Occasion **Promote ICE software**
Paper or Printing **Corporate Image**
Number of Colors **Two**

To create awareness of a new connectivity software program, a crystal clock was
used to refer to its name—ICE. The clock was an attention-getting device that,
unlike the standard promotional giveaway, established a direct graphic tie to the
product itself.

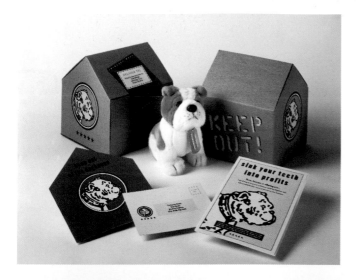

Design Firm **Webster Design Associates, Inc.**
Art Director **Dave Webster**
Designers **Julie Findley, Dave Webster**
Illustrator **Julie Findley**
Client **Inacom**
Purpose or Occasion **Promote Network General Sniffer**
Paper or Printing **Richardson Printing**
Number of Colors **Two**

Network General Sniffer is a network protocol analyzer that is able to detect network problems and allow technicians to make repairs and keep a system running at peak efficiency. The goal of direct mail promotion was to develop product awareness and persuade computer dealers to participate in a company-sponsored rental plan.

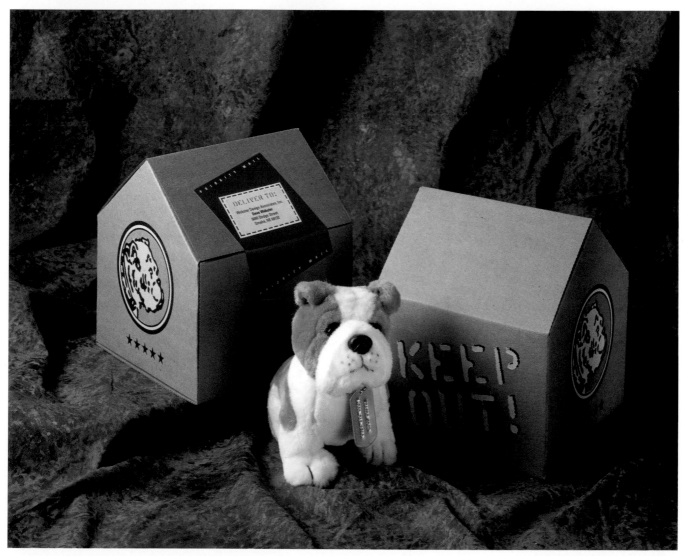

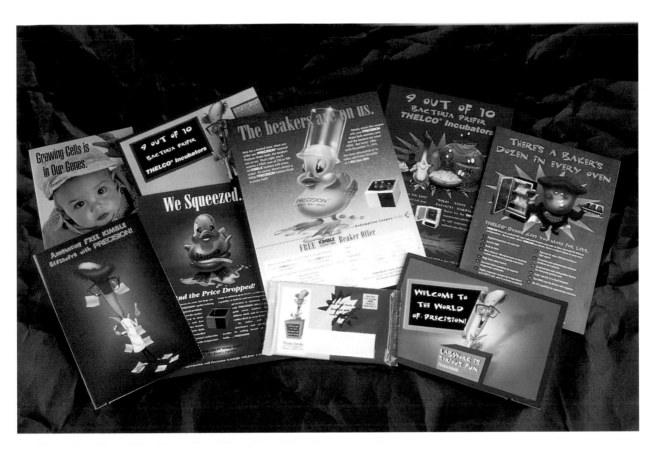

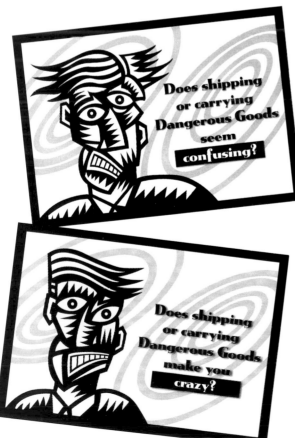

Design Firm **Zgraphics, Ltd.**
Art Director **Joe Zeller**
Designer **Gregg Rojewski**
Client **Precision Scientific**
Purpose or Occasion **Increase product sales**
Paper/Printing **Centura/Lithography**
Number of Colors **Four**

This assortment of direct-marketing pieces was designed for Precision Scientific, a manufacturer of biomedical laboratory equipment. Cartoon characters and the theme "Labwork is Serious Fun!" were used to help the company stand out from its competition.

◁

Design Firm **X Design Company**
All Design **Alex Valderrama**
Client **IHS Transport Data Solutions**
Purpose or Occasion **Direct response campaign**
Paper/Printing **Richtman's Printing**
Number of Colors **One**

This product promotion was directed at potential clients. A series of two postcards were mailed and followed by phone calls from IHS. The illustrations were boldly designed to stand out in the mail. A positive phone response reinforced the effectiveness of these postcards.

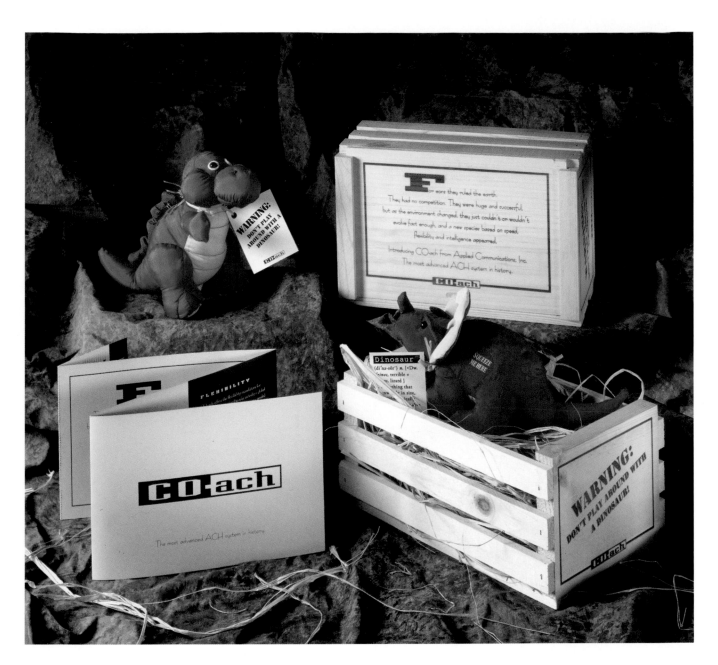

Design Firm **Webster Design Associates, Inc.**
Art Director **Dave Webster**
Designers **Dave Webster, Todd Eby**
Illustrator **Ryle Smith**
Client **ACI**
Purpose or Occasion **Introduce new product**
Paper or Printing **Nappa Wooden Box Company**
Number of Colors **One**

The slogan "Don't play around with a dinosaur" was an ideal way of saying that ACI's technology is faster and more efficient than their competitor's product. At the same time, the use of a squeaking toy dinosaur softens the hard edge of the message, making the point more palatable than a hard, straight sell.

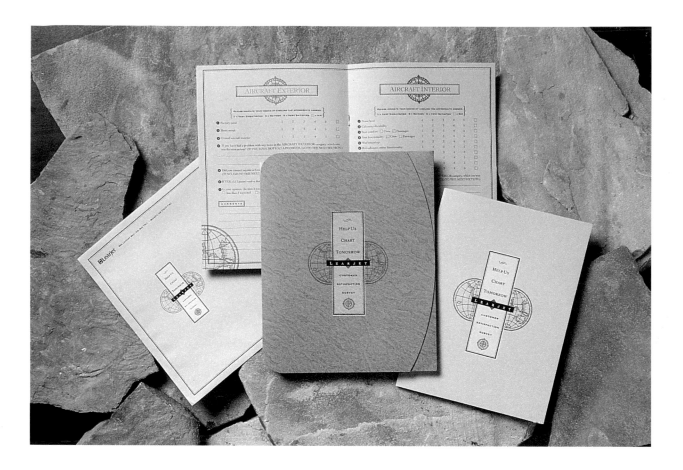

Δ

Design Firm **Allan Burrows Limited**
Art Director/Designer **Roydon Hearne**
Client **Ford Motor Company Limited**
Purpose or Occasion **Maverick Direct Marketing**
Paper/Printing **McNaughtons Speckletone**
Number of Colors **Four**

Created to generate sales of the Ford Maverick 4 x 4, this mail piece features the notion "Leave an impression wherever you go." The designer commissioned a model maker to produce six different terrains with tire-tracks across each to suggest Maverick's off-road capabilities. The designers created the piece using Adobe Photoshop, Adobe Illustrator, and QuarkXPress.

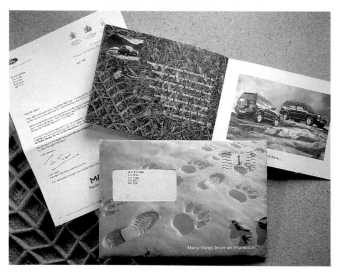

Δ

Design Firm **Greteman Group**
Art Directors/Designers **Sonia Greteman, James Strange**
Illustrator **James Strange**
Client **Learjet**
Purpose or Occasion **Customer response form**
Paper/Printing **Passport/Offset**
Number of Colors **Three**

This piece was sent to Learjet owners to get responses on the quality and performance of their Learjets. The piece needed to give the feeling of a worldly, rich feel. A bit of white enhanced the subtle quality of the paper and graphics. All art was created in Macromedia FreeHand.

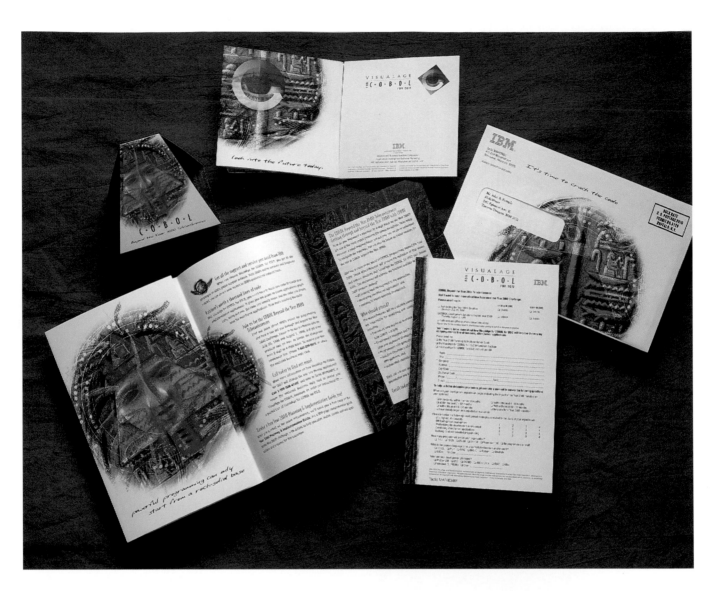

Design Firm **The Riordon Design Group, Inc.**
Art Director **Claude Dumoulin (FCB Toronto)**
Designer/Illustrator **Dan Wheaton**
Client **IBM (Cobol—Visual Age)**
Purpose or Occasion **Product launch for year 2000**
Paper/Printing **Potlach**
Number of Colors **Four**

These pieces, created digitally in Adobe Photoshop, Adobe Illustrator, and QuarkXPress, were designed to promote IBM's cobol product for Visual Age. The tag line was "Crack of Code" referring to the change for all computers at the turn of the century. Egyptian hieroglyph symbols were used as a visual metaphor. The success of this campaign was exceptional, both in response and awards.

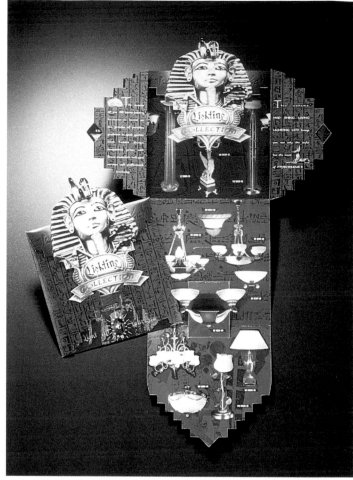

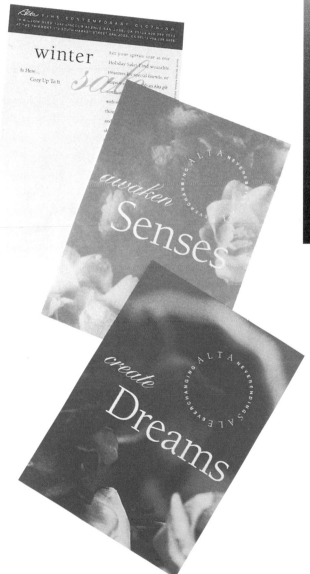

△
Design Firm **Grand Design Company**
Art Director **Grand So**
Designers **Grand So, Rex Lee, Ringo Lam, Raymond Au, Mimi Lee**
Client **Hop Shing Loong Lighting Ltd.**
Purpose or Occasion **Hop Shing Loong autumn/winter direct mail**
Number of Colors **Four**
Paper/Printing **Die-cut, offset**

A beautiful and outstanding image was chosen as the primary image in the catalog. The color separation and printing played a major role in the beauty of the final piece.

◁
Design Firm **Melissa Passehl Design**
Art Director **Melissa Passehl**
Designers **Melissa Passehl, Charlotte Lambrects, David Stewart**
Writer **Susan Sharpe**
Client **Alta**
Purpose or Occasion **Clothing store sale cards**
Paper/Printing **Teton/Litho**
Number of Colors **Two**

These postcards were designed to advertise the seasonal sales that take place at the store throughout the year. The poetic text combined with the unique colors remind the shopper of the unique shopping experience awaiting them at Alta.

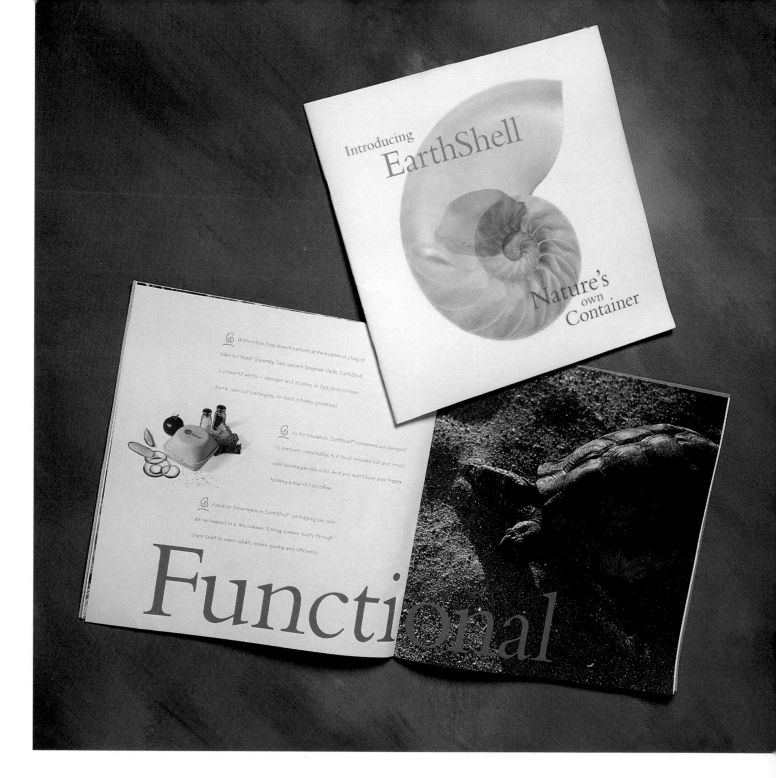

Design Firm **Hornall Anderson Design Works**
Art Director **John Hornall**
Designers **John Hornall, Jana Nishi, Bruce Branson-Meyer**
Illustrator **Julia LaPine**
Client **EarthShell Container Corp.**
Purpose or Occasion **Capabilities brochure**
Paper/Printing **Glama Natural 29 lb. vellum, Mohawk Opaque Brilliant White**

The client wanted a look and feel that connected them and their product with nature. The client creates disposable, fast-food packaging and needed a capabilities brochure that would introduce their product to restaurants. The brochure simplifies technical information for reader-friendly, sales purposes.

P eace I leave
with you.
My peace I
give you.
I do not give
to you as the
world gives.
Do not let
your hearts be
troubled
and do not be
afraid.

J o h n 1 4 : 2 7

C ome to the edge.

No, we will fall.

Come to the edge.

No, we will fall.

They came to the edge.

He pushed them,

a n d t h e y f l e w.

Guillaume Apollinaire

Today, like every
other day,
we wake up empty
and afraid.
Do not go to
your study and
begin reading.
Take down a
musical instrument.
Let the beauty
we love be what
we do. There are
hundreds of ways
to kneel and kiss
the ground.

Rumi

Design Firm **Held Diedrich**
Art Director **Doug Diedrich**
Designer **Megan Snow**
Client **Spring Hollow**
Purpose or Occasion **Direct mail**
Number of Colors **Four**

The direct-mail campaign for Spring Hollow focused on the facility's country setting. These mailers went out to primary referral sources who might point prospects to Spring Hollow. The designer chose a warm color palette to reinforce the peaceful surroundings. The piece was created in Adobe Photoshop and QuarkXPress.

Equifax Check Services
5301 West Idlewild Avenue
TA-06
Tampa, FL 33634

Take a look at the future
of check management.

PathWays™

Is This Simple
ring.

Authorization Risk Management Collections

All it
Takes to

u n l o c k

the Power
of
Equifax

PathWays

More Files,
More Doors,

More
PathWays
to Check Revenue
Than You Ever
Dreamed Possible.

What if
You Could

o p e n

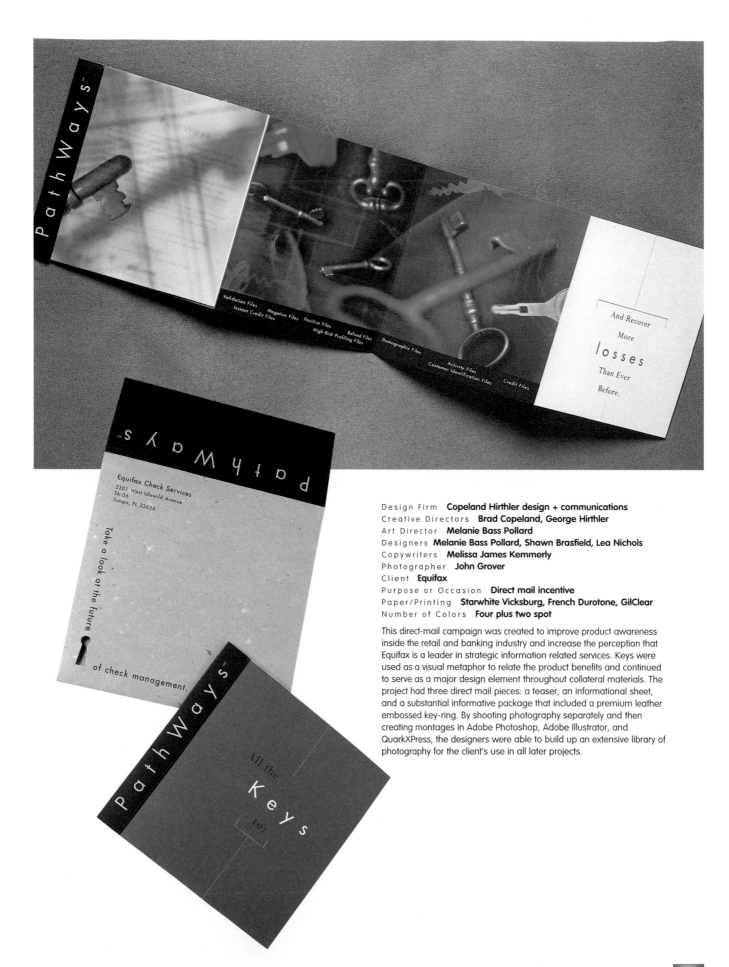

Design Firm **Copeland Hirthler design + communications**
Creative Directors **Brad Copeland, George Hirthler**
Art Director **Melanie Bass Pollard**
Designers **Melanie Bass Pollard, Shawn Brasfield, Lea Nichols**
Copywriters **Melissa James Kemmerly**
Photographer **John Grover**
Client **Equifax**
Purpose or Occasion **Direct mail incentive**
Paper/Printing **Starwhite Vicksburg, French Durotone, GilClear**
Number of Colors **Four plus two spot**

This direct-mail campaign was created to improve product awareness inside the retail and banking industry and increase the perception that Equifax is a leader in strategic information related services. Keys were used as a visual metaphor to relate the product benefits and continued to serve as a major design element throughout collateral materials. The project had three direct mail pieces: a teaser, an informational sheet, and a substantial informative package that included a premium leather embossed key-ring. By shooting photography separately and then creating montages in Adobe Photoshop, Adobe Illustrator, and QuarkXPress, the designers were able to build up an extensive library of photography for the client's use in all later projects.

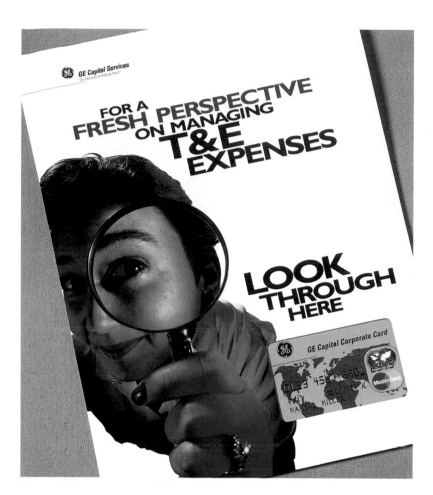

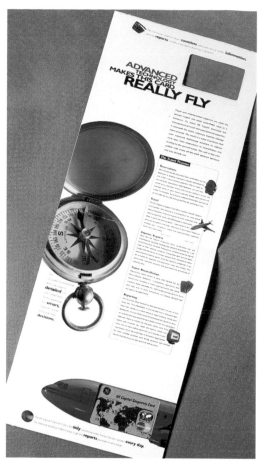

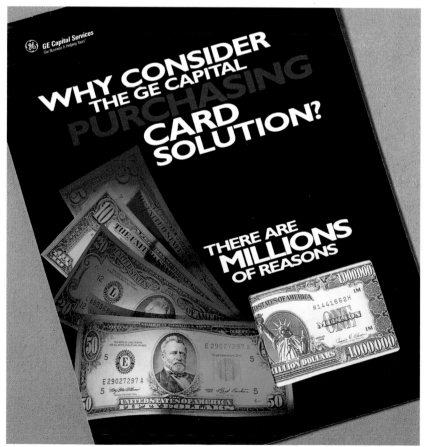

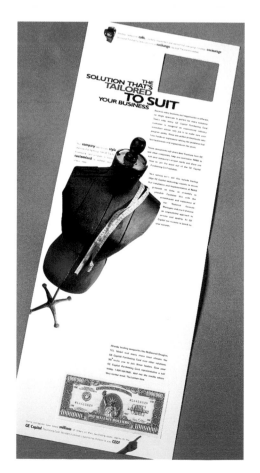

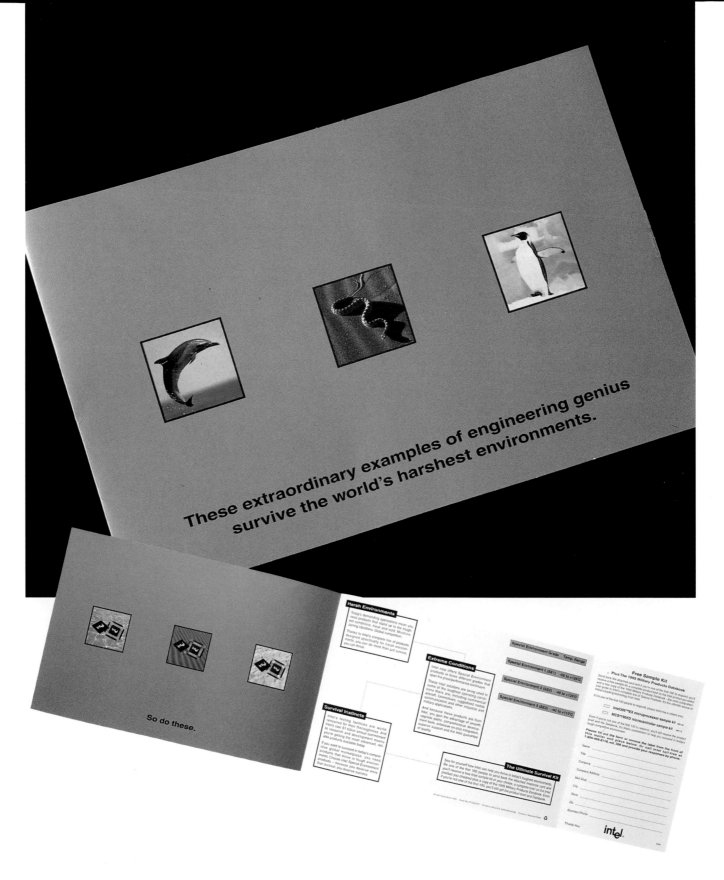

These extraordinary examples of engineering genius survive the world's harshest environments.

So do these.

◁
Design Firm **After Hours Creative**
Photographer **Bob Carey**
Client **GE Capital**
Number of Colors **Four plus varnish**

These pieces were provided to customers to give them more information on two GE Capital credit-card products. They had to convince the customers that GE was a major player in this crowded industry, and that GE's solution was preferable to others.

△
Design Firm **After Hours Creative**
Client **Intel**
Number of Colors **Four**

This direct-mail piece provided engineers with information about a new chip product from Intel. The designers used a metaphor of animals that survive harsh environments to communicate new chip's ability to survive extreme heat, cold, or damp environments.

Product Promotion 79

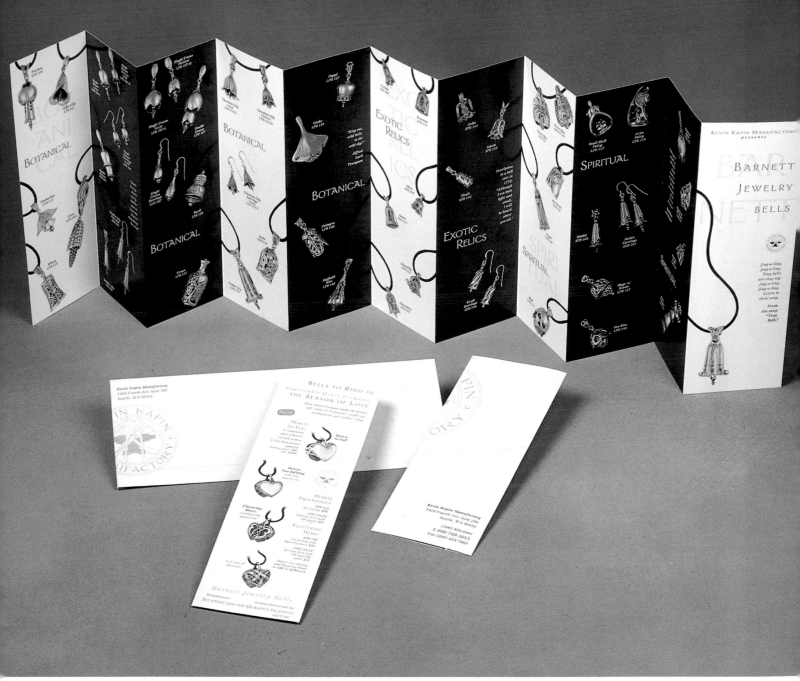

Δ
Design Firm **Belyea Design Alliance**
Art Director **Patricia Belyea**
Designer **Adrianna Jumping Eagle**
Illustrator **Ron Hansen**
Client **Kevin Kapin Manufacturing**
Purpose or Occasion **Wholesale mailer**
Number of Colors **Four**

All of the jewelry bells were photographed under a dome as well as retouched to remove any reflections. They were reproduced at exact size to show the scale of the product.

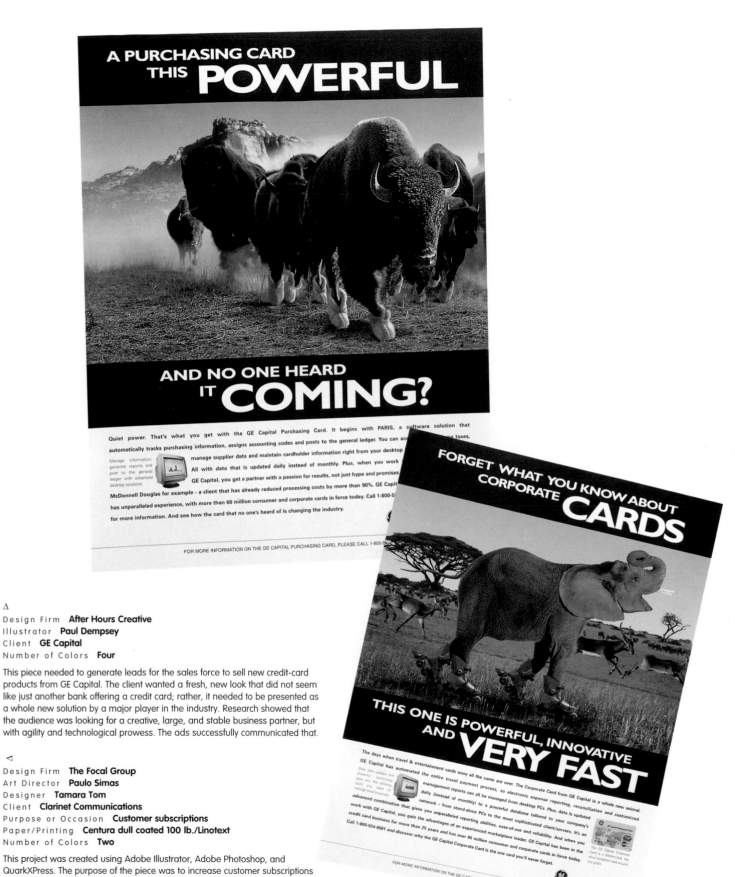

A PURCHASING CARD THIS POWERFUL

AND NO ONE HEARD IT COMING?

Quiet power. That's what you get with the GE Capital Purchasing Card. It begins with PARIS, a software solution that automatically tracks purchasing information, assigns accounting codes and posts to the general ledger. You can ac taxes, manage supplier data and maintain cardholder information right from your desktop

Manage information, generate reports and post to the general ledger with advanced desktop solutions. All with data that is updated daily instead of monthly. Plus, when you work GE Capital, you get a partner with a passion for results, not just hype and promises.

McDonnell Douglas for example - a client that has already reduced processing costs by more than 90%. GE Capit has unparalleled experience, with more than 66 million consumer and corporate cards in force today. Call 1-800-5 for more information. And see how the card that no one's heard of is changing the industry.

FOR MORE INFORMATION ON THE GE CAPITAL PURCHASING CARD, PLEASE CALL 1-800-5

FORGET WHAT YOU KNOW ABOUT CORPORATE CARDS

THIS ONE IS POWERFUL, INNOVATIVE AND VERY FAST

The days when travel & entertainment cards were all the same are over. The Corporate Card from GE Capital is a whole new animal. GE Capital has automated the entire travel payment process, so electronic expense reporting, reconciliation and customized management reports can all be managed from desktop PCs.

Daily data updates, and powerful technology give you the agility both you need to manage travel expense. daily (instead of monthly) to a powerful database tailored to your company's network - from stand-alone PCs to the most sophisticated client/servers. It's an advanced combination that gives you unparalleled reporting abilities, ease-of-use and reliability. And when you work with GE Capital, you gain the advantages of an experienced marketplace leader. GE Capital has been in the credit card business for more than 25 years and has over 66 million consumer and corporate cards in force today. Call 1-800-554-0581 and discover why the GE Capital Corporate Card is the one card you'll never forget.

FOR MORE INFORMATION ON THE GE CAPITAL CORPORATE CARD, PLEASE CALL 1-800-554-0581

GE Capital Services
Our Business Is Helping Yours®

△
Design Firm **After Hours Creative**
Illustrator **Paul Dempsey**
Client **GE Capital**
Number of Colors **Four**

This piece needed to generate leads for the sales force to sell new credit-card products from GE Capital. The client wanted a fresh, new look that did not seem like just another bank offering a credit card; rather, it needed to be presented as a whole new solution by a major player in the industry. Research showed that the audience was looking for a creative, large, and stable business partner, but with agility and technological prowess. The ads successfully communicated that.

◁
Design Firm **The Focal Group**
Art Director **Paulo Simas**
Designer **Tamara Tom**
Client **Clarinet Communications**
Purpose or Occasion **Customer subscriptions**
Paper/Printing **Centura dull coated 100 lb./Linotext**
Number of Colors **Two**

This project was created using Adobe Illustrator, Adobe Photoshop, and QuarkXPress. The purpose of the piece was to increase customer subscriptions to the client an Internet access provider. Coffee, coasters, and images were given away to help in the campaign's efforts.

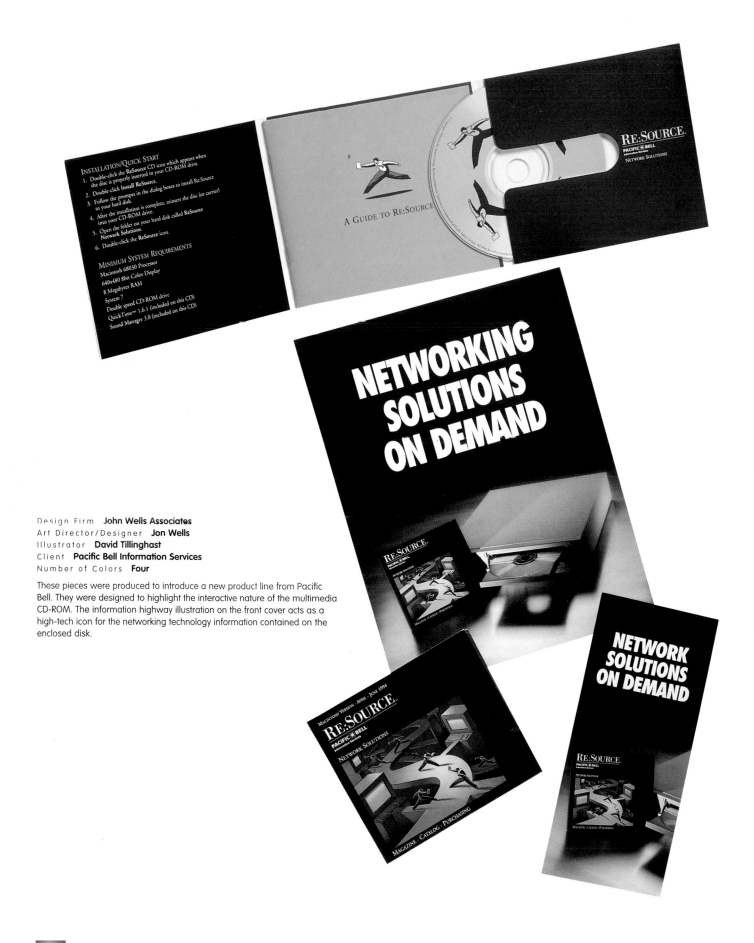

INSTALLATION/QUICK START
1. Double-click the ReSource CD icon which appears when the disc is properly inserted in your CD-ROM drive.
2. Double-click Install ReSource.
3. Follow the prompts in the dialog boxes to install ReSource to your hard disk.
4. After the installation is complete, reinsert the disc (or carrier) into your CD-ROM drive.
5. Open the folder on your hard disk called ReSource Network Solutions.
6. Double-click the ReSource icon.

MINIMUM SYSTEM REQUIREMENTS
Macintosh 68030 Processor
640x480 8bit Color Display
8 Megabytes RAM
System 7
Double speed CD-ROM drive
QuickTime™ 1.6.1 (included on this CD)
Sound Manager 3.0 (included on this CD)

A GUIDE TO RE:SOURCE

RE:SOURCE
PACIFIC✴BELL
Information Services
NETWORK SOLUTIONS

NETWORKING SOLUTIONS ON DEMAND

NETWORK SOLUTIONS ON DEMAND

Design Firm **John Wells Associates**
Art Director/Designer **Jon Wells**
Illustrator **David Tillinghast**
Client **Pacific Bell Information Services**
Number of Colors **Four**

These pieces were produced to introduce a new product line from Pacific Bell. They were designed to highlight the interactive nature of the multimedia CD-ROM. The information highway illustration on the front cover acts as a high-tech icon for the networking technology information contained on the enclosed disk.

Δ

Design Firm **The Wyatt Group**
Art Director **James Ward**
Copywriter **Mike Maccioli**
Creative Directors **Mark Wyatt, Mike Maccioli**
Client **Omega Optical**
Purpose or Occasion **Promotion**
Number of Colors **Four**

This promotion was a five-month rebate program designed to encourage the dispensing of specific lenses. Opticians could receive five or ten dollars for each lens they dispensed. The designers provided a monthly tracking device and envelopes to make the rebate easy.

Δ

Design Firm **DHI (Design Horizons International)**
Art Director **Jim Carlton**
Designers **Krista Ferdinand, Victoria Huang**
Illustrator **Richard Goldburg**
Client **Motorola**
Purpose or Occasion **Dealer Education Campaign**
Paper/Printing **Strathmore Grandee**
Number of Colors **Four**

The challenge was to develop a campaign to simplify the idea of a mobile office through the use of Motorola's new line of cellular devices.

Design Firm **Directech, Inc.**
Art Director **Richard Johnson**
Assistant Designer **Jeff McAllister**
Illustrator **Ken Condon**
Client **Sun Microsystems, Inc.**
Purpose or Occasion **Product promotion—Domain Manager**
Paper/Printing **Patina 7 pt./Sheetfed, W. E. Andrews**
Number of Colors **Four plus PMS; process yellow substituted
 with fluorescent yellow**

This self-mailer promotes a networking software product called Domain
Manager. The piece illustrates the product's capabilities, folding out to
poster size.

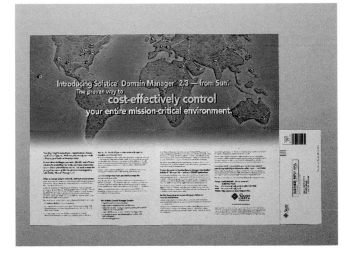

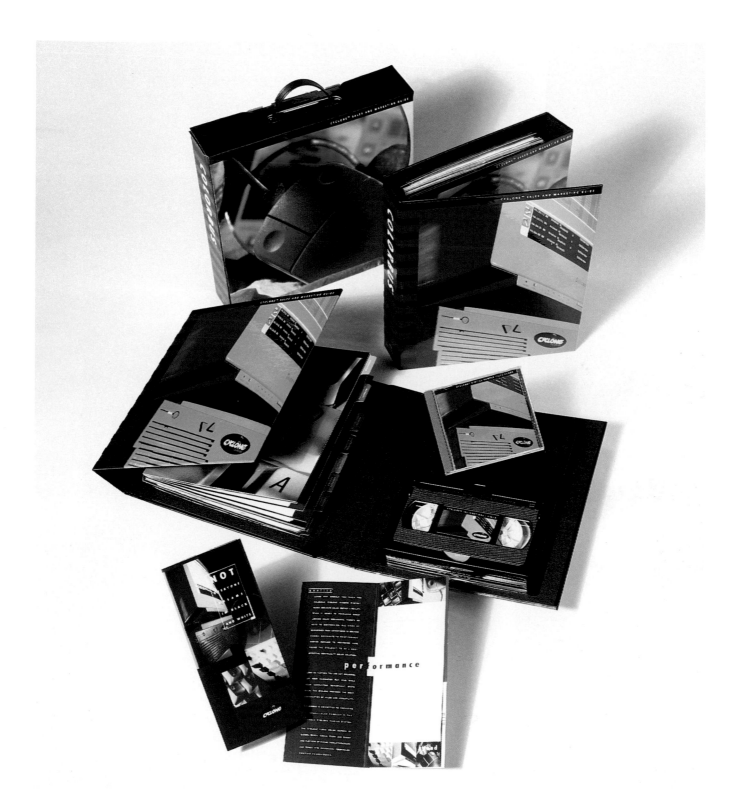

Design Firm **David Riley + Associates**
Art Director **David Riley**
Designers **Dennis Thorp, David Riley**
Photographer **Lonnie Duka**
Client **Colorbus**
Purpose or Occasion **Product sales package**

The innovative Colorbus Cyclone Imaging System maximizes the use of color
copiers by turning them into color printers and scanners. The brochures illustrate
the power of communication in color through a combination of saturated
photography, brilliant color, and bold design. Together with the other sales tools,
they help position Colorbus as a pioneer in their field.

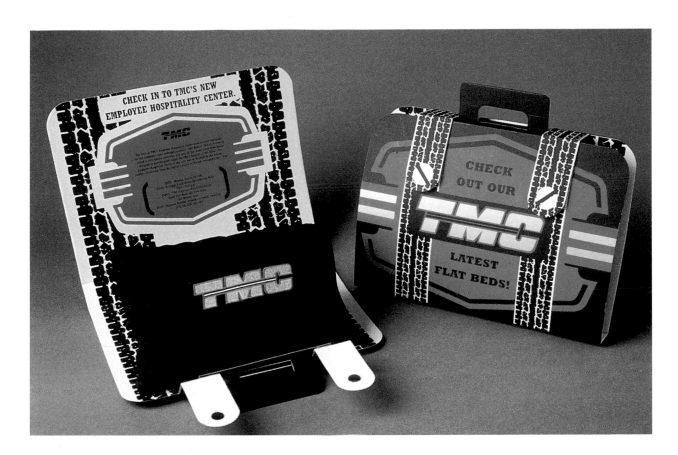

Design Firm **Sayles Graphic Design**
Art Director **John Sayles**
Designers **John Sayles, Jennifer Elliot**
Copywriter **Wendy Lyons**
Illustrator **John Sayles**
Client **TMC Transportation**
Purpose or Occasion **Grand-opening announcement**
Paper/Printing **Curtis Riblaid Black, corrugated/Screen-printed,
 laminated; Image Maker**
Number of Colors **Three**

The TMC Hospitality Center is a company-owned hotel with accommo-
dations available only to the flatbed trucking line's employee-drivers.
This unique announcement is a corrugated suitcase screen-printed with
tire tracks; inside is a custom-made pillow embroidered with the
company logo with a foil-wrapped TMC chocolate attached. Copy
invites recipients to "take a closer look at our flatbeds," a reference to
both the trucking company's equipment and the amenities of the
new Hospitality Center.

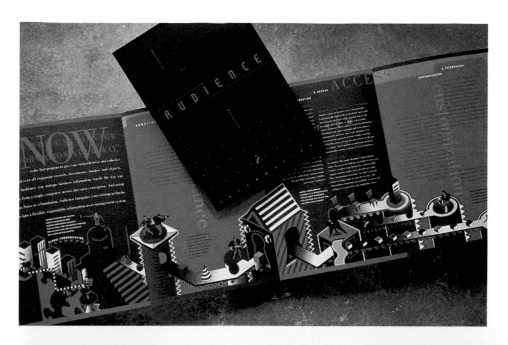

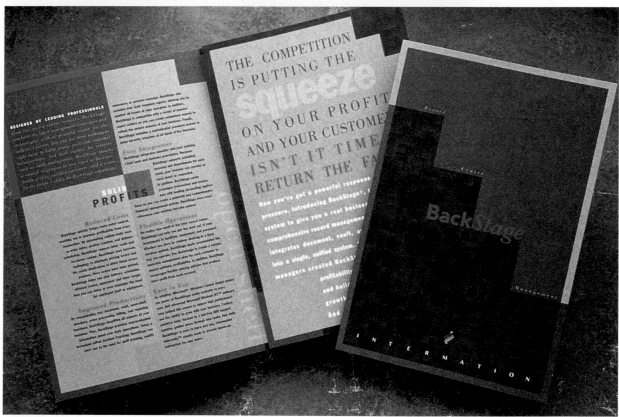

Δ *TOP*
Design Firm **Hornall Anderson Design Works**
Art Director **Jack Anderson**
Designers **Jack Anderson, David Bates, Suzanne Haddon**
Illustrator **Eddie Yip**
Client **Intermation Corporation**
Purpose or Occasion **Capabilities brochure**

This brochure was designed using QuarkXPress and Macromedia FreeHand. Its purpose is to present Audience, a software package developed as a global approach to managing corporate records, documents, images, and objects.

Δ
Design Firm **Hornall Anderson Design Works**
Art Director **Jack Anderson**
Designers **Jack Anderson, David Bates, Suzanne Haddon**
Client **Intermation Corporation**
Purpose or Occasion **Capabilities brochure**
Paper/Printing **Jaguar Smooth 80 lb. cover**

This brochure was designed using QuarkXPress, Macromedia FreeHand, and Adobe Photoshop. Its purpose is to present Backstage, a software package developed for warehouse environments to help with maintaining, managing, and tracking inventory.

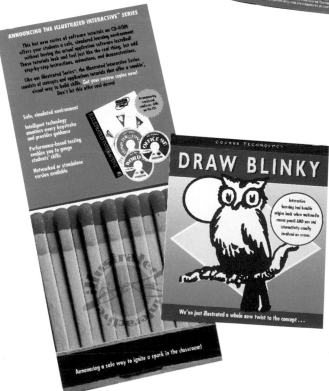

△
Design Firm **Manley Design**
Art Directors **Don Manley, Howie Green**
Designer **Don Manley**
Client **Course Technology**
Purpose or Occasion **To highlight selected Course products**
Paper/Printing **Patina 80 lb. matte cover/Offset**
Number of Colors **Four plus varnish**

This piece was designed to highlight and promote existing Course products. The designer primarily used QuarkXPress and Adobe Photoshop for the creation of this piece.

◁
Design Firm **Manley Design**
Art Directors **Don Manley, Howie Green**
Designer **Don Manley**
Photography **Gene Dwiggins**
Client **Course Technology**
Purpose or Occasion **Introduction of new product**
Paper/Printing **Patina 80 lb. matte cover/Offset**
Number of Colors **Four plus varnish**

Draw Blinky was designed to promote the introduction of interactive CD-ROM. Course Technology is known in the academic world for distributing software instruction manuals. Draw Blinky is a metaphor for interactivity, as well as being a lighthearted way to introduce a product. This piece was created primarily with QuarkXPress and Adobe Photoshop.

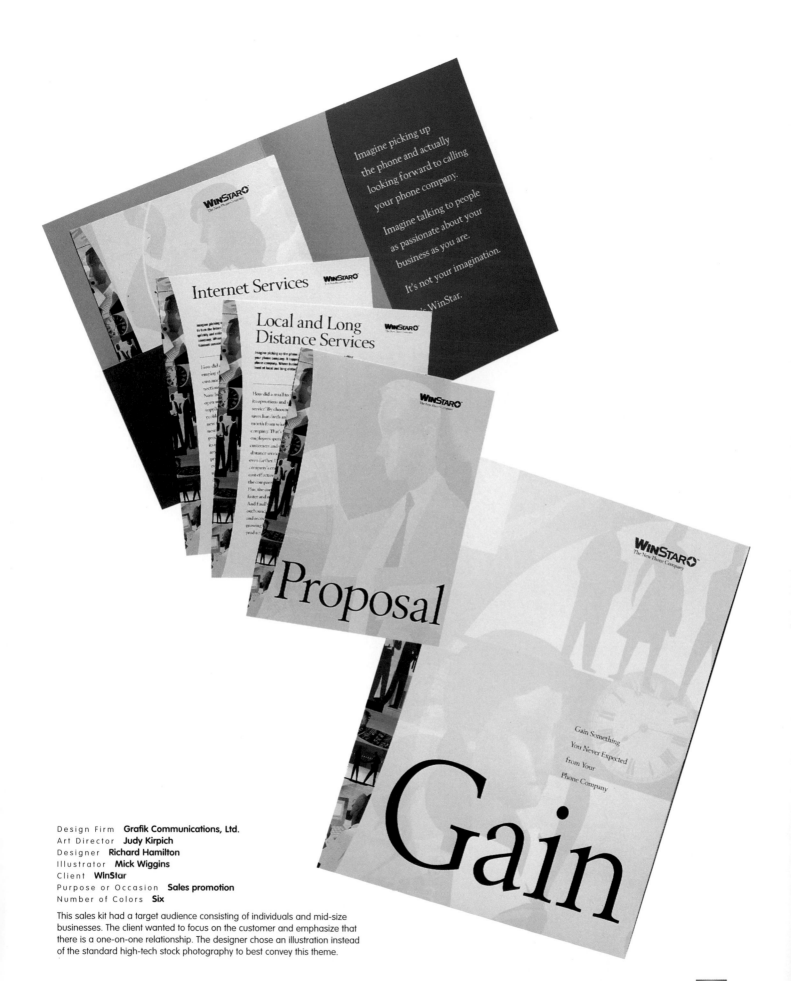

Imagine picking up the phone and actually looking forward to calling your phone company.

Imagine talking to people as passionate about your business as you are.

It's not your imagination.

It's WinStar.

Internet Services

Local and Long Distance Services

Proposal

Gain Something
You Never Expected
from Your
Phone Company

Gain

Design Firm **Grafik Communications, Ltd.**
Art Director **Judy Kirpich**
Designer **Richard Hamilton**
Illustrator **Mick Wiggins**
Client **WinStar**
Purpose or Occasion **Sales promotion**
Number of Colors **Six**

This sales kit had a target audience consisting of individuals and mid-size businesses. The client wanted to focus on the customer and emphasize that there is a one-on-one relationship. The designer chose an illustration instead of the standard high-tech stock photography to best convey this theme.

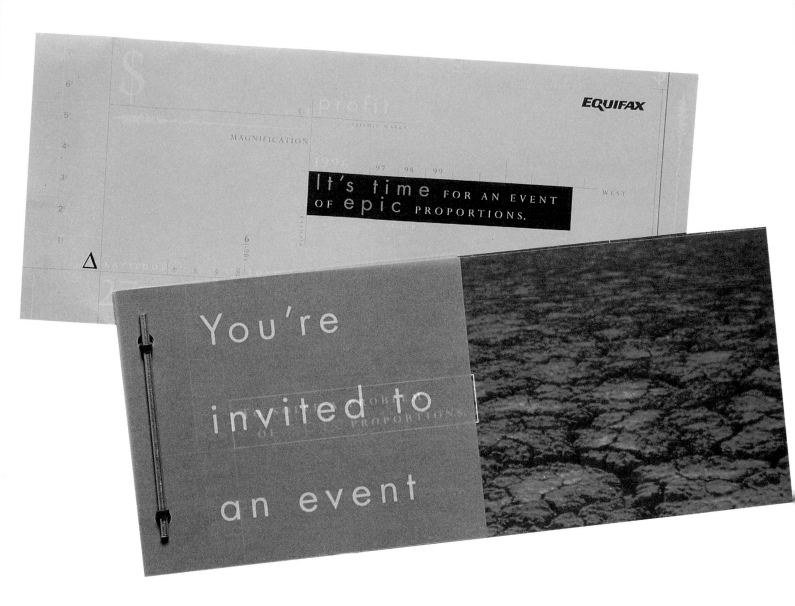

It's time FOR AN EVENT OF epic PROPORTIONS.

You're invited to an event

△
Design Firm **Copeland Hirthler design + communications**
Creative Directors **Brad Copeland, George Hirthler**
Art Director/Designer **Melanie Bass Pollard**
Copywriters **Clint Carruth, Melissa James Kemmerly**
Photographers **Fredrik Broden, Jerry Burns, stock photography**
Client **Equifax**
Purpose or Occasion **Invitation/direct mail**
Paper/Printing **Neenah Classic Crest-Tarragon; Starwhite Vicksburg
 Vellum, High Tech; CilClear Medium; Quintessance Dull; Curtis Black 130 pt.**
Number of Colors **Four plus two metallic colors plus spot varnish**

The design incorporates the dramatic use of earthquake-related visuals as
metaphors that emphasize the new product's strengths. The metal binding rod
enabled the piece to be updated over a six-month period. Additional brochures,
product notebooks, and a slide show were based on the effects created for the
invitation and dovetailed with the imaging system created for the company. The
initial earthquake photography was created from a stock image and combined
with seismographic artwork using Adobe Photoshop and Adobe Illustrator.

▷
Design Firm **Get Smart Design Company**
Art Director **Jeff MacFarlane**
Designer **Tom Culbertson**
Client **WCB/McGraw-Hill Publishers**
Purpose or Occasion *Genetics,* **Third Edition**
Paper/Printing **WCB/McGraw-Hill**
Number of Colors **Four**

The piece was designed to appeal to college professors. A clean and flowing
design helped to convey the message of a top-quality textbook. Illustrations
sampled from the book were used along with photography from the book's
cover and interior. The piece was assembled in QuarkXPress.

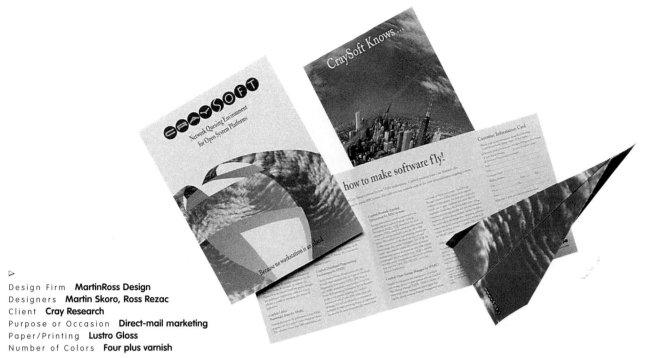

▷
Design Firm **MartinRoss Design**
Designers **Martin Skoro, Ross Rezac**
Client **Cray Research**
Purpose or Occasion **Direct-mail marketing**
Paper/Printing **Lustro Gloss**
Number of Colors **Four plus varnish**

Cray wanted to promote their Craysoft software through a direct-mail piece that would tie into a trade show they would be attending. The brochures were sent before the show, and the paper airplanes were handed out at the trade show as part of the display.

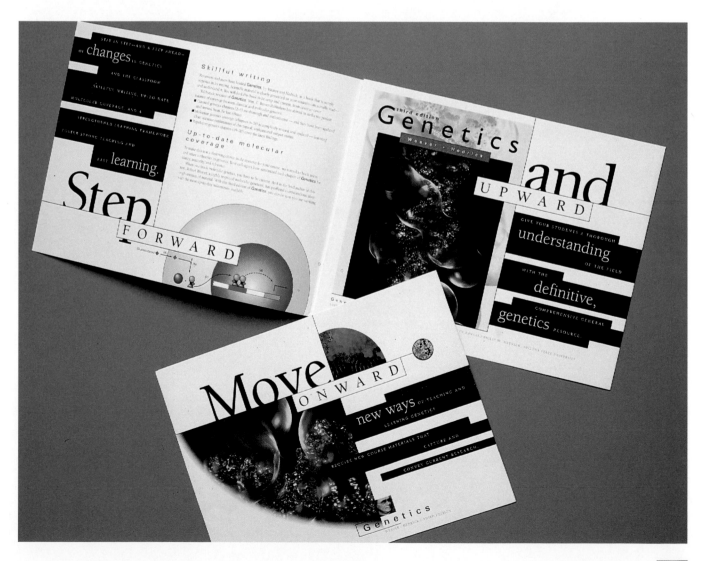

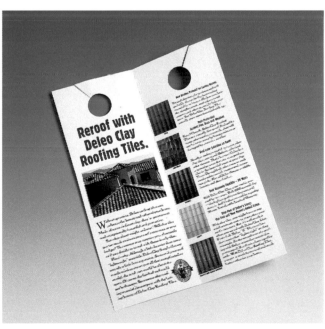

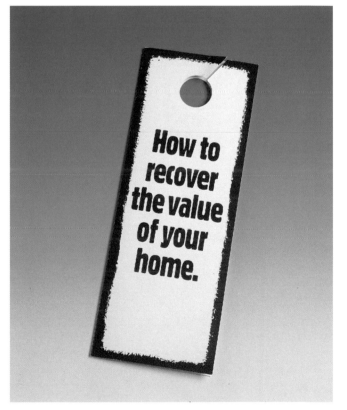

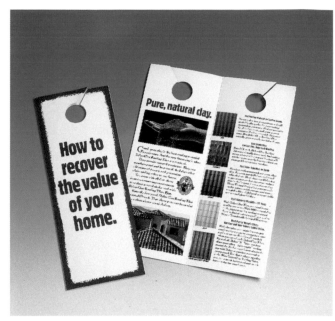

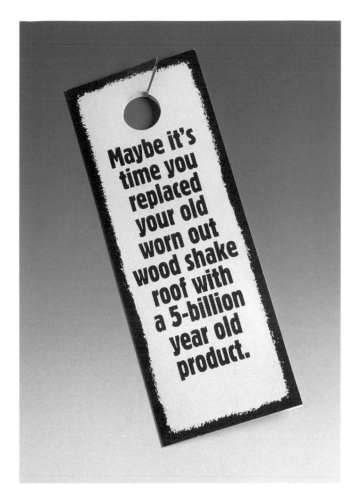

Design Firm **Mires Design**
Art Director **Jose Serrano**
Designer **Jose Serrano**
Copywriter **Kelly Smothermon**
Client **Deleo Clay Tile Company**
Paper/Printing **Continental Graphics**
Number of Colors **Four**

This piece is a door-to-door hanger that roofing contractors can place throughout an area that they are working in.

Pure, natural clay.

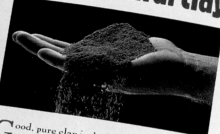

Good, pure clay is the best roofing material in existence. And the very finest clay is what Deleo Clay Roofing Tiles are made of.

They provide natural insulation. They are weather-proof and bug-proof. And they offer a lifetime of beauty and protection while adding value to any home.

Yet, even with all that, there is an even more important reason to replace a wood shake roof with Deleo Clay Roofing Tiles. **Fire.**

Virtually fire-proof, Deleo Clay Roofing Tiles are rated Class A. That alone puts our beautiful tiles a class above wood shakes.

RED

ANTIQUE

ADOBE

BUFF

(SHOWN: TURQOISE GLAZE)
MATTE AND GLAZE FINISHES

Best Roofing Material for Lasting Beauty.
Natural clay has always been and will probably always be the best roofing material in existence. Shakes turn brittle, shingles crack, and color-coated cement and other materials fade over time. But Deleo Clay Roofing Tiles actually grow more beautiful with age.

Best Protection Against Fire, Bugs and Weather.
Rated Class A. Deleo Clay Roofing Tiles are virtually fire-proof. And unlike many other roofing materials, they will not be eaten away by hungry critters or damaged by corrosive weather.

Best Color Selection on Earth
No other roofing material, not even other clay tiles, can match Deleo's unlimited color choices. That's because Deleo has a special process that can even produce tiles in the beautiful tones of pure clay. These Throughbody tiles come in such earthy colors as rich creams and sensuous pinks. Also, all Deleo tiles are available in matte and glaze finishes.

Best Warranty Possible – 50 Years
With Deleo Clay Tiles, your roof is covered by two ways. With 100% natural clay — the highest quality roofing material there is. And it's also covered by a quality 50 year Transferable Limited Warranty.

Best Part of Deleo's Story: Our Cost and Your Home's Added Value.
With clay tiles, you might have to pay reinforcement costs to strengthen your roof's structure. But it's well worth it when you reroof with Deleo Clay Tiles. First of all, Deleo "S" Tiles cost less than most other "lightweight" roofing materials. So the overall cost of reroofing with Deleo or another material is pretty equal. But that's where equality ends. With Deleo Clay Roofing Tiles, you get a much better roof and much better value for your home.

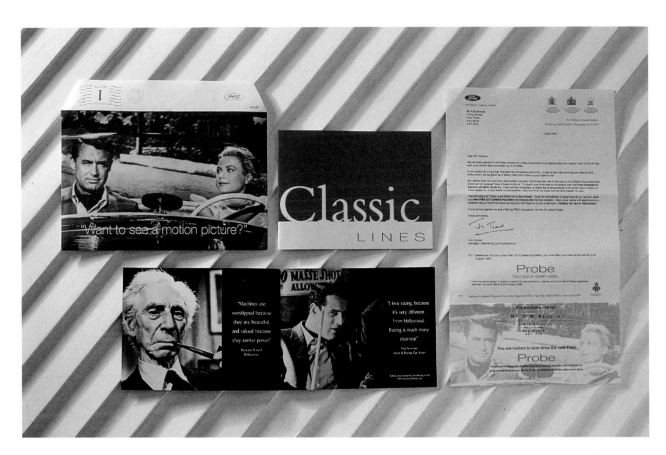

△
Design Firm **Allan Burrows Limited**
Art Director/Designer **Roydon Hearne**
Client **Ford Motor Company Limited**
Purpose or Occasion **Probe direct marketing**
Paper/Printing **McNaughton Skye Silk**
Number of Colors **Four**

Playing on the classic theme of "Want to see a motion picture?," the designers used archive pictures and quotations from well-known people to talk about the classic lines of Probe. The piece included cinema tickets plus a trip to a Hollywood prize drawing.

▷
Design Firm **The Weber Group, Inc.**
Art Director **Anthony Weber**
Designer **Jeff Tischer**
Client **J. C. Pendergast, Inc.**
Purpose or Occasion **Magazine ad**
Number of Colors **Four**

J. C. Pendergast, Inc. was looking for a masculine and distinguished ad that gave the feeling that a person could enjoy a favorite cigar not just in a club, but in French smoking furniture at home. The piece is distinguished, classy, and classic.

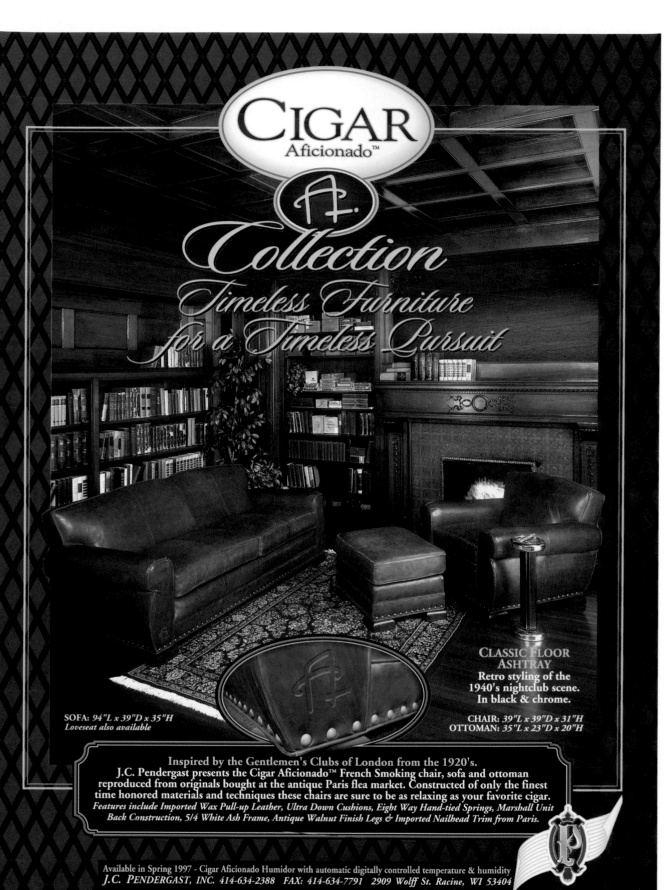

CIGAR
Aficionado™

A.
Collection
Timeless Furniture for a Timeless Pursuit

CLASSIC FLOOR ASHTRAY
Retro styling of the 1940's nightclub scene.
In black & chrome.

SOFA: 94"L x 39"D x 35"H
Loveseat also available

CHAIR: 39"L x 39"D x 31"H
OTTOMAN: 35"L x 23"D x 20"H

Inspired by the Gentlemen's Clubs of London from the 1920's.
J.C. Pendergast presents the Cigar Aficionado™ French Smoking chair, sofa and ottoman reproduced from originals bought at the antique Paris flea market. Constructed of only the finest time honored materials and techniques these chairs are sure to be as relaxing as your favorite cigar.
Features include Imported Wax Pull-up Leather, Ultra Down Cushions, Eight Way Hand-tied Springs, Marshall Unit Back Construction, 5/4 White Ash Frame, Antique Walnut Finish Legs & Imported Nailhead Trim from Paris.

Available in Spring 1997 - Cigar Aficionado Humidor with automatic digitally controlled temperature & humidity
J.C. PENDERGAST, INC. 414-634-2388 FAX: 414-634-7791 2909 Wolff St. Racine, WI 53404
©1997 J.C. Pendergast, Inc.

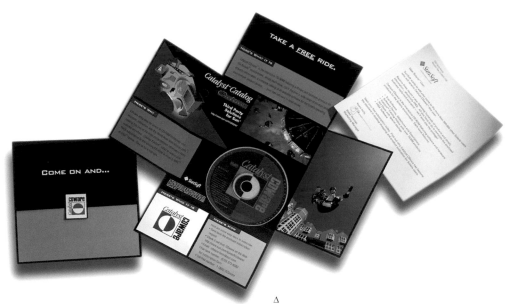

Δ
Design Firm **The Focal Group**
Art Director/Designer **Paulo Simas**
Client **Sunsoft**
Purpose or Occasion **Free software campaign**
Paper/Printing **Dull coated 100 lb.**
Number of Colors **Five**

Sunsott approached designers about creating a direct-mail piece that would promote their product with free compact-disc software. The piece needed to be energetic and colorful to cross all markets. The project was designed and created using Adobe Illustrator, Adobe Photoshop, and QuarkXPress.

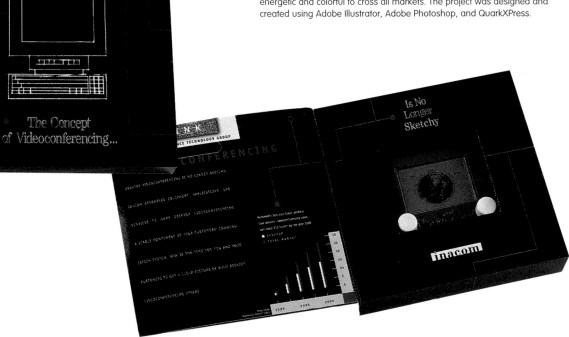

Δ
Design Firm **Webster Design Associates, Inc.**
Art Director **Dave Webster**
Designer **Sean Heisler**
Illustrator **Phil Thompson**
Client **Inacom**
Purpose or Occasion **Promote desktop video**
Paper or Printing **Richardson Printing**
Number of Colors **Four**

The concept of videoconferencing is no longer sketchy; Etch-a-Sketch promotion informed the audience about new developments in desktop-video technology.

▷
Designer **Christopher To**
Client **Memorex**
Purpose or Occasion **(CES Show) CDR recorder and CDR**
Paper/Printing **Poster**
Number of Colors **Four**

This poster for the CES show in Las Vegas was designed to promote the client's CD Recorder and CDR. The image is a composition of several images: piano keys, a strip of numbers, ring, wave. The technique required many layers. It was touched up with the use of a lens flare filter, and a motion trail was added.

CD Recorder & CDR

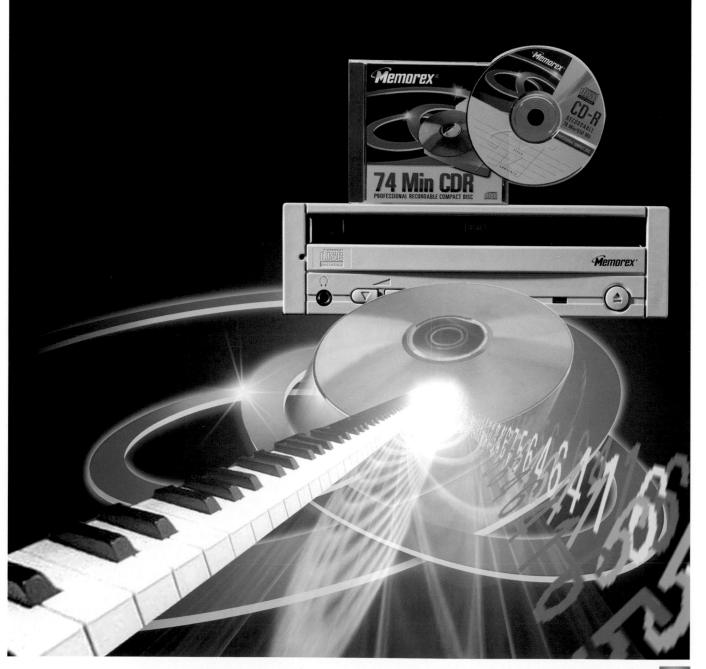

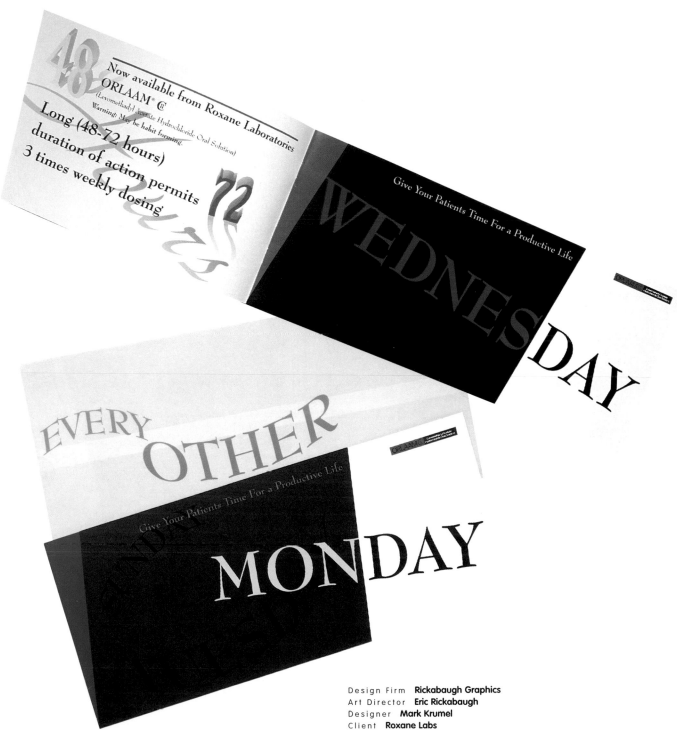

Design Firm **Rickabaugh Graphics**
Art Director **Eric Rickabaugh**
Designer **Mark Krumel**
Client **Roxane Labs**
Purpose or Occasion **Direct mailer to notify doctors**
Paper/Printing **Kromekote/Carpenter Reserve**
Number of Colors **Four plus two varnishes**

This piece was sent to doctors at clinics to alert them to a medication that is administered every other day, a real savings in time and money, not only for the patient, but the doctor as well. The standard medication must be given daily, so the cover pages needed to work like a calendar describing various facts on one page and the days administered on the other. Unfortunately, the bulk of the piece, the legal copy, had to be attached.

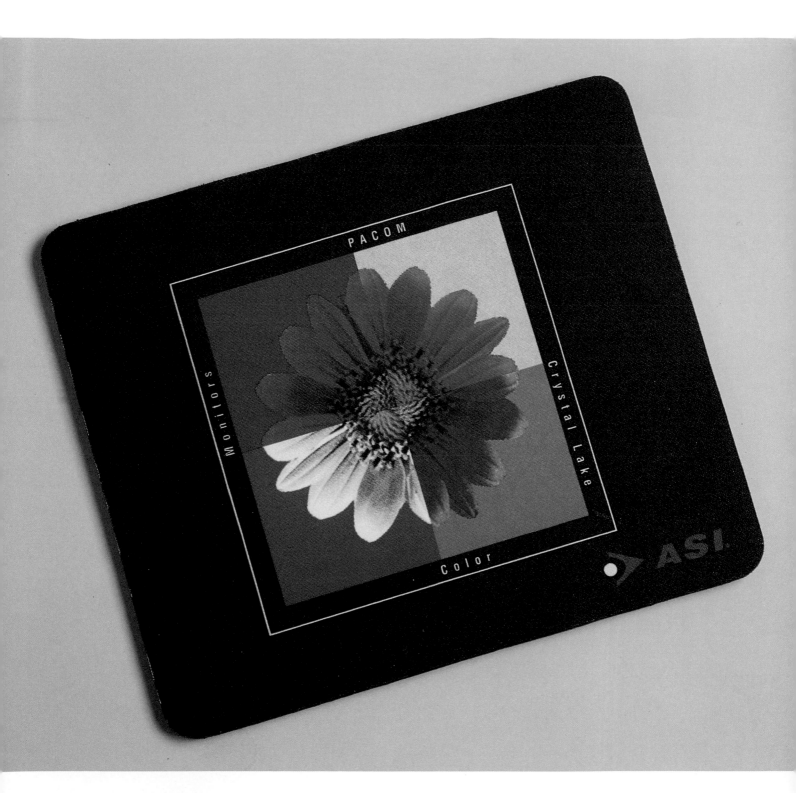

Design Firm **Melissa Passehl Design**
Art Director **Melissa Passehl**
Designers **Melissa Passehl, Charlotte Lambrects, David Stewart**
Client **Pacom**
Purpose or Occasion **Mousepad giveaway**
Paper/Printing **Dye sub-transfer**
Number of Colors **Four**

The imagery on the mousepad was created to show the vibrant color imagery
that can be experienced with Pacom color monitors.

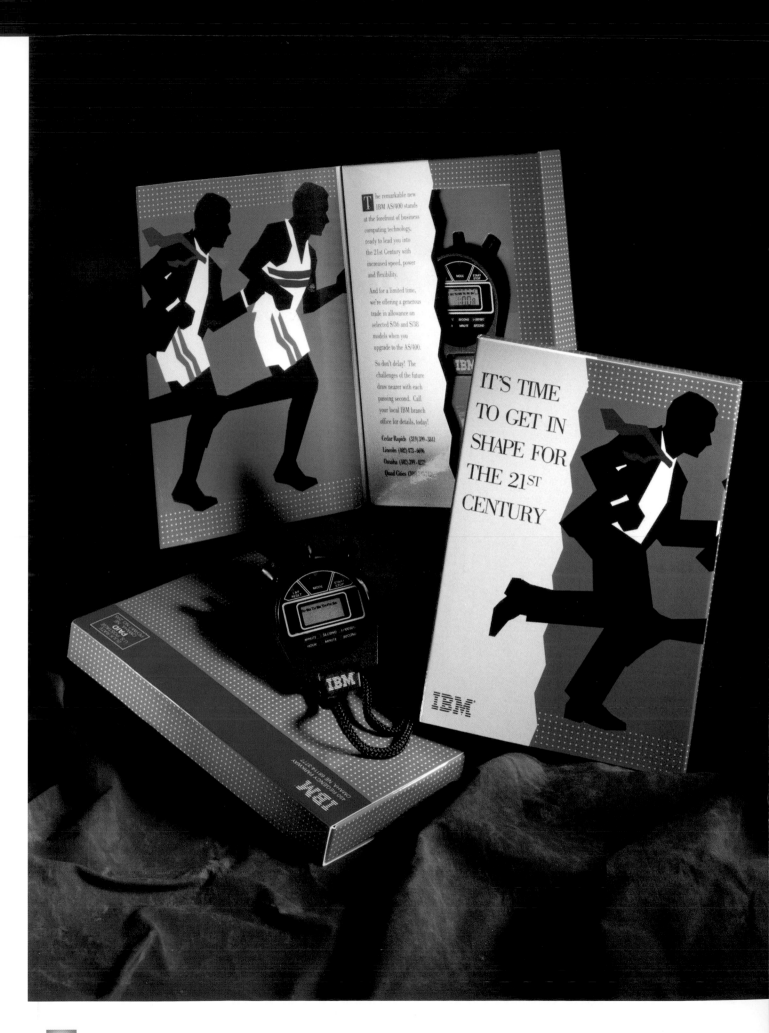

Δ
Design Firm **Mires Design**
Art Director **Jose Serrano**
Designers **Deborah Horn, Jose A. Serrano**
Photographer **Carl Vanderschuit**
Client **Agassi Enterprises**
Paper/Printing **Continental Graphics**
Number of Colors **Four**

With the help of strong visuals and bold color, this mailer helped launch
a new product for retail.

◁
Design Firm **Webster Design Associates, Inc.**
Art Director/Designer **Dave Webster**
Illustrator **Todd Eby**
Client **IBM**
Purpose or Occasion **Promote new computer line**
Paper or Printing **Corporate Image**
Number of Colors **Four PMS**

To promote IBM's new line of computer products, a limited-time offer for
upgrading was introduced with a stopwatch. The watch reinforced the message
of the offer's limited-time nature, as well as its timeliness. The heading on the
front of the box and the graphic metamorphosis of the corporate figure
complement the theme, unifying the message and the promotional item.

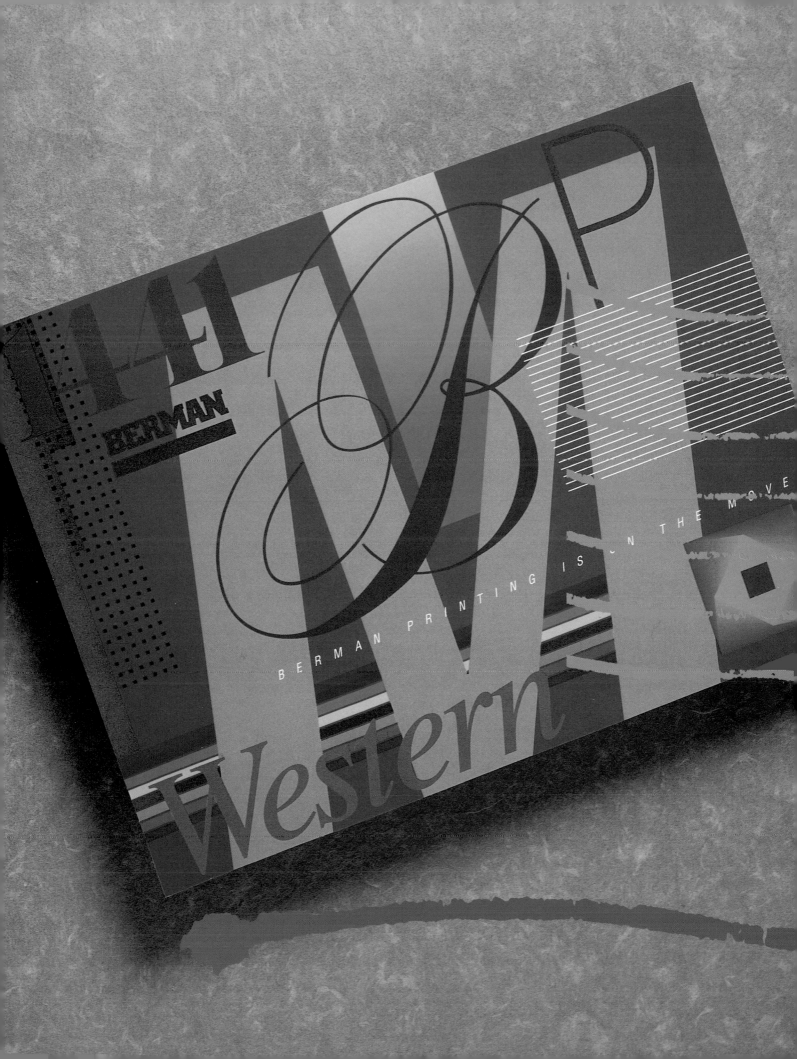

A COLLECTION OF INSPIRING SELF-PROMOTIONAL MARKETING PIECES DESIGNED FOR RESPONSE

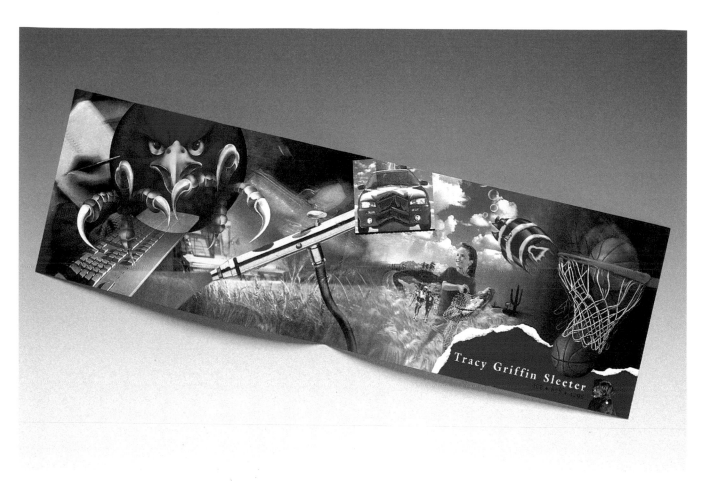

Design Firm **Tracy Griffin Sleeter**
Designer **Tracy Griffin Sleeter**
Illustrator **Tracy Griffin Sleeter**
Purpose or Occasion **Self-promotion**
Paper/Printing **Indigo Press**
Number of Colors **Four and one**

This promotional piece was intended to highlight different illustration and design services.

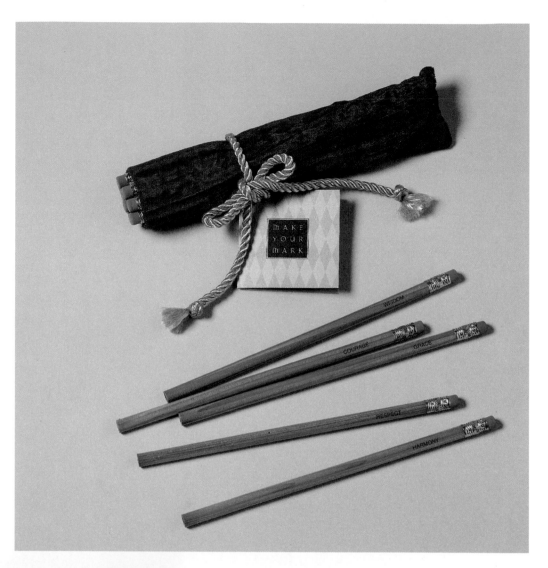

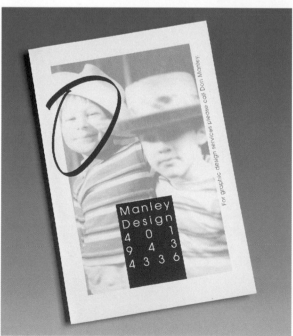

△
Design Firm **Melissa Passehl Design**
Art Director **Melissa Passehl**
Designers **Melissa Passehl, Charlotte Lambrects, David Stewart**
Writer **Susan Sharpe**
Purpose or Occasion **New Year greeting**
Paper/Printing **Evergreen, velvet, gold cord/Litho, foil stamp**
Number of Colors **Two**

Melissa Passehl Design created this gift set of pencils as a reminder to their clients that everyone has the communication tools to "Make Your Mark" in the New Year. Each pencil is foil stamped with words such as passion, humility, and respect.

◁
Design Firm **Manley Design**
Art Director/Designer **Don Manley**
Client **Manley Design**
Purpose or Occasion **Self-promotion**
Paper/Printing **Offset**
Number of Colors **Two**

This was a self-promotional ad that appeared on the inside back cover of a local Chamber-of-Commerce publication. This piece was created primarily with QuarkXPress and Adobe Photoshop.

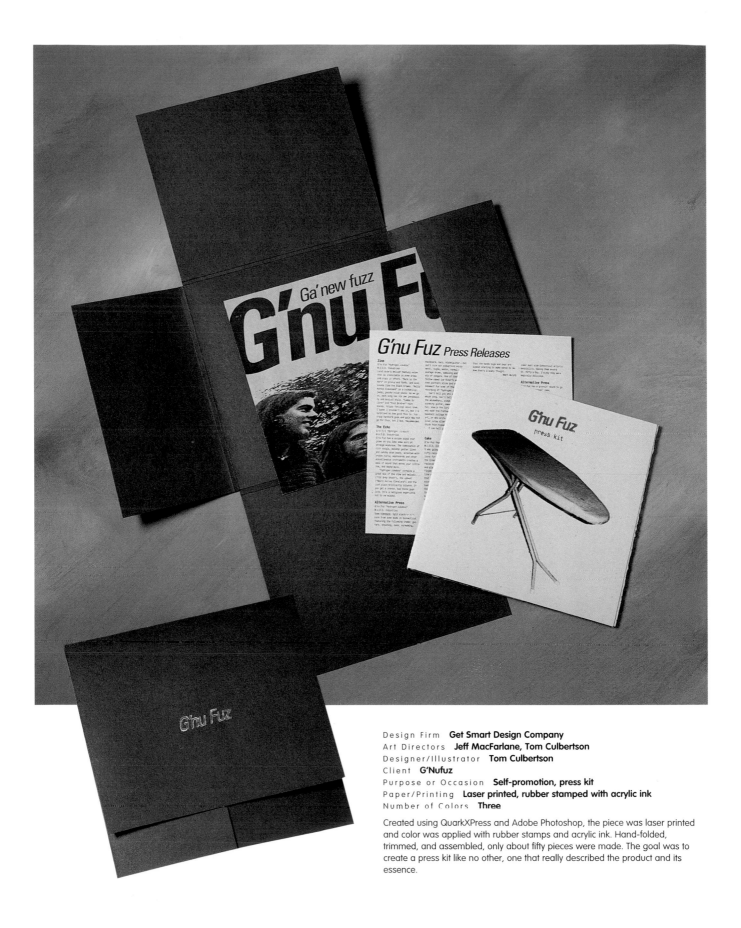

Design Firm **Get Smart Design Company**
Art Directors **Jeff MacFarlane, Tom Culbertson**
Designer/Illustrator **Tom Culbertson**
Client **G'Nufuz**
Purpose or Occasion **Self-promotion, press kit**
Paper/Printing **Laser printed, rubber stamped with acrylic ink**
Number of Colors **Three**

Created using QuarkXPress and Adobe Photoshop, the piece was laser printed and color was applied with rubber stamps and acrylic ink. Hand-folded, trimmed, and assembled, only about fifty pieces were made. The goal was to create a press kit like no other, one that really described the product and its essence.

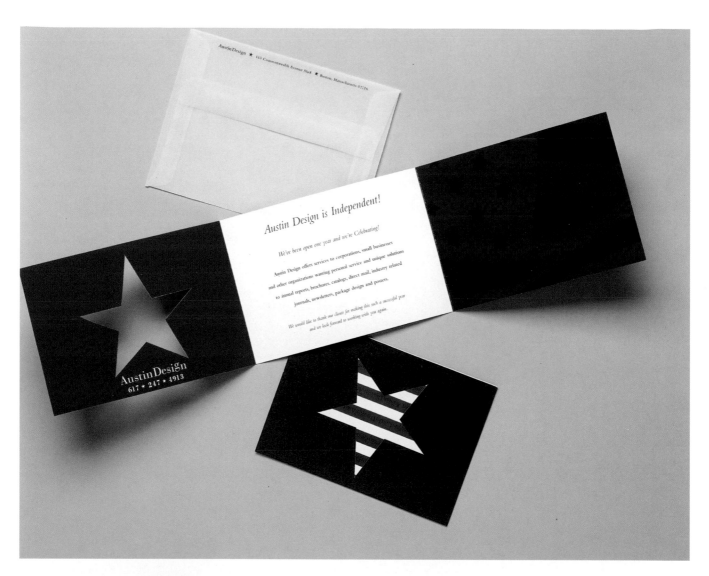

△

Design Firm **Austin Design**
Art Director/Designer **Wendy Austin**
Purpose or Occasion **July 4th announcement**
Number of Colors **Two**

This piece was produced to let clients and friends know of Austin Design's first-year anniversary. The flag image was used because of its mass appeal. The response was very positive and it paid for itself within a week of mailing it.

◁

Design Firm **Directech, Inc.**
Art Director **Christine Rosecrans**
Assistant Designers **Thom Lewis, Richard Johnson**
Photographer **Gerry Evelyn**
Client **Directech, Inc.**
Purpose or Occasion **Self-promotion**
Paper/Printing **Strathmore Elements, low gloss**
Number of Colors **Eight**

Designed to appeal to high-technology executives, this presentation uses a uniquely designed die-cut folder, special-effects photography, and a set of coordinated data sheets. The overview brochure doubles as a stand-alone promotional piece.

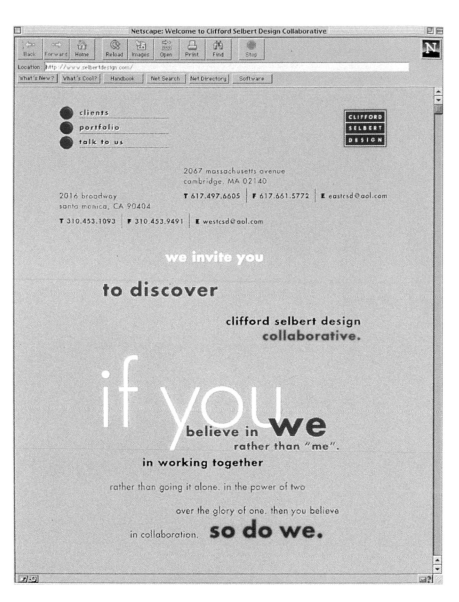

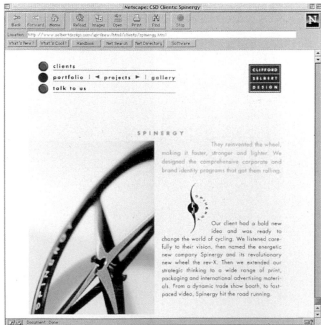

Design Firm **Clifford Selbert Design Collaborative**
Art Directors **Clifford Selbert, Lynn Riddle**
Designer **Susanne Hefel**
Purpose or Occasion **Visibility on the World Wide Web**

The Clifford Selbert Design Collaborative Website incorporates unique type treatments that appear when the site is retrieved. The site also features an extensive portfolio of projects and project spotlights that describe, in detail, the design problem or objective and its solution. The software used to create the site was QuarkXPress and Adobe Illustrator.

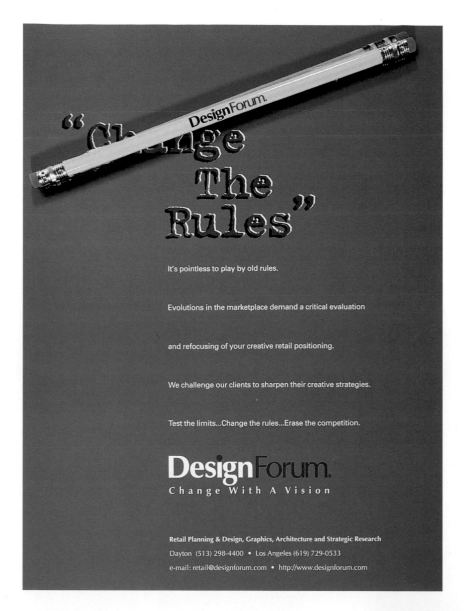

Δ
Design Firm **Design Forum**
Art Director **Bill Chidley**
Designer **Dave Nixon**
Purpose or Occasion **Direct mail corresponding to ad in VM&SD Magazine**
Number of Colors **Four**

This piece accompanied the first advertisement in a three-part series of an ad campaign. Design Forum sent this mailer to its clients and top prospects. The unique pencil has since been spotted on the desks of many clients.

▷
Design Firm **Animus Communicacao**
Art Director **Rique Nitzsche**
Designer **Robson Macedo**
Purpose or Occasion **Christmas gift by mail**
Paper/Printing **Cardboard**
Number of Colors **Four**

Animus sent this pack full of handmade truffles to all clients, suppliers, prospects, and friends.

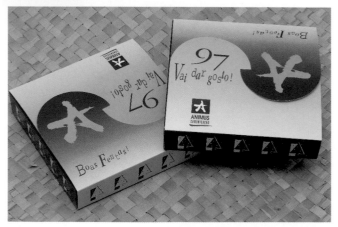

Δ
Design Firm **Designworks Studio, Ltd.**
Art Director/Designer **Jason Vaughn**
Illustrators **Jason Vaughn, Jennifer Rapier**
Paper/Printing **World Wide Website**
Number of Colors **Four**

The design firm needed to develop a reliable, but aggressive, alternative to their traditional marketing and advertising program. The Web provides enough space to include most everything the firm offers plus samples of work. Created in Adobe PageMill using frames to help organize and keep the layout simple and easy to use.

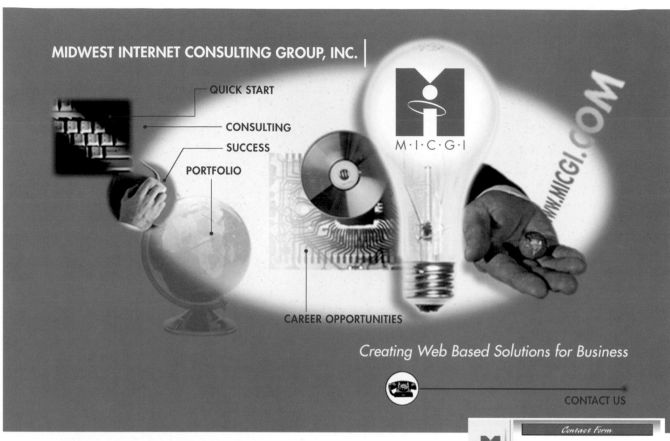

MIDWEST INTERNET CONSULTING GROUP, INC.

QUICK START

CONSULTING

SUCCESS

PORTFOLIO

M·I·C·G·I

WWW.MICGI.COM

CAREER OPPORTUNITIES

Creating Web Based Solutions for Business

CONTACT US

Design Firm **Midwest Internet Consulting Group, Inc.**
Director **Lim, Ho Yen**
Designers **Paul Buescher, John Harrell**
Illustrator **Lim, Ho Yen**
Client **Midwest Internet Consulting Group, Inc.**
Purpose or Occasion **Electronic capabilities brochure**

This Website was developed to illustrate to potential clients the variety of services and products we offered. The main considerations were to design a functional, yet aesthetically pleasing Website without a long download time. Emphasis was also placed on the viewing quality on a 256-color monitor. Whimsical and humorous business illustrations have been created to show potential clients that their advertisements don't have to be all serious.

Δ
Design Firm **Mires Design**
Art Directors **Jose Serrano, John Ball**
Designer **Jose Serrano**
Illustrator **Henry Ball**
Purpose or Occasion **Corporate Identity program**
Paper/Printing **Khromekote/Continental Graphics**
Number of Colors **Four over two**

This portfolio piece showcases the design firm's logos for various clients.

∇ Δ
Design Firm **Mires Design**
Art Director **Jose Serrano**
Designers **Jose Serrano, Jeff Samaripa**
Paper/Printing **Continental Graphics, xerography, letterpress**

The case-study books offer a step-by-step view of the design process. The books are created in an easy-to-follow format and are used as a marketing tool.

Δ
Design Firm **Mires Design**
Art Director **Jose Serrano**
Designer **Jose Serrano**
Purpose or Occasion **Capabilities brochure**
Paper/Printing **Khromekote/Continental Graphics**
Number of Colors **Three**

This portfolio piece showcases the design firm's logos for various clients.

▷
Design Firm **Sheaff Dorman Purins**
Art Director/Designer **Uldis Purins**
Purpose or Occasion **New Year's greeting**
Number of Colors **Three**

Sheaff Dorman Purins sends out a New Year's card to friends and clients every year. Its main purpose is to convey greetings, but since the phone number is on the card, many people call back to express graditude, which often starts a conversation. It is a low-key way of soliciting business.

That's one small step for man, one giant leap for mankind.
Neil Armstrong

We must join forces in the Great Leap Forward.
Mao Tse-tung

Leapin' Lizzards!
Little Orphan Annie

Happy Leap Year!
Sheaff Dorman Purins
sheaff@tiac.net

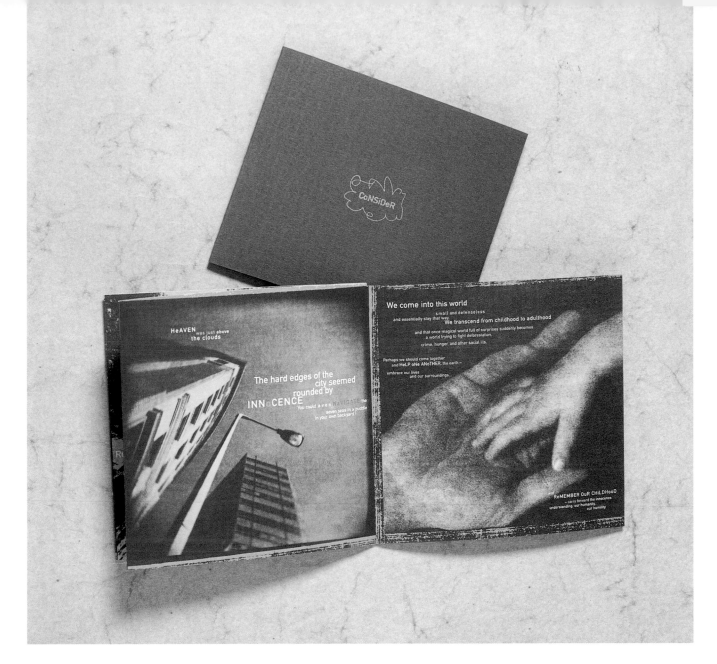

Design Firm **Stewart Monderer Design, Inc.**
Art Director **Stewart Monderer**
Designer **Aime Lecusay**
Photographer **Keller and Keller**
Purpose or Occasion **Self-promotion**
Paper/Printing **Gilbert Esse, textured finish**
Number of Colors **Three match colors over one match color**

The objective was invite readers to embrace the sentiment expressed within the brochure. The hope is that the brochure will help readers interpret their lives and their relationship to the world as they once did from "a child's perspective." Production was done in QuarkXPress, Adobe Illustrator, and Adobe Photoshop.

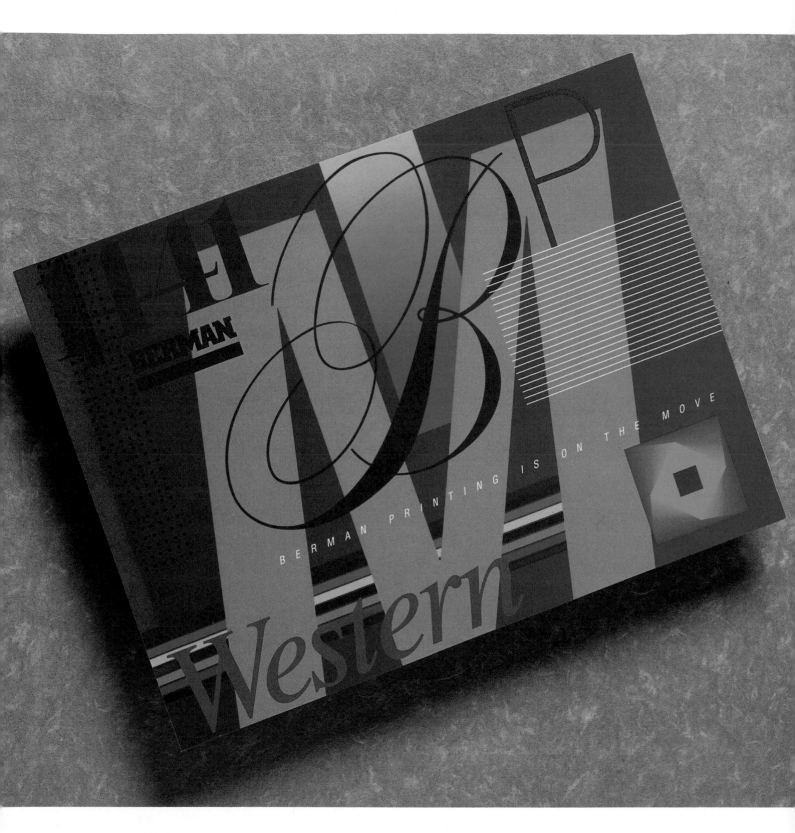

Design Firm **Wood/Brod Design**
All Design **Stan Brod**
Client **Berman Printing Co.**
Purpose or Occasion **Moving announcement**
Paper/Printing **Kromekote/Offset**
Number of Colors **Four**

This moving announcement was designed to inform current clients of Berman's
services and their move to a new location. Use of new technology and current
excellence in printing is also demonstrated.

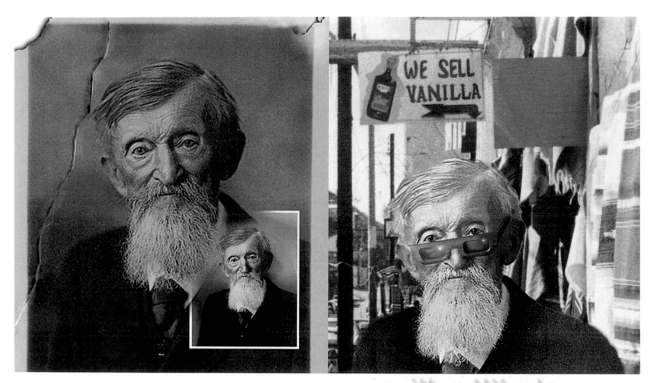

Photo Restoration . . . **with attitude.**

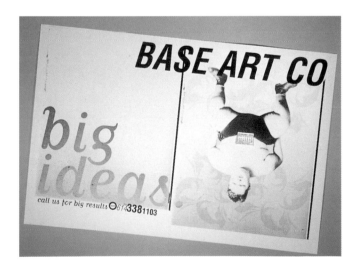

△

Design Firm **Gardner Graphics**
Designer **Dianne Gardner**
Purpose or Occasion **Self-promotion**
Number of Colors **Four**

The postcard was designed as a self-promotional tool for photo-restoration work. The designer used Adobe Photoshop, 3D Studio, and Adobe PageMaker.

◁

Design Firm **Base Art Company**
Art Director/Designer **Terry Alan Rohrbach**
Purpose or Occasion **Self-promotional calendar**
Paper/Printing **Sepia print**

A large sepia print was output from 100 dpi film. Surplus promotional calendars were then tipped on to the image. This enabled an efficient means to promote Base Art Company with minimal investment. The calendars were sent out with introductory letters to prospective and existing clients. Adobe Photoshop and Macromedia FreeHand were used to create this piece.

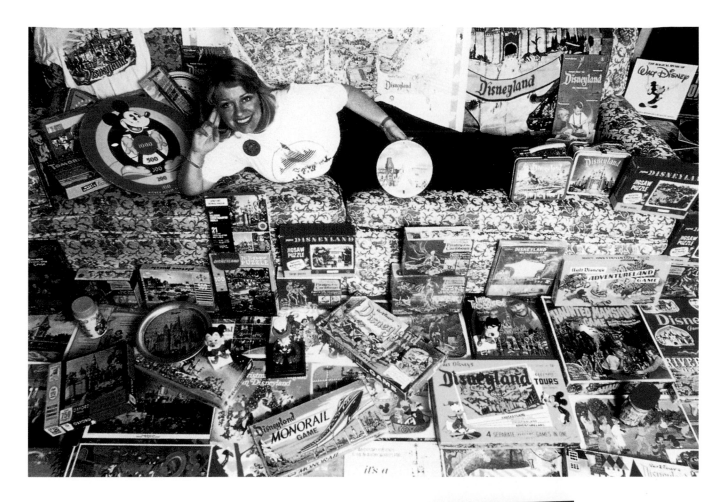

Δ
Design Firm **Cervon Ent.**
Designer **L. Cervon**
Purpose or Occasion **Self-Promotion**

The image is of the designer with part of a collection of Disneyland souvenirs and memorabilia. It is used to advertise the designer's mail order collectibles business.

▷
Design Firm **Manley Design**
All Design **Don Manley**
Purpose or Occasion **Self-promotion**
Paper/Printing **Neenah Classic Crest/Peppercorn Printing**
Number of Colors **Four**

The designer's self-promotional pieces are humorous, light-hearted, and often incorporate personal artifacts.

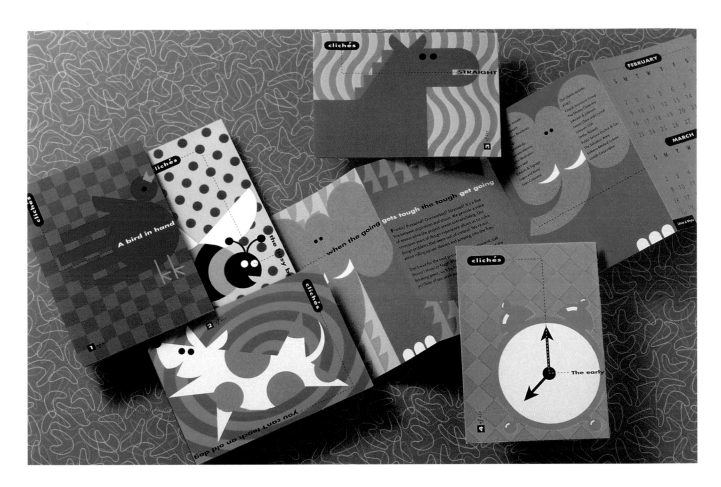

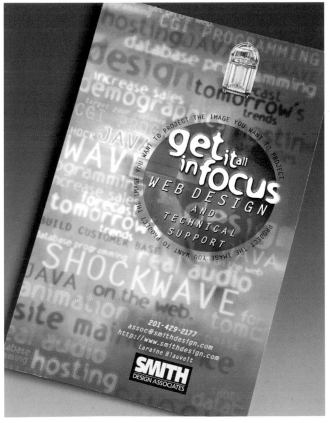

△

Design Firm **Lehner & Whyte**
Art Directors/Designers **Donna Lehner, Hugh Whyte**
Illustrator **Hugh Whyte**
Purpose or Occasion **Self-promotion**
Paper/Printing **G. J. Haerer Co.**
Number of Colors **Four**

This bi-monthly calendar was mailed to clients and potential clients. The theme was clichés, shown in a illustrative design style over backgrounds created in Adobe Illustrator. Photographic backgrounds were used for overall textures. The piece was created in Adobe Photoshop and QuarkXPress.

◁

Design Firm **Smith Design Associates**
Art Director **Martha Gelber**
Designer **Eileen Berezni**
Illustrator **Dwight Adams**
Purpose or Promotion **Self-promotion**
Paper/Printing **Coated 80 lb. cover**
Number of Colors **Four**

The objective was to create a postcard promoting the design firm's services for Web design. The unfocused image in the background represents the feelings of many people concerning the deluge of new technology and terminology facing them daily. The concept is that Smith Design Associates can "get it all in focus" from design to technical support, and will help businesses project the image they want on the Web. The jukebox image ties into the Website and the decor of the firm.

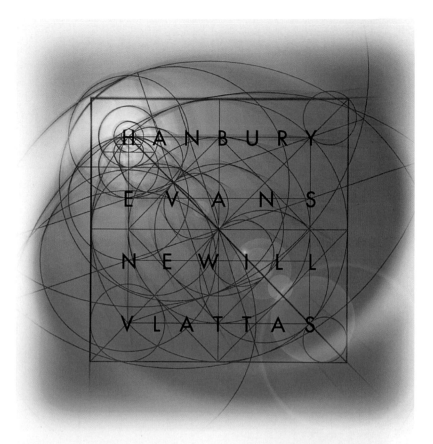

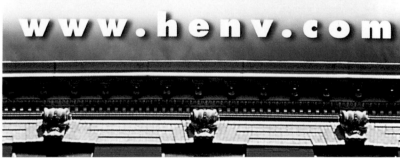

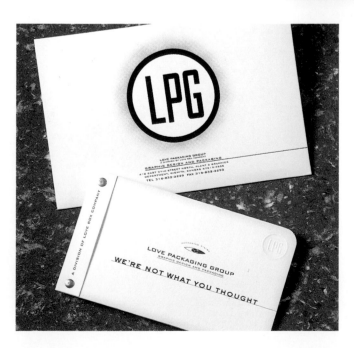

△
Design Firm **Hanbury Evans Newill Viattas Architects**
All Design **Chip Taylor**
Purpose or Occasion **WWW site announcement**
Paper/Printing **Card stock**
Number of Colors **Four**

The postcard design concept was to develop a compelling graphic that would lead current and potential clients to the firm's new Website. Adobe Illustrator and Adobe Photoshop were used to place the firm's logo in the sky above its office.

◁
Design Firm **Love Packaging Group**
All Design **Brian Miller**
Purpose or Occasion **Self-promotion**
Paper/Printing **Gilbert, Esse/Rand Graphics, Inc., litho, screen-printed**
Number of Colors **Two**

The piece spells out the services of LPG in a way that is straightforward, yet uniquely subtle. Layout was done in Macromedia FreeHand, where background words were warped with Perspective, 3-D, and Envelope tools. These words were brought into Adobe Photoshop where subtle gradients were applied so that just enough of each word is discernible. The piece is mailed in a Stay-Flat container from Calumet Carton Co. that was screen-printed in the same two colors as the booklet.

Identity crisis? A graphic identifier is the visual expression of the essence of an organization.

Please call to see a portfolio of our graphic communications tailored to your needs.

Toni Schowalter Design Tel 212 727 0072 Fax 212 727 0071

From left: HMA, executive search company ; Easy Link, computer mailbox; Zetek, fire control symbol; Star, a newsletter masthead; MWI, Marshall Watson Interiors.

Image differentiation.

Includes a variety of elements working together to create a singular, impactful, and memorable impression.

Please call to see a portfolio of our graphic communications tailored to your needs.

Toni Schowalter Design Tel 212 727 0072 Fax 212 727 0071

From left: Symbol for flexible savings; Judy Freedman, yoga instructor; Symbol for telephone access; Interior Business Furniture Group; SAGE, financial investments; Junior League logotype.

What's in a name?

A good name provides the foundation from which to build a unique and successful identity.

Please call to see a portfolio of our graphic communications tailored to your needs.

Toni Schowalter Design Tel 212 727 0072 Fax 212 727 0071

From left: Spirulina, Cosmetic Brand; FocalPoint, a newsletter; Rare Wine Auction; Vitamin Works, a retail store; Fun Works, a Johnson & Johnson's employee committee.

Graphic Identifier. The unique visual characteristics that set one company apart from another.

Please call to see a portfolio of our graphic communications tailored to your needs.

Toni Schowalter Design Tel 212 727 0072 Fax 212 727 0071

From left: MorseDiesel, construction management ; CFI, furniture dealer; IAWCR, proposed logo; HealthShare, employee newsletter for Nabisco Brands; Spirulina, proposed cosmetics logo; Paddlemania, Beacon Hill Club event.

Design Firm **Toni Schowalter Design**
Art Director/Designer **Toni Schowalter**
Purpose or Occasion **Self-promotional mailing**
Paper/Printing **Kromekote 10 pt. cast coated**
Number of Colors **Two PMS**

A series of four cards was created and mailed to existing and potential clients
of the design firm. The objective was for the recipient to evaluate their current
image and call the firm for design help.

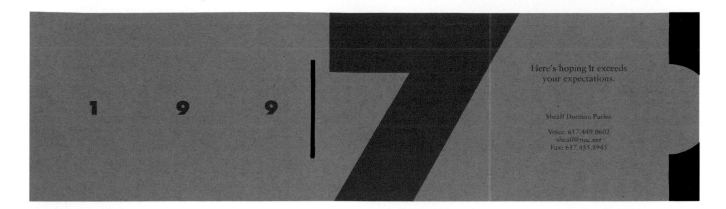

Here's hoping it exceeds
your expectations.

Sheaff Dorman Purins

Voice: 617.449.0602
sheaff@tiac.net
Fax: 617.455.8945

△

Design Firm **Sheaff Dorman Purins**
Art Director **Uldis Purins**
Purpose or Occasion **New Year's greeting**
Number of Colors **Three**

Sheaff Dorman Purins sends out a New Year's card to friends and clients every
year. Its main purpose is to convey greetings, but since the phone number is on
the card, many people call back to say thanks, which often starts a conversation.
It is a low-key way of soliciting business.

Do you believe in love at first sight?

Great.

When can we show you
our latest portfolio?

Happy Valentine's Day
from the people
you'll love to work with!

Sheaff Dorman Purins
Strategic Thinking and Design

Voice: 617.449.0602
sheaff@tiac.net
Fax: 617.455.8945

△

Design Firm **Sheaff Dorman Purins**
Art Director/Designer **Uldis Purins**
Purpose or Occasion **Valentine's Day**
Number of Colors **Two**

Sheaff Dorman Purins produces these cards monthly, sending them out to friends
and clients, conveying greetings and subtly soliciting new business.

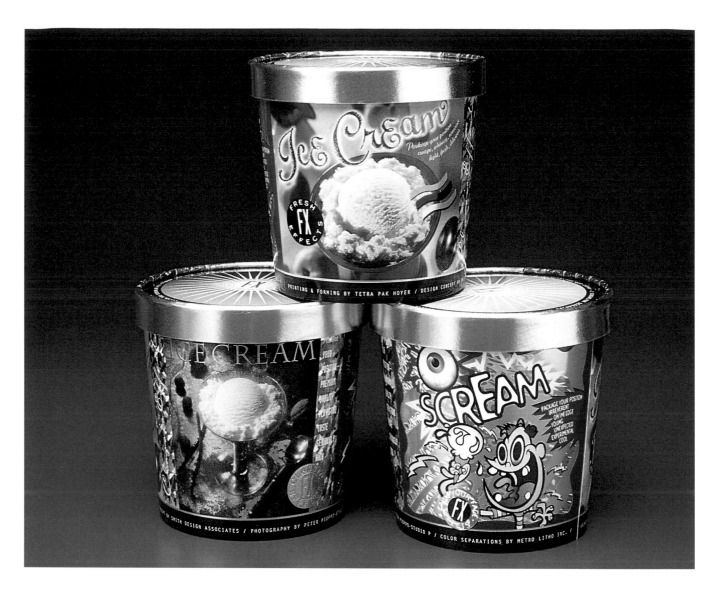

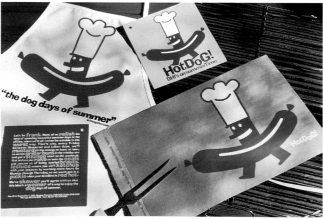

Δ
Design Firm **Smith Design Associates**
Art Director **Laraine Blauvelt**
Designers **Carol Konkowski, Eileen Berezni**
Illustrator **Jeff Jarka**
Purpose or Promotion **Self-promotion**
Paper/Printing **LDPE Clay Coated Stock/Hot stamps**
Number of Colors **Four**

The objective was to design a self-promotional ice-cream container that takes hot-stamped special effects to the extreme. Three face panels were developed to target different consumer groups: children, families, and adults. This was achieved through the use of appropriately themed foils, embossings, holographs, photography, and illustration.

Δ
Design Firm **DHI (Design Horizons International)**
All Design **Mike Schacherer**
Purpose or Occasion **Self-promotion**
Number of Colors **Two PMS plus black**

"Hot Dog!" was the theme used for a summer self-promotion.

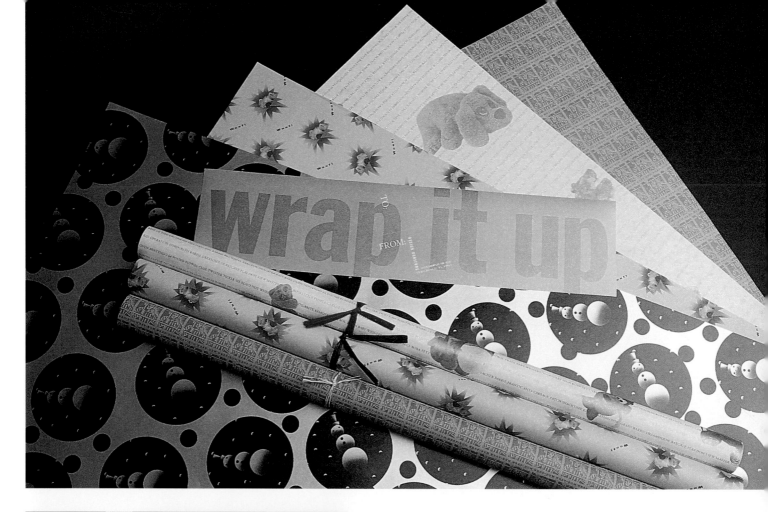

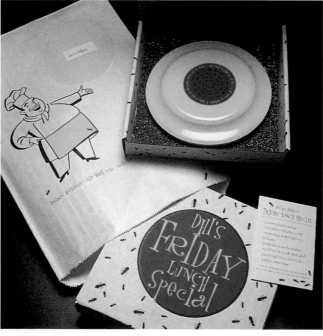

Δ
Design Firm **DHI (Design Horizons International)**
Art Director **Kim Reynolds**
Designers **Kim Reynolds, Mike Schacherer**
Illustrator **Krista Ferdinand**
Purpose or Occasion **Holiday self-promotion**
Number of Colors **Two**

The designers named this holiday self-promotion, "Wrapping Paper."

Δ
Design Firm **DHI (Design Horizons International)**
Art Director/Designer **Victoria Huang**
Purpose or Occasion **Self-promotion**
Number of Colors **Three PMS**

This summer self-promotional piece is titled, "DHI Friday Lunch Special."

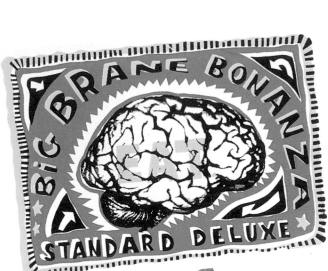

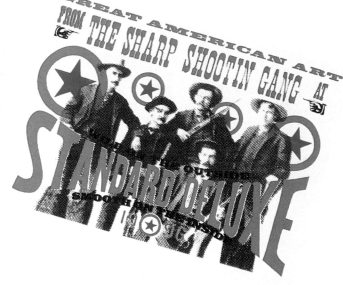

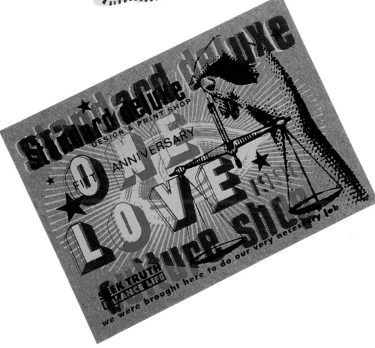

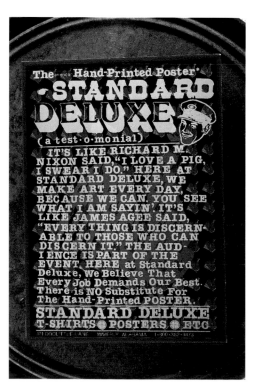

Δ

Design Firm **Standard Deluxe, Inc.**
Art Director **Scott Peek**
Designer **Andrew Cost, Kevin Bradley, Scott Peek**
Purpose or Occasion **Self-promotion**
Paper/Printing **Board/Hand silk-screened**
Number of Colors **Three to four**

The handmade mechanical separations were hand silk-screened in a day by three designers.

▷

Design Firm **Standard Deluxe, Inc.**
Designer **Kevin Bradley**
Purpose or Occasion **Self-promotional poster**
Paper/Printing **Chipboard/hand silk-screened**
Number of Colors **Four**

Each letter was press-type individually by hand. The background was created with the computer.

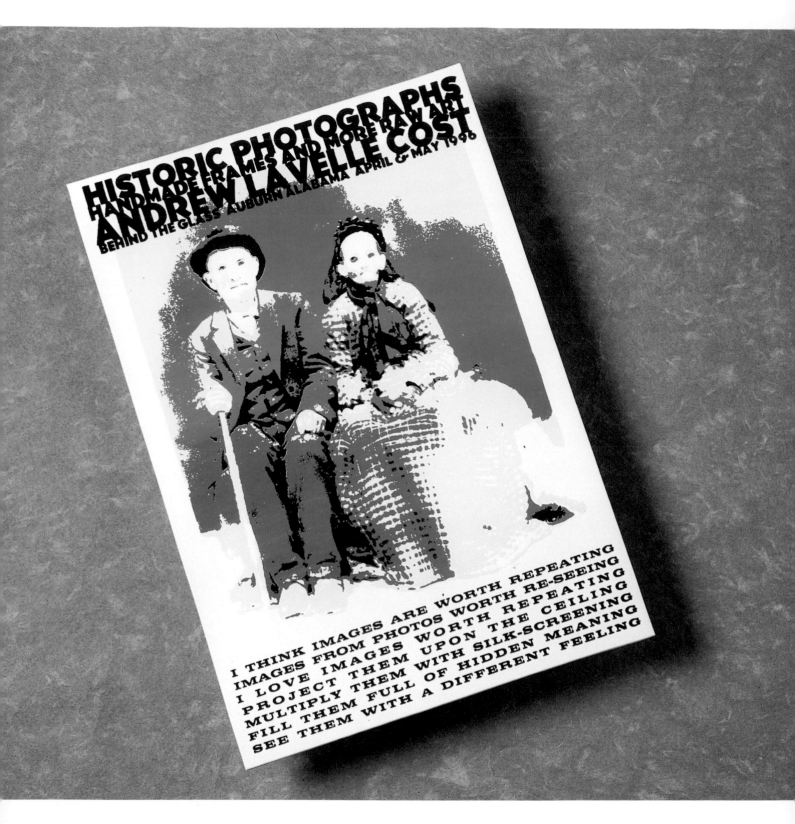

Design Firm **Standard Deluxe, Inc.**
Designer/Illustrator **Andrew Cost**
Purpose or Occasion **Self-promotional poster**
Paper/Printing **Hand silk-screened**
Number of Colors **Three**

The image was created with posterized separations of an antique photo using
Adobe Illustrator; the typesetting was done in Illustrator also. Each flyer was
unique due to the manipulation of inks while printing. A variety of papers were
used as well.

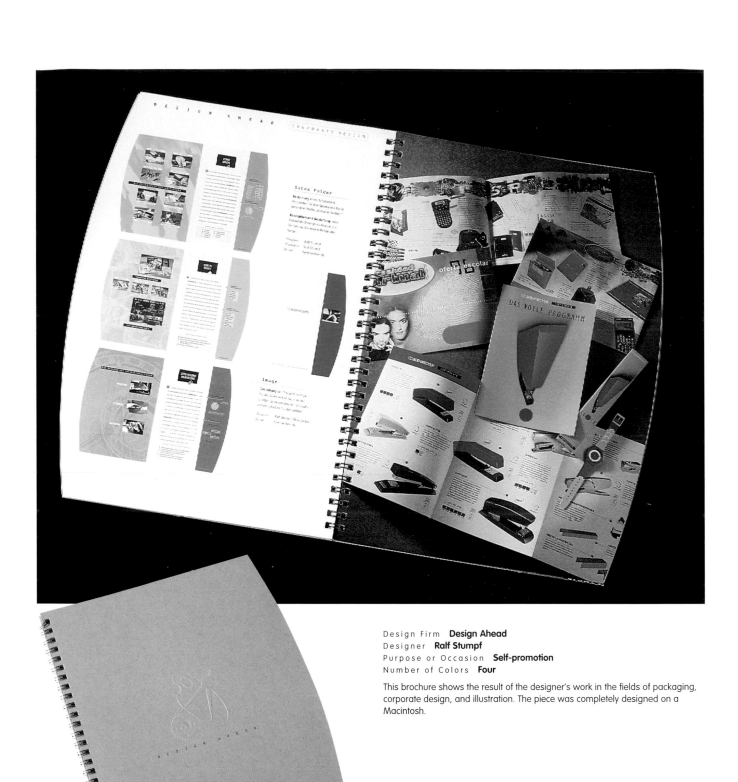

Design Firm **Design Ahead**
Designer **Ralf Stumpf**
Purpose or Occasion **Self-promotion**
Number of Colors **Four**

This brochure shows the result of the designer's work in the fields of packaging, corporate design, and illustration. The piece was completely designed on a Macintosh.

Design Firm **Webster Design Associates, Inc.**
Art Director/Designer **Dave Webster**
Typography **Dave Webster**
Client **Webster Design Associates**
Purpose or Occasion **Holiday mailing**
Paper or Printing **French Speckletone**
Number of Colors **Two**

The name "OutofaJam" was inspired by puns and wordplay associated with the product, and the idea that getting clients out of graphic quandaries is the design firm's function. The firm frequently uses this method in promotion and mailings: making connections between product and copy that are unique, humorous, and attention grabbing.

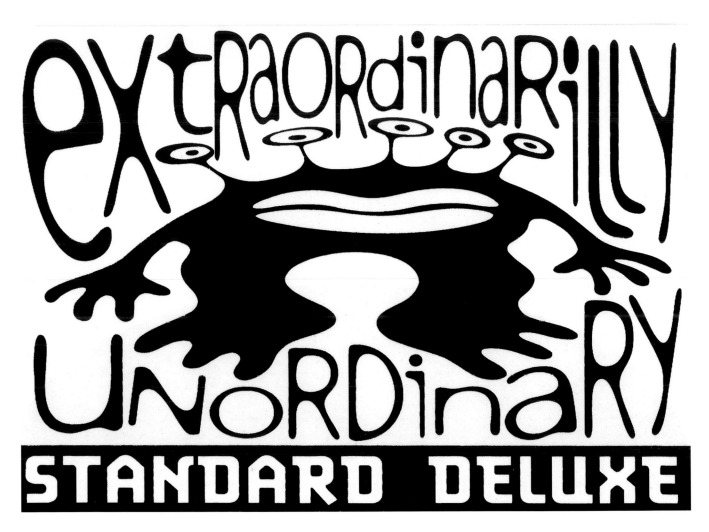

Design Firm **Standard Deluxe, Inc.**
Designer/Illustrator **Andrew Cost**
Purpose or Occasion **Promotional**
Paper/Printing **Hand silk-screened**
Number of Colors **Two**

Manipulation of type for this piece was done in Adobe Illustrator. Original artwork
of an alien was scanned into Adobe Photoshop, streamlined, and then
manipulated in Adobe Illustrator.

Design Firm **Animus Communicacao**
Art Director **Rique Nitzsche**
Designer **Victal Caesar**
Purpose or Occasion **First direct mail of 1997**
Number of Colors **Four**

The text on the back of the card says that Animus can change the corporate image of their clients.

SERVICE DESIGN PROMOTION

A COLLECTION OF SERVICE ADVERTISING
PIECES DESIGNED TO INSPIRE

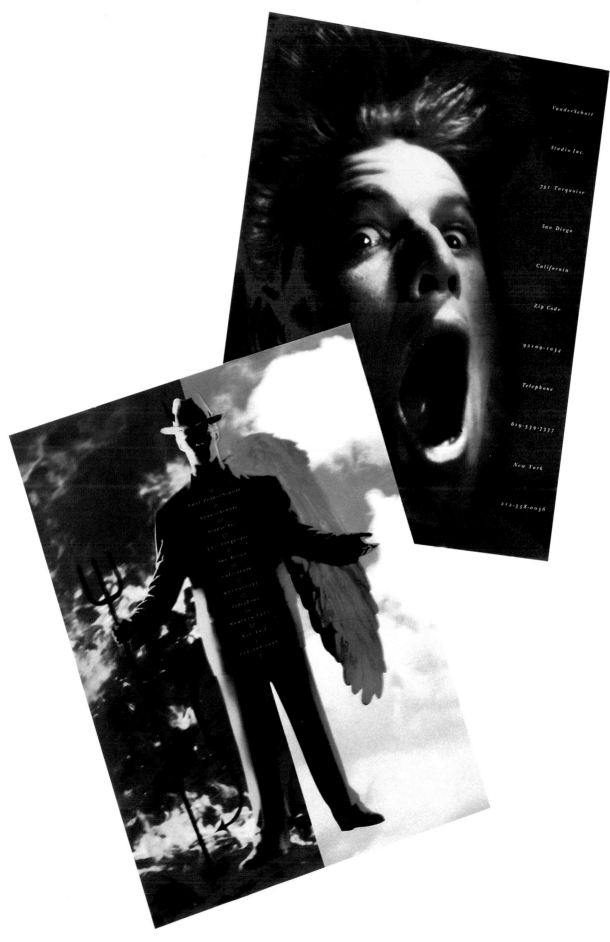

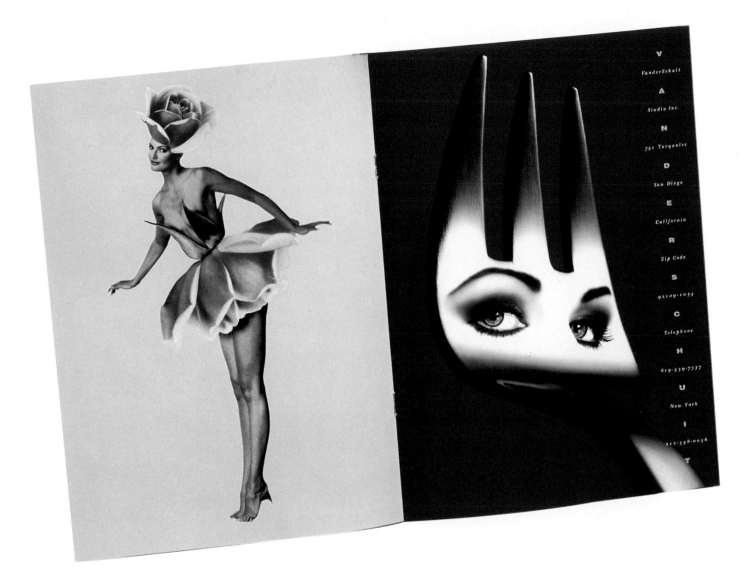

◁ △
Design Firm **Mires Design**
Art Director **Jose Serrano**
Designers **Jose Serrano, Eric Freedman**
Photographer **Carl Vanderschuit**
Client **Vanderschuit Photography**
Purpose or Occasion **Announcement of new photography style**
Number of Colors **Four**

The purpose of this mailer was to showcase a new style of photography in a fresh way without too much copy. This way, the visuals were able to speak for themselves.

△
Design Firm **Held Diedrich**
Art Director **Doug Diedrich**
Designer **Megan Snow**
Client **Virtual Meeting Strategies**
Purpose or Occasion **Newsletter**
Number of Colors **Two**

The client was looking for a template that would allow them to imprint newsletters throughout the year without incurring two-color costs. The piece needed to include a fax-back form. Creative folding and proper paper selection allowed the client to achieve this. This self-mailer was created in Adobe Illustrator with the client logowork as an imported graphic.

▷
Design Firm **Held Diedrich**
Art Director **Doug Diedrich**
Designer/Illustrator **Jeff Wiggington**
Client **BMH Health Strategies**
Purpose or Occasion **Direct-mail campaign**
Number of Colors **Two**

The direct-mail campaign was targeted to a variety of audiences. Thematically, the piece kept a familiar look with previously printed materials. Adobe Illustrator was used to create the print image. The photos were PhotoCD-format images that we converted through Adobe Photoshop to duotones. The designer utilized QuarkXPress to create the final electronic file.

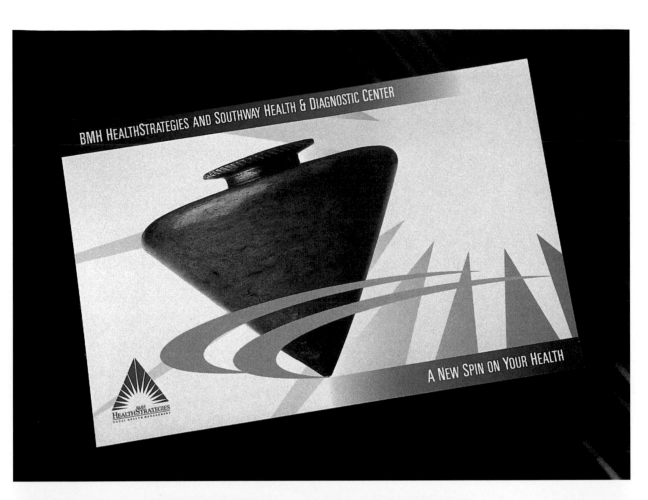

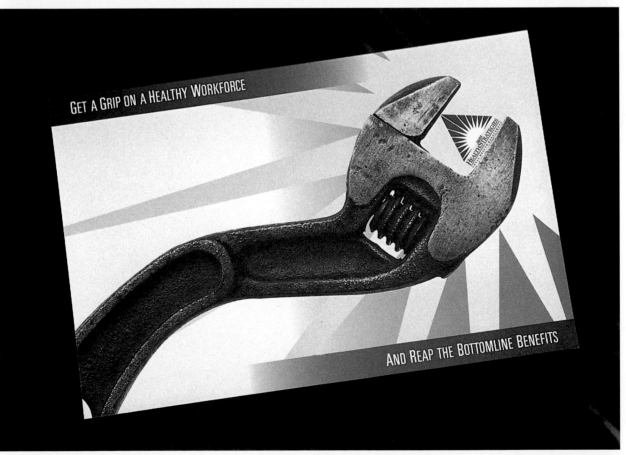

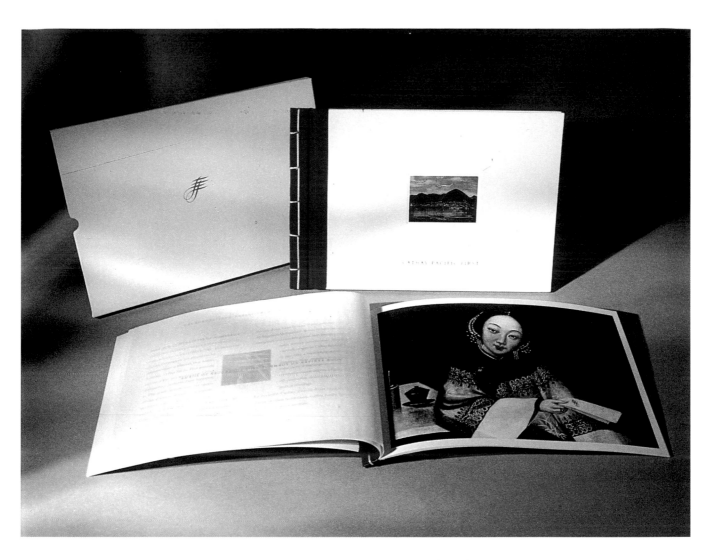

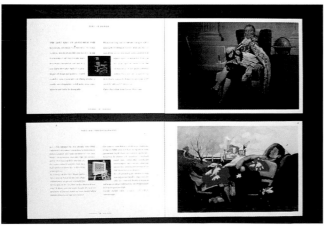

Design Firm **The Design Group—Leo Burnett**
Art Director **Stefan Sagmeister**
Designers **Peter Rae, Patrick Daily**
Illustrator **Steven Haag**
Client **Cathay Pacific**
Purpose or Occasion **First class promotion**
Paper/Printing **Offset, foil stamping**
Number of Colors **Six**

Brochure promoting the new, first class service on Cathay Pacific, Hong Kong's airline. Several special offers were included with the brochure.

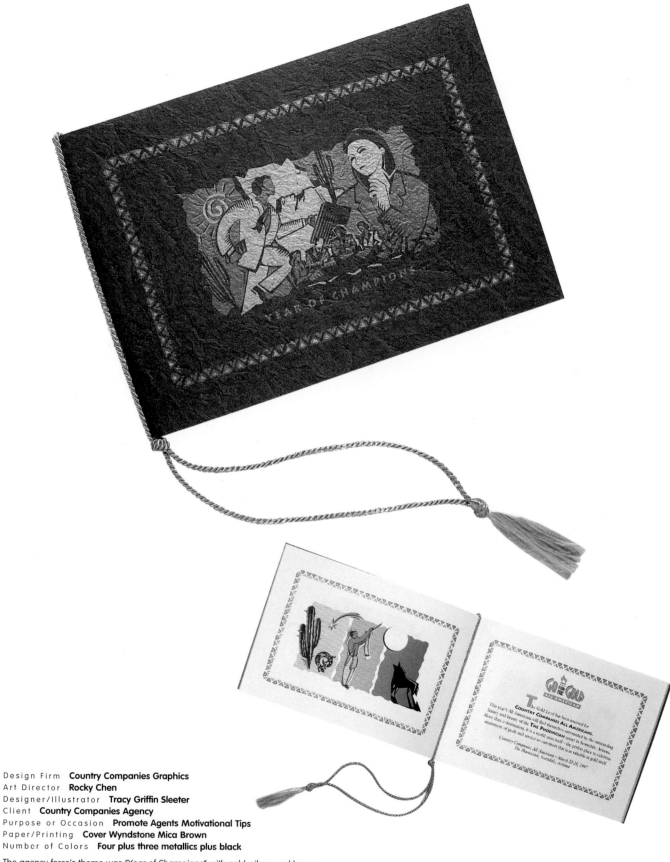

Design Firm **Country Companies Graphics**
Art Director **Rocky Chen**
Designer/Illustrator **Tracy Griffin Sleeter**
Client **Country Companies Agency**
Purpose or Occasion **Promote Agents Motivational Tips**
Paper/Printing **Cover Wyndstone Mica Brown**
Number of Colors **Four plus three metallics plus black**

The agency force's theme was "Year of Champions" with gold, silver, and bronze chosen as the year's colors. The promotional piece highlighted three different contests with different rip destinations. The interior illustrations supported the trips, while the cover illustration served to promote the agency force.

◁
Design Firm **Aerial**
Art Director/Designer **Tracy Moon**
Photographer **R. J. Muna**
Client **Aureole**
Purpose or Occasion **Seventh anniversary poster**
Paper/Printing **Letterpress**
Number of Colors **Four**

A limited-edition letterpress print and portfolio was sent to top patrons of Aureole, a four-star Manhattan restaurant, to commemorate the restaurant's seventh anniversary. The print features a digitally composed goddess-of-plenty image that was separated and printed via letterpress along with a poem by Byron.

▽
Design Firm **Julia Tam Design**
Art Director/Designer **Julia Chong Tam**
Client **Burdge, Inc.**
Purpose or Occasion **Sales brochure**
Number of Colors **Three**

The client, a classic, elegant engraver, came to Julia Tam Design after a previous failure with another designer. The existing photography had to be used, but the design was completely original. The result was warm and classy, and brought out the characteristics of the printer.

Design Firm **Aerial**
Art Director/Designer **Tracy Moon**
Illustrators **Tracy Moon, Clay Kilgore**
Client **Alva**
Purpose or Occasion **Direct-mail promotion**
Paper/Printing **Transparency, glassine envelope**
Number of Colors **Four plus one**

This direct-mail piece for a Soho bistro, Alva, has a
lightbulb theme inspired by Thomas Alva Edison. In order
to inform patrons that the restaurant served from noon to
midnight, an original lightbulb transparency was sent,
complete with attached on/off pull chain.

Design Firm **Becker Design**
Art Director/Designer **Neil Becker**
Client **Charlton Photos, Inc.**
Purpose or Occasion **Postcard series**
Paper/Printing **Copyfast Printing Co.**
Number of Colors **Four**

This series of postcards was created to introduce Charlton Photos Website.
Charlton specializes in agricultural stock and assignment photography and video.

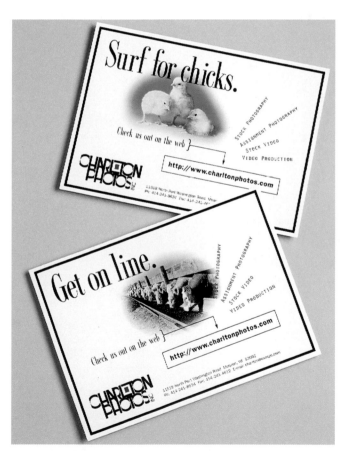
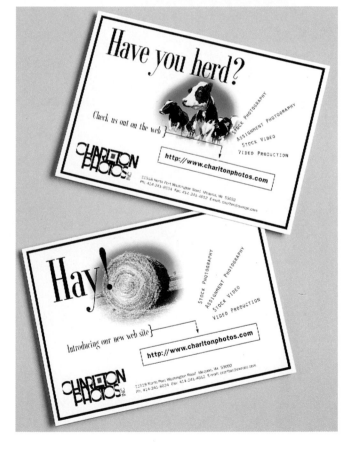

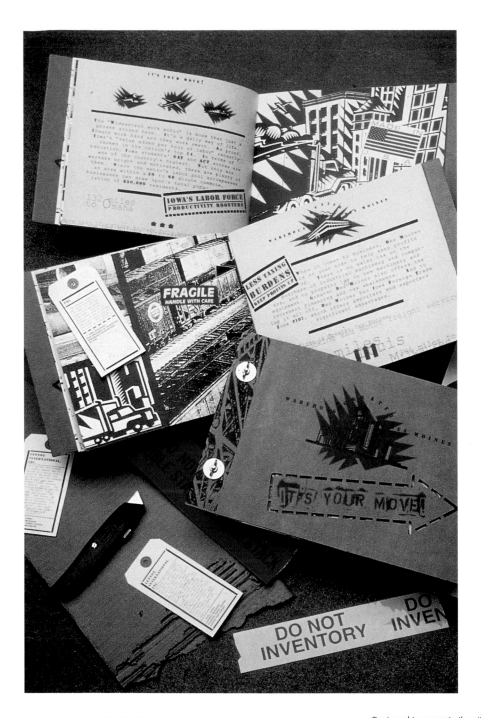

Design Firm **Sayles Graphic Design**
Art Director **John Sayles**
Designers **John Sayles, Jennifer Elliott**
Illustrator **John Sayles**
Client **Greater Des Moines Chamber of Commerce**
Purpose or Occasion **Informational Brochure**
Paper/Printing **Manila tag, Curtis Tuscan Terra, corrugated/Offset, screen-printed**
Number of Colors **Two**

Designed to promote the city's warehouse and distribution potential, the brochure has a corrugated cardboard cover that is bound with bolts and wing nuts. A die-cut arrow surrounds type that tells the recipient that "It's Your Move," while reinforcing the "industrial warehouse" look of the mailing. Inside the brochure, grainy photographs and Sayles' original illustrations are reproduced on manila tagboard. Each spread in the brochure features a colorful label with a different warehousing message. Manila shipping tags are tipped in, featuring different testimonials from different warehouse-company executives. A perforated reply card is also included. The mailer is held closed with "Do Not Inventory" box tape.

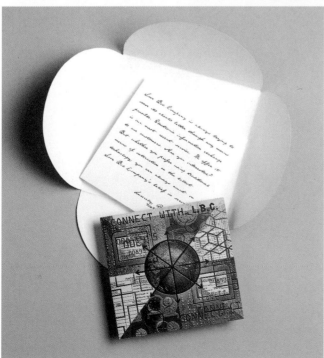

Design Firm **Love Packaging Group**
All Design **Tracy Holdeman**
Client **Love Box Company**
Purpose or Occasion **Promote E.D.I. Computer Services**
Number of Colors **Four**

This piece visually describes the process of tracking client inventories by computer remote; a feature desirable to the client but visually uninspiring. Tracy Holdeman created an interesting and informative piece in Adobe Photoshop and Macromedia FreeHand that can be mailed to prospective clients or handed out by sales representatives as a sales tool.

A REAL BREAKTHROUGH IN COMMUNICATIONS WITH **WEBCALL**™

A true communication breakthrough, by definition, should be a seamless connection...a two-way, free-flowing dialogue. Now you can offer your customers websites that make this valuable **connection** between **real people**. After all, when a customer can speak to a real person without an insulting, infuriating wait, that makes a **real difference**.

Spanlink Communications provides solutions that link telephones, computers and the Internet. We have broken down the barriers that have restricted your person-to-person website communication offerings to an 800 number or e-mail. Spanlink introduces the most **convenient and effective** way for your website customers to provide a direct and intelligent connection to real sales and service representatives. **WebCall**.

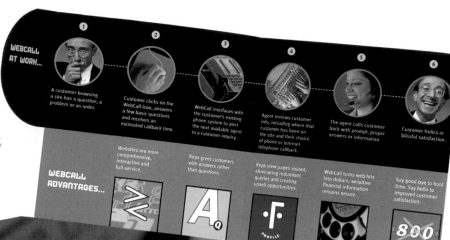

WEBCALL AT WORK...

1. A customer browsing a site has a question, a problem or an order.
2. Customer clicks on the WebCall icon, answers a few basic questions and receives an estimated callback time.
3. WebCall interfaces with the customer's existing phone system to alert the next available agent to a customer inquiry.
4. Agent reviews customer info, including where that customer has been on the site and their choice of phone or Internet telephone callback.
5. The agent calls customer back with prompt, proper answers or information.
6. Customer frolics in blissful satisfaction.

WEBCALL ADVANTAGES...

- Websites are more comprehensive, interactive and full-service.
- Reps greet customers with answers rather than questions.
- Reps view pages visited, eliminating redundant queries and creating upsell opportunities.
- WebCall turns web hits into dollars; sensitive financial information remains secure.
- Say good-bye to hold time. Say hello to improved customer satisfaction.

Your WEBSITES can now make PHONES RINGING

"Hello"

Design Firm **Larsen Design + Interactive**
Art Directors **Tim Larsen, Gayle Jorgens**
Designers **Sascha Boecker, Zmark Kundmann, Ellen Huber**
Illustrator **Sascha Boecker**
Client **Spanlink**
Paper/Printing **Vintage 100 lb. cover/Heartland Graphics**
Number of Colors **Four plus one PMS**

Spanlink's WebCall direct-response marketing piece informs customers of the WebCall feature that can be added to a company's Website allowing them to request a telephone call-back from a sales-and-service representative. The return portion of the piece persuades customers to join the Spanlink Developer Partnership Program, receiving free WebCall service for their Website. With the use of photos, graphics, bulleted points and instructions, the piece effectively informs customers of the advantages of WebCall and how it works.

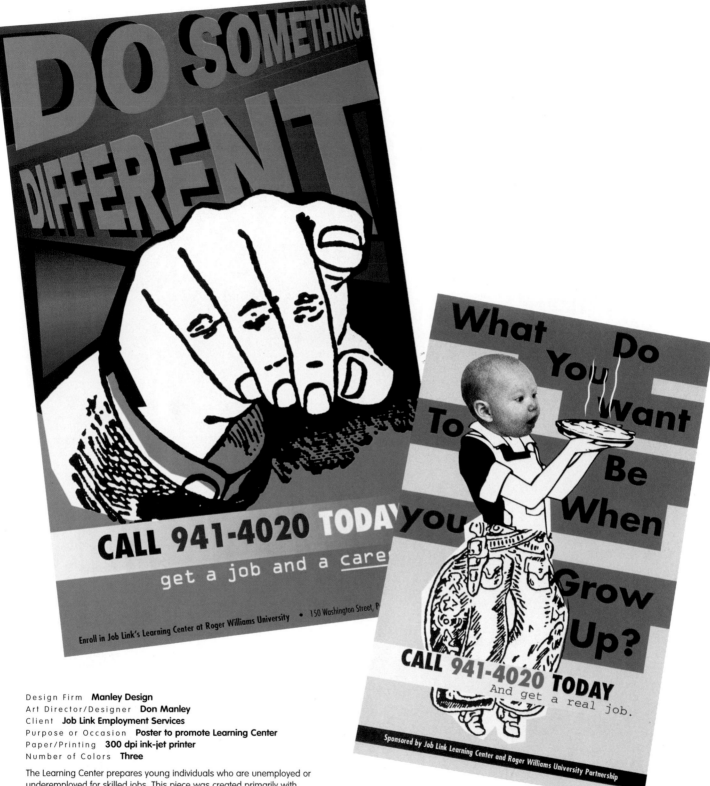

Design Firm **Manley Design**
Art Director/Designer **Don Manley**
Client **Job Link Employment Services**
Purpose or Occasion **Poster to promote Learning Center**
Paper/Printing **300 dpi ink-jet printer**
Number of Colors **Three**

The Learning Center prepares young individuals who are unemployed or underemployed for skilled jobs. This piece was created primarily with QuarkXPress and Adobe Photoshop.

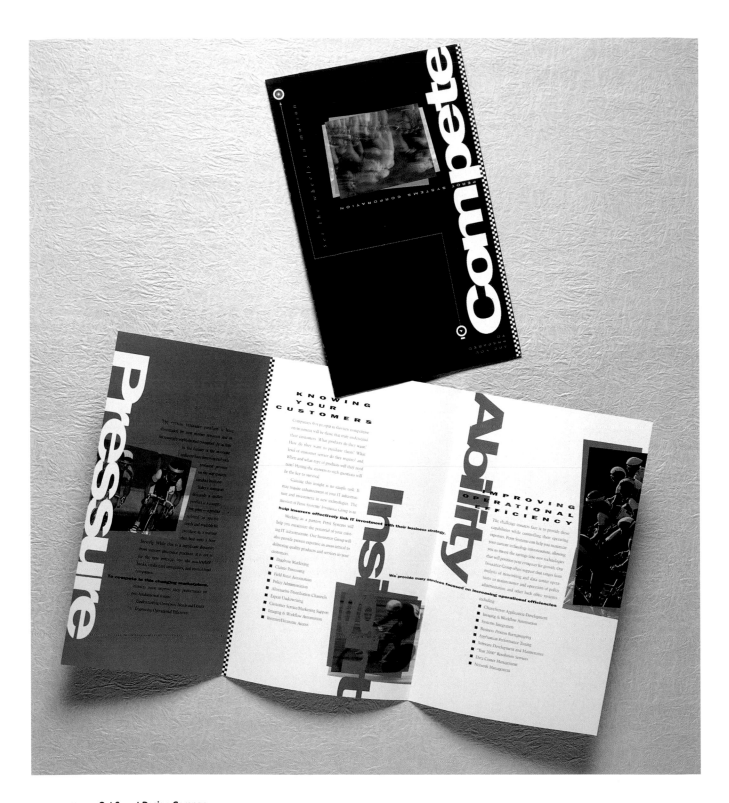

Design Firm **Get Smart Design Company**
Art Director **Jeff MacFarlane**
Designer **Tom Culbertson**
Client **Perot Systems**
Purpose or Occasion **Insurance Group**
Paper/Printing **Union-Hoermann Press**
Number of Colors **Three**

The piece is targeted towards leading insurance companies. The purpose is to inform them of the need for competitive insurance systems. The sport motif was used because of its universal acceptance and because it graphically illustrates the four key features of the brochure: competition, pressure, insight and ability. The piece was assembled using QuarkXPress.

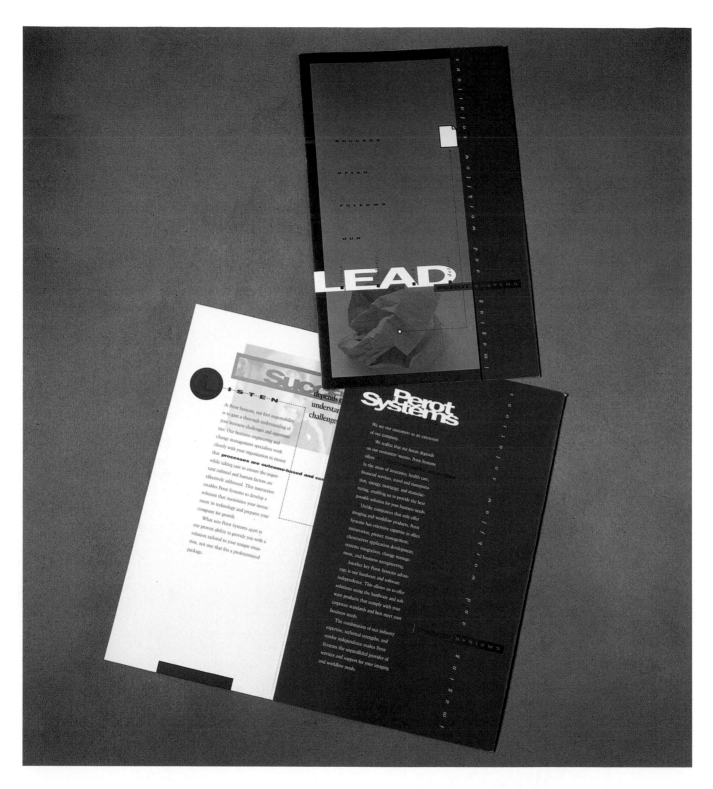

Design Firm **Get Smart Design Company**
Art Director/Designer **Jeff MacFarlane**
Client **Perot Systems**
Paper/Printing **Union-Hoermann Press**
Number of Colors **Three**

The purpose of this piece is to illustrate that Perot Systems offers imaging and workflow solutions. The LEAD concept was developed to make the customers aware that Perot Systems leads the way, and by using the LEAD concept the customer can also lead the industry. The piece was assembled using QuarkXPress.

Design Firm **Clifford Selbert Design Collaborative**
Art Director **Robert Merk**
Designers **Robert Merk, Tony Dowers, Julia Sedykh**
Illustrator **Tom Christopher**
Client **Mount Holyoke College, Office of Admissions**
Purpose or Occasion **Improve and expand the college's existing viewbook**
Paper/Printing **J. C. Otto**
Number of Colors **Up to six per piece**

The design firm created an expanded version of the college's existing viewbook that graphically differentiates itself from its competition and increases awareness of the college. It also promoted name recognition and presents the college to prospective students and their parents in a unique and memorable way.

LINCOLN COLLEGE

LINCOLN COLLEGE, TWO CAMPUSES, TWO ATMOSPHERES

Unlock Your Future

Design Firm **Tracy Griffin Sleeter**
Art Director **Kathy Luedke**
Designer/Illustrator **Tracy Griffin Sleeter**
Client **Lincoln College**
Purpose or Occasion **Promote both college campuses**
Paper/Printing **Four and two**

The cover shows the university's diverse student population and promotes both campuses with the tagline "Lincoln College—two campuses, two atmospheres." The piece had a limited budget, included a great deal of information, and contained a business-reply card.

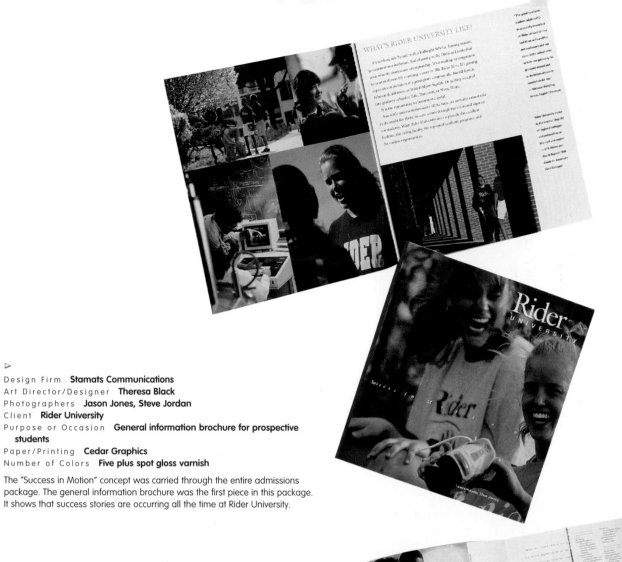

▷
Design Firm **Stamats Communications**
Art Director/Designer **Theresa Black**
Photographers **Jason Jones, Steve Jordan**
Client **Rider University**
Purpose or Occasion **General information brochure for prospective students**
Paper/Printing **Cedar Graphics**
Number of Colors **Five plus spot gloss varnish**

The "Success in Motion" concept was carried through the entire admissions package. The general information brochure was the first piece in this package. It shows that success stories are occurring all the time at Rider University.

▷
Design Firm **Stamats Communications**
Art Director/Designer **Theresa Black**
Photographer **Jason Jones**
Client **Point Park College**
Purpose or Occasion **General information brochure for prospective students**
Paper/Printing **Productolith Dull/Cedar Graphics**
Number of Colors **Five**

The "Energy of Tomorrow" concept is carried out through the use of bright two-color photos juxtaposed with engaging four-color photos and copy that is visually synchronized with these images.

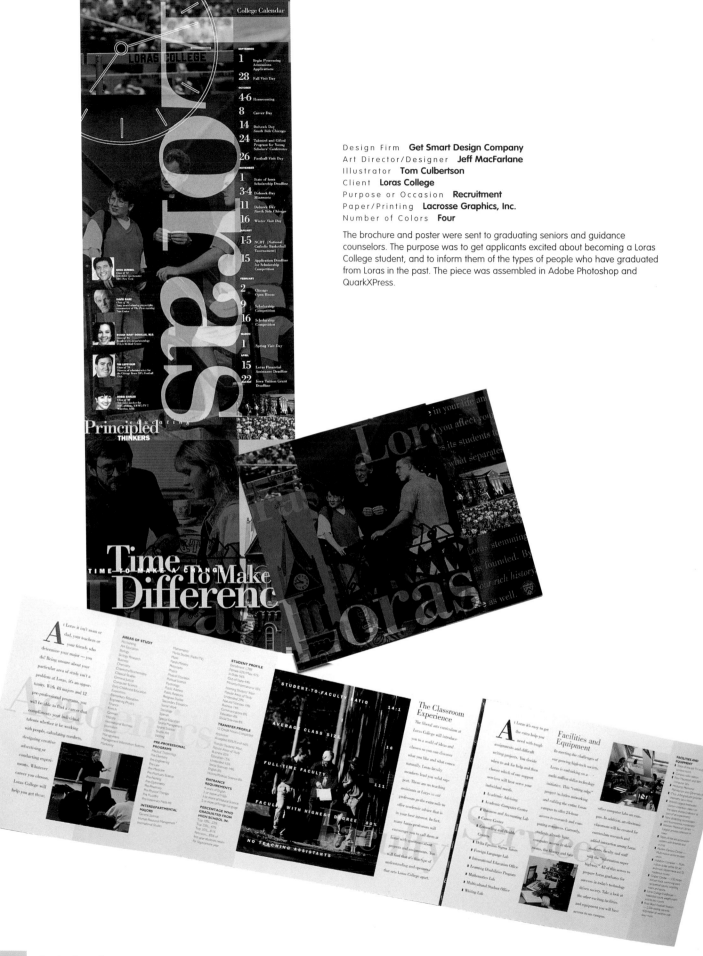

Design Firm **Get Smart Design Company**
Art Director/Designer **Jeff MacFarlane**
Illustrator **Tom Culbertson**
Client **Loras College**
Purpose or Occasion **Recruitment**
Paper/Printing **Lacrosse Graphics, Inc.**
Number of Colors **Four**

The brochure and poster were sent to graduating seniors and guidance counselors. The purpose was to get applicants excited about becoming a Loras College student, and to inform them of the types of people who have graduated from Loras in the past. The piece was assembled in Adobe Photoshop and QuarkXPress.

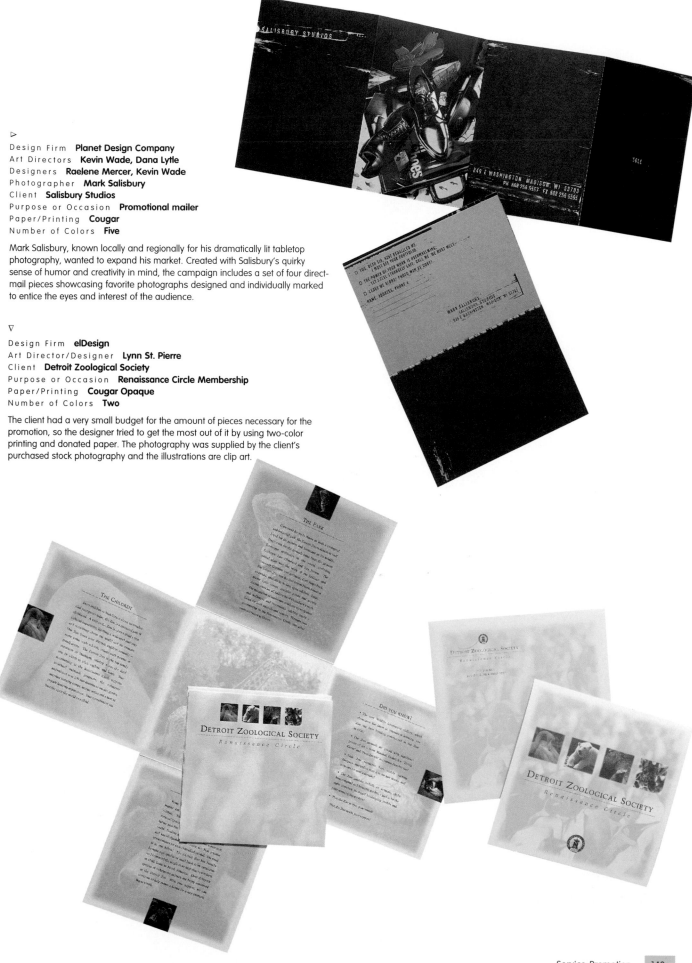

Design Firm **Planet Design Company**
Art Directors **Kevin Wade, Dana Lytle**
Designers **Raelene Mercer, Kevin Wade**
Photographer **Mark Salisbury**
Client **Salisbury Studios**
Purpose or Occasion **Promotional mailer**
Paper/Printing **Cougar**
Number of Colors **Five**

Mark Salisbury, known locally and regionally for his dramatically lit tabletop photography, wanted to expand his market. Created with Salisbury's quirky sense of humor and creativity in mind, the campaign includes a set of four direct-mail pieces showcasing favorite photographs designed and individually marked to entice the eyes and interest of the audience.

Design Firm **elDesign**
Art Director/Designer **Lynn St. Pierre**
Client **Detroit Zoological Society**
Purpose or Occasion **Renaissance Circle Membership**
Paper/Printing **Cougar Opaque**
Number of Colors **Two**

The client had a very small budget for the amount of pieces necessary for the promotion, so the designer tried to get the most out of it by using two-color printing and donated paper. The photography was supplied by the client's purchased stock photography and the illustrations are clip art.

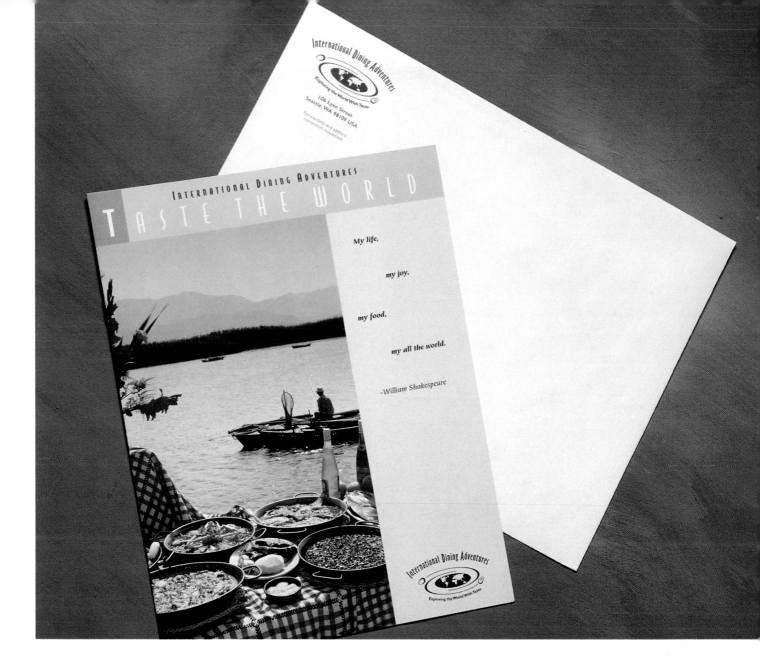

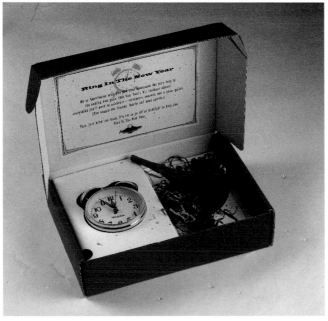

△
Design Firm **Belyea Design Alliance**
Art Director **Patricia Belyea**
Designer **Christian Salas**
Client **International Dining Adventures**
Purpose or Occasion **Tour sales mailer**
Number of Colors **Four**

As the client did not have photographs for all of the proposed destinations, the designers worked with images from international travel commissions. Color corrections and retouching were necessary, as many of the transparencies were yellowed or scratched.

◁
Design Firm **Webster Design Associates, Inc.**
Art Director **Dave Webster**
Designer/Illustrator **Sean Heisler**
Illustrator **Julie Findley**
Client **AmeriServe**
Purpose or Occasion **Promote AmeriServe**
Paper or Printing **Digital**
Number of Colors **Four**

This "timely" holiday promotion helps AmeriServe's clients ring in the new year.

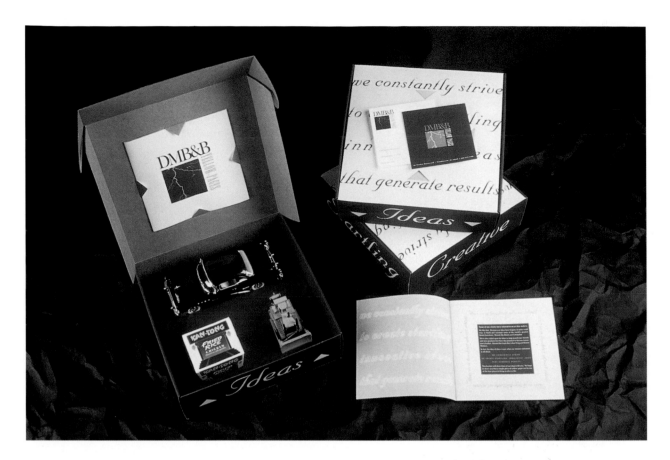

Δ
Design Firm **ZGraphics, Ltd.**
Art Director **Joe Zeller**
Designer **Gregg Rojewski**
Client **DMB&B Yellow Pages**
Purpose or Occasion **To market potential customers**
Paper/Printing **Starwhite Vicksburg/Lithography**
Number of Colors **Three**

This promotional piece was designed for prospective clients of DMB&B Yellow Pages. Based on DMB&B's mission statement, the piece shows how DMB&B used innovative ideas to help three existing clients market their businesses.

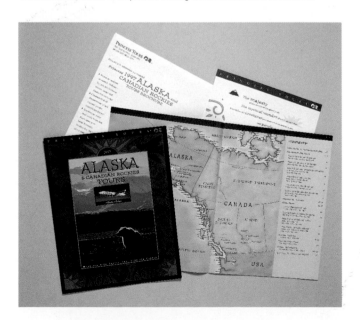

◁
Design Firm **Belyea Design Alliance**
Art Director **Patricia Belyea**
Designer **Ann Buckley**
Illustrator **Julie Paschkis**
Client **Princess Tours**
Purpose or Occasion **Tour sales mailer**
Number of Colors **Four plus two**

Many of the photographs in the catalogs are reproduced with vignetted edges for a relaxed mood. Small spot illustrations used on the direct-mail letter and envelope are pulled from the illustration framing the catalog covers.

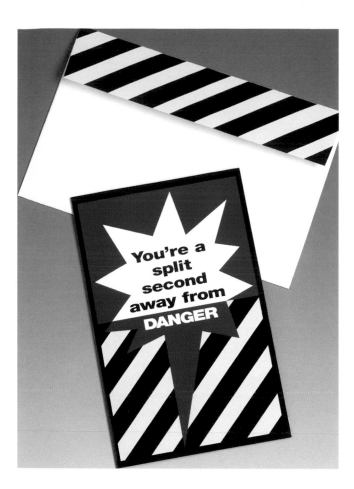

Design Firm **Becker Design**
Art Director/Designer **Neil Becker**
Illustrator **Drew Dallet**
Client **Wisconsin Electric**
Purpose or Occasion **Public awareness of electrical danger**
Paper/Printing **Burton & Mayer, Inc.**
Number of Colors **Three**

This piece is used to inform the public about the potential dangers of underground electrical cables. It contains stickers with a series of emergency and non-emergency phone numbers to be used prior to digging.

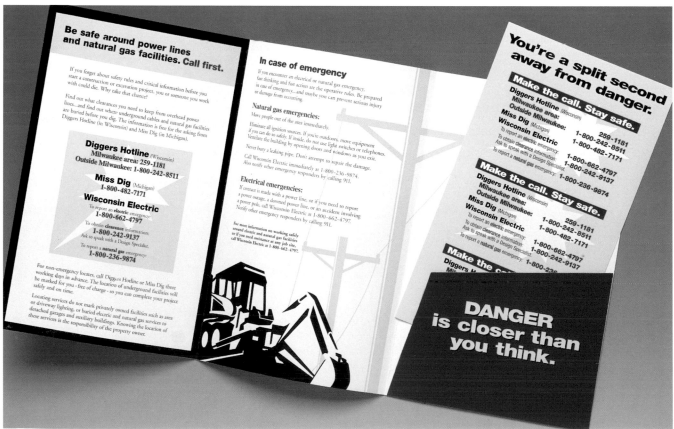

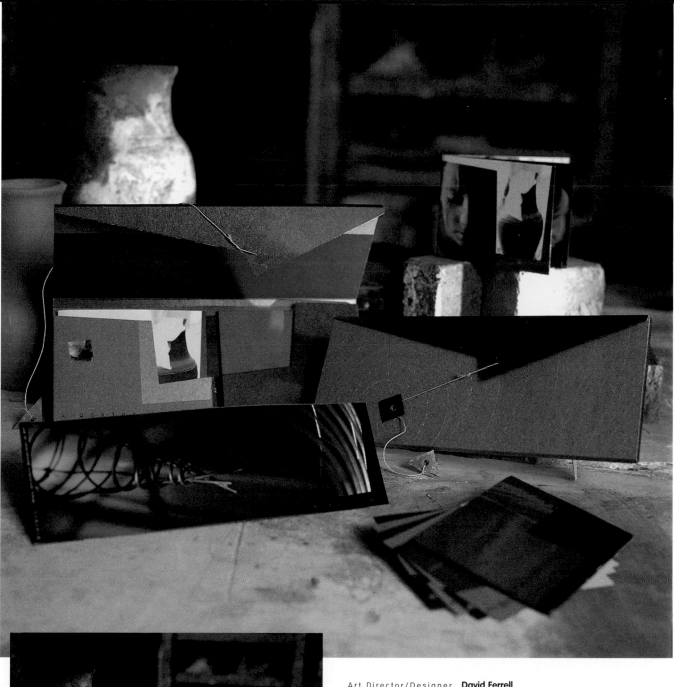

Art Director/Designer **David Ferrell**
Photographers **Ira Lippke, Joel Vermillion**
Client **Biola University art department**
Purpose or Occasion **Recruitment promotion**
Paper/Printing **Productolith Dull, 24 pt. chipboard, Simspon Quest**
Number of Colors **Four plus two metallic PMS plus black**

Biola University's art program needed a promotional piece to be sent to high-school students interested in art and design. The concept of "a worthy vessel" was explored using images of broken pottery and a clay-covered face to convey the art program's personal focus. Design, photography, and printing were donated.

Design Firm **Hornall Anderson Design Works**
Art Director **Jack Anderson**
Designers **Jack Anderson, Lisa Cerveny, Jana Wilson, Alan Florsheim, Michael Brugman**
Client **The Frank Russell Company**
Purpose or Occasion **Services kit**
Paper/Printing **Mohawk Superfine**

This modular brochure package focuses on different Defined Contributions companies. The kit includes four brochures and a small, square overview brochure. This kit was designed using QuarkXPress, Adobe Photoshop, and Macromedia FreeHand.

Design Firm **Hornall Anderson Design Works**
Art Director **Jack Anderson**
Designers **Jack Anderson, Julie Lock**
Client **Starbucks Coffee Company**
Purpose or Occasion **Sales-promotion kit**

This sales-promotion kit was aimed at real estate management as possible lease holders of space for Starbucks Coffee Company stores. This piece was presented to realtors of retail buildings as well.

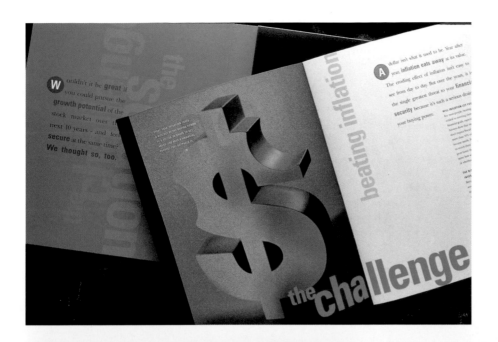

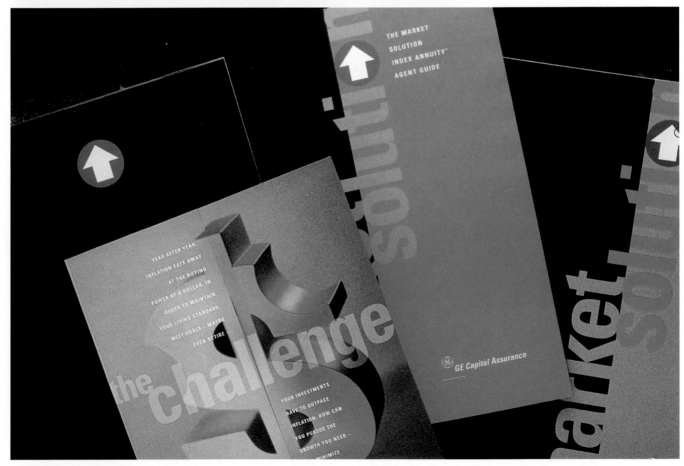

Design Firm **Hornall Anderson Design Works**
Art Director **Jack Anderson**
Designers **Jack Anderson, Lisa Cerveny, Jana Wilson**
Client **GE Capital Assurance**
Purpose or Occasion **Sales promotion kit**

This sales promotion kit was created to target potential clients of GE Capital
Assurance. A series of color-coded brochures was included to describe each
service.

▷
Design Firm **MartinRoss Design**
Art Directors/Designers **Martin Skoro, Ross Rezac**
Client **Welsh & Associates for American Bank**
Purpose or Occasion **Direct marketing**
Number of Colors **Four plus varnish**

The client wanted to show business customers that their present bank may
be too small, so through photography and Adobe Photoshop, humorous
situations were created. The brochures are bright and appealing to the eye
and not as busy as much of the direct mail that's received. They have small
die-cut doors that open and give a hint of what's inside.

▽
Design Firm **Tim Noonan Design**
Art Director/Designer **Tim Noonan**
Illustrator **Olivia McElroy**
Client **Elan Financial Services**
Purpose or Occasion **Open new Elan accounts**
Paper/Printing **Starwhite Vicksburg/Fox Printing Co.**
Number of Colors **Four PMS**

The sweepstakes was an incentive for employees of institutions participating
in the Elan Financial Services Credit Card Program to open new accounts.
Each time an employee opened a new Elan account, they would qualify for a
chance to win one of over 160 prizes. The prizes tied into the concept: "There's
No Place Like Home." Layout was created in QuarkXPress and the illustrations in
Macromedia FreeHand.

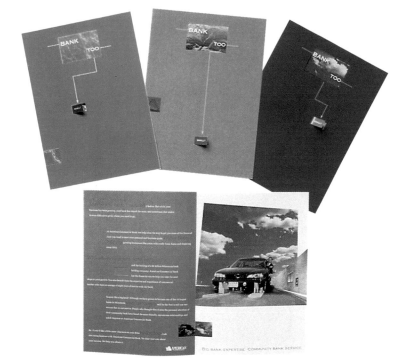

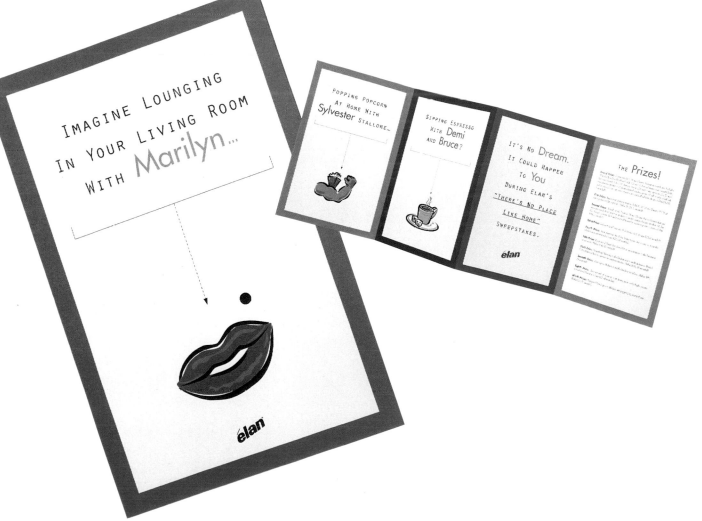

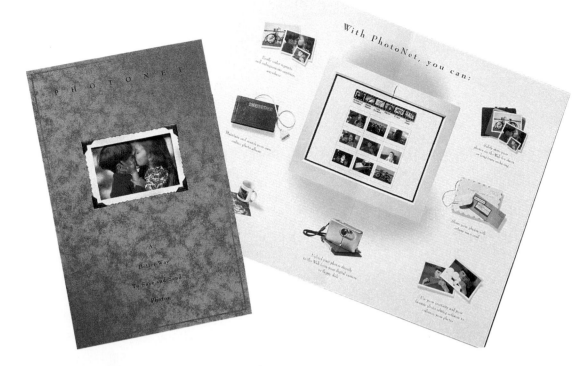

Δ

Design Firm **Hornall Anderson Design Works**
Art Director **David Bates**
Designers **David Bates, Margaret Long**
Client **PhotoNet**
Purpose or Occasion **Capabilities brochure**
Paper/Printing **Mohawk Superfine**

PhotoNet is a provider of a service that digitalizes photographs. This service is provided through camera stores. The brochure was designed using Macromedia FreeHand, Adobe Photoshop, and QuarkXPress.

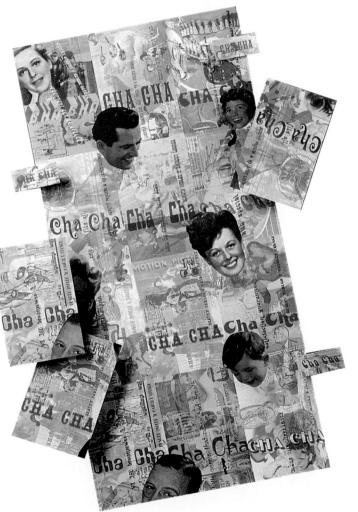

◁

Design Firm **Planet Design Company**
Art Directors **Kevin Wade, Dana Lytle**
Designers **Kevin Wade, Darci Bechen**
Photographer **Mark Salisbury**
Client **Cha Cha Beauty Parlor and Haircut Lounge**
Purpose or Occasion **Poster, grand opening postcard set**
Paper/Printing **Offset**
Number of Colors **Four**

Cha Cha Beauty Parlor and Haircut Lounge is a truly one-of-a-kind hair salon. The poster was created with a fresh and funky image in mind. Since budget was an issue, the designers printed a direct-mail campaign on the back of the poster, which was then cut into twelve ready-to-send direct-mail cards.

Index and Directory